Photography in focus

A BASIC TEXT

MARK JACOBS
KEN KOKRDA

 NATIONAL TEXTBOOK COMPANY • Lincolnwood, Illinois U.S.A.

ACKNOWLEDGMENTS

Thanks to the following for helping keep this project in focus: Sharon Savage, Ben and Faye Jacobs, Jenny Mueller, B. Banana, Louis Kat, Albert Gator, Elaine Equi, Roberta Rolak, Gail Wylde, Jack Levin, Gay Menges, Karen Christoffersen.

The authors also wish to express their appreciation to the following institutions, companies, and individuals for their generous cooperation in supplying photographs used in the book: International Museum of Photography at the George Eastman House, Rochester, New York; The Art Institute of Chicago; Museum of Modern Art, Department of Photography, New York: Metropolitan Museum of Art, New York; Gernsheim Collection; Humanities Research Center, University of Texas, Austin; Farm Security Administration, Library of Congress, Washington, D.C.; Vivitar Corp.; Nimslo Corp.; Nikon, Inc.; Canon, U.S.A.; Eastman Kodak; Globuscope, Yosef Karsh; Jerry Uelsmann; W. Eugene Smith; Andrea Jennison; Alex Sweetman; Bill Brandt; Norman Weisberg.

PHOTOGRAPHY IN FOCUS

We live in a visual world. One in which photography is making an impact as never before. Today, people in all walks of life are using photography as a tool in everything from their careers to their hobbies. And as photographic technology has advanced, and cameras have become easier to use—even more people have gotten into photography.

But the ones who get the most out of it will be those who develop a thorough understanding of the medium. Because the camera is an outlet for creativity, a device that can make you see yourself and your world in a special way—the more you know about this tool, the more satisfaction it will provide. And the more you'll be able to communicate your special insight to others.

We are pleased to cooperate in the publishing of this revised edition of *Photography in Focus,* as part of *Popular Photography's* long-standing national program to increase public awareness of the educational and creative rewards of photography. This new edition incorporates the many changes which have occurred in our industry since the first edition. The text will not only help you learn and understand this valuable skill, but it will also enable you to participate in photography to a greater and more satisfying degree.

Sidney Holtz
Popular Photography

Contents

INTRODUCTION

Photography has been called the most democratic of the arts because almost anyone can take a photograph and indeed, almost everyone has. Although the technology has been simplified, the medium still offers the knowledgeable technician the range and power to achieve images of great beauty.

In this book we assume no prior understanding of photography. Here you will find clear explanations of the basic processes and techniques of photography. This book differs from traditional texts in that it does not start with a discussion of the history and uses of photography. Instead, you are immediately involved in making and developing photographs.

Photography in Focus is divided into two parts: foundation chapters (1-6) and expansion chapters (7-13). In the foundation chapters, you will learn the basic elements, principles, and functions of cameras, exposure, film development, and printmaking. Chapters 7-13 expand on the knowledge gained from those earlier chapters to show you ways to achieve better photographs through techniques such as enlargement and the use of filters and special lenses and through an understanding of visual aspects of photography. Concluding the book is a chapter on the history of photography, an extensive bibliography, a glossary, and an index.

Seeing the world in a perceptive and open manner increases our understanding of that world and its people. Used with imagination, the camera can supplement our eyes and expand our ability to see. We not only take photographs using visible light but routinely take photographs with light that our eyes cannot see—infrared and x-rays. Our eyes perceive the motion of a bird in full flight, but the camera can record it as a frozen image. The camera can go where we cannot; we now have photographs of developing embryos, of the outer reaches of space, and of ocean depths. Perhaps, though, the most valuable revelations that are produced by photographs are scenes which show us in our daily lives engaged in the details of peace and war, love and despair, affluence and poverty. We hope that this book, with photography as the focus, will increase our understanding of the world and of each other.

Dedicated to Henry Lavander

Photograms
1

The word *photography* comes originally from two Greek words that mean "light drawing." Light is the heart of photography, from the initial exposure of the picture to the final developing and printing.

The easiest photographic image to make is the photogram, a simple record of light and shadow. The photogram was also the earliest surviving example of a negative-positive image relationship. The calotypes, or *photogenic drawings,* made in the early 19th century by William H. F. Talbot were essentially photograms.

A photogram is a recorded shadow. It can be made by two methods, one using direct sunlight and the other using darkroom equipment.

Talbot: Photogenic drawing, 1839

Printed-Out Photogram

A *printed-out photogram* does not require darkroom or chemicals. A kind of printed-out photogram can be seen in a suntan—the darkening of skin that is exposed to the sun's rays, while the "unexposed" part of the skin remains light. In a photographic photogram, the pattern is caused by the action of light on a sheet of photographic paper. Photographic paper has a coating or *emulsion* on one side that is sensitive to light. Exposing the paper to direct sunlight for a few hours causes the emulsion side of the paper to turn dark.

To make a printed-out photogram, you need photographic printing paper. A partial list of papers that can be used includes those manufactured by Eastman Kodak such as Kodabromide, Polyfiber, Medalist, and Kodabrome II. Papers manufactured by Ilford include Ilfobrom, Ilfospeed, and Multigrade II; and those made by Agfa include Brovira and Portriga. In addition, both Unicolor and Seagul manufacture photographic paper. Whichever brand of paper you choose, we recommend that you use a glossy surface paper to help distinguish the emulsion (light-sensitive) side from the back side of the paper. If possible, purchase a resin-coated (RC) paper since it is easier to handle.

composing the photogram

To begin, remove one sheet of photo paper from the package while you remain in the safelight conditions of your darkroom. Be sure to put unused photo paper back into the package or box because any other type of light will harm the paper. Once the unused paper is stored, hold the removed sheet of paper so you can determine which side is the emulsion side. Again, do this under safelight conditions. Next, put the paper on a clean, dry, flat surface with the emulsion side facing up. Then, lay some small opaque objects on the emulsion side. Some objects include keys, coins, leaves, plants, pencils, paper clips, and rubber bands. After the objects have been arranged on the paper, expose the photo paper to regular room light or, better still, light from an intense source such as a spotlight or a lamp directed at the paper. The objects should remain in place on the emulsion side from one to two hours without moving either the objects or the light source. However, the more intense the source of light the shorter the exposure time. Conversely, a weak light source requires longer exposure time.

After completing the exposure, examine the photogram under dim light. This method is necessary since prolonged exposure to light will cause the entire image to darken. A correctly exposed photogram reveals the area underneath the objects as a light area (white if an opaque object is used). The portion of the paper exposed to light (area surrounding the object) will be dark. Light areas result from the opaque objects blocking the light rays from hitting those portions of the photo paper while the surrounding portions are exposed to the light causing those areas to darken. Since the recorded image is lighter (or whiter) where the light is blocked and darker where the light strikes, the tonal scale is reversed and thus a *negative* image is produced.

One problem that may occur when making a printed-out photogram is a lack of tonal contrast between light and dark areas. This

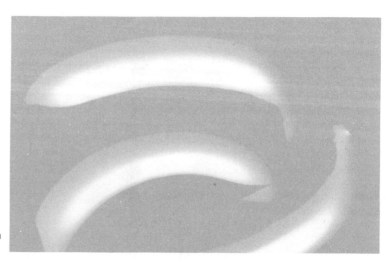

printed out photogram
note lack of contrast

condition is called *underexposure.* Underexposure in a printed-out photogram happens for the following reasons: the light source is too weak or dim; the light source is too far away from the paper; or the exposure time to the light source is too short. To correct a photogram that lacks contrast between the light and dark areas use a brighter light source, move the light source closer to the paper, or increase the exposure time to the light source.

A shorter exposure can be accomplished by using a special type of photographic paper. Print-out paper, which is made by the Eastman Kodak Company and sold under the brand names of Studio Proof and Portrait Proof, is designed for use with most types of white light. With print-out paper, the exposure time is shortened to a few minutes. Professional photographers present black and white *proofs* to their clients on these same papers; but like professional proofs, the image fades rapidly if not protected from light.

Developed-Out Photograms

Light is necessary for exposure in a developed-out photogram as well as in a printed-out photogram. However, a developed-out photogram requires photographic chemicals to make the image visible. Developed-out photograms solve two major problems associated with printed-out photograms. The first problem is the length of exposure time necessary to produce a contrasty image. The second problem concerns the continual fading away of the image as it is exposed to normal room light. By adding photographic chemicals to the process both problems become resolved. As you recall, the image in a printed-out photogram is visible only after prolonged application of a high-intensity light source. That light eventually causes a chemical reaction in the photographic paper where the areas exposed to the light source turn dark. Chemicals stabilize (or

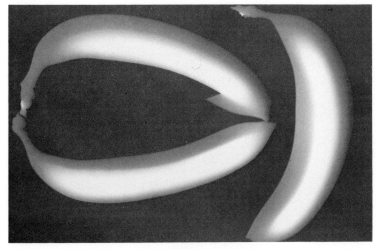

developed-out photogram

photogram of translucent objects

fix) the image so that light no longer affects it. Chemicals for this process include a developer, a stop bath, a fixer, and water.

To make a developed-out photogram, begin the same as when making the printed-out type. First, remove a sheet of photo paper from the package under safelight conditions and store the rest. We do not recommend that you use print-out paper for this purpose. Next, lay your objects on the paper with the emulsion side up. Keep in mind that the more transparent an object, the more light will pass through it, causing the area underneath the object to receive more exposure resulting in a darker area. After the objects are on the paper, make the exposure to white light (room light). Because chemicals, as opposed to the action of light, cause the image to appear, exposure time is reduced to 1 or 2 seconds.

After making the exposure, remove the objects from the paper. At this point, you will notice that nothing seems to have happened to the paper. It is still white, seemingly unaffected by the shorter exposure. However, an invisible image has been recorded on the sensitized paper. This is called the *latent image* that can only be seen after being chemically treated.

Chemical Steps

The chemical for making the invisible latent image visible is the *developer*. A developer chemically changes the latent image on the emulsion to a visible image composed of metallic silver. The greater the exposure, the denser the silver. Different brands of developers have their own particular characteristics. However, since we are using photographic paper for these photograms, be sure to acquire a developer made for photographic paper (as opposed to film developer).

The length of time that the photo paper remains in the developer is determined by the type of paper, the type of developer, and the temperature of the developer. A chart is usually provided with the package of paper or the developer. If none is available, refer to the chart at the end of this section.

The second chemical, the *stop bath*, halts the action of the developer. It usually consists of a mild solution of acetic acid. The stop bath also helps preserve the useful life of the next chemical, the *fixer*.

The fixer (or hypo) removes the unexposed silver from the paper, those areas that are not exposed to light. After the paper is treated in the fixer, it is no longer sensitive to light and thus the print can be viewed in normal room light.

Although not a chemical (unless you live in one of our more polluted areas), running water must be used to remove any excess fixer. If this is not done, the print stains after a few weeks, and eventually the image bleaches itself due to certain ingredients in the fixer.

To begin the chemical process, set up four developing trays. If the darkroom you are working in has a large counter or sink, position

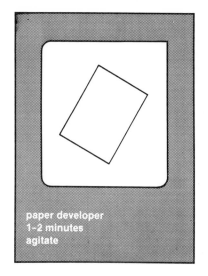

paper developer
1–2 minutes
agitate

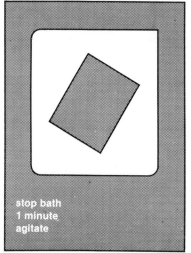

stop bath
1 minute
agitate

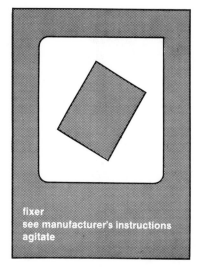

fixer
see manufacturer's instructions
agitate

the trays in a line and work from left to right with the developer first, followed by the stop bath, fixer, and finally water. Assuming you have an exposure, immerse the paper in the developer. Generally, leave the paper there from 1 to 2 minutes, depending on the factors already discussed. Again, while the paper is in the developer, continue to work under safelight conditions.

Next, remove the paper from the developer and immerse it in the second chemical, the stop bath. Although times will vary in this step also, generally it should remain there for 30 seconds. Then, move the print to the fixer. After the print remains in the fixer for approximately 2 minutes, it may be viewed under normal room light. The print should not remain in the fixer longer than 10 minutes since, like the stop bath, it contains a mild acid and after several hours the image will be bleached out.

After the print leaves the fixer, wash it for at least 30 minutes in running water. Drying the wet paper can present certain problems. The quickest way is to simply wipe off the excess water with a clean sponge and air dry it. However, curling occurs with many types of paper. If time allows, put the print between two blotters and leave a heavy book on top to keep the print flat. With this method, the paper usually takes a couple of days to dry thoroughly. If you are using an RC paper, then hang the print to dry using clothes pins or paper clips. Because RC paper will not curl up as it dries, we highly recommend it.

Interestingly, a photogram that is made by the printed-out method can also be made light permanent. To do this, skip both the developer and stop bath trays and immerse the print in the fixer. Wash and dry the paper as described. Once both prints are dry, compare them. Notice that the print made by the printed-out method lacks the brilliance and contrast of the developed-out photogram.

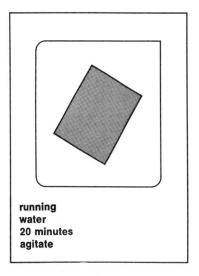

running
water
20 minutes
agitate

negative photogram

positive photogram

Negative—Positive Relationship

Both these methods of making photograms produce *negative* images; in other words, they reverse the normal tonal scale, substituting white for black. There are two methods, the wet process and the dry process, that can be used to reverse the negative image to a normal positive.

The advantage of the wet process is that the negative photogram does not have to be dried before a positive is made. After a negative photogram has been washed in running water for ten minutes, turn

the safelight on and the room light off. Take a sheet of unexposed photo paper and put it in the wash water for two minutes. Remove both the wet negative and the wet unexposed paper and press them together, emulsion sides facing each other. Lay the paper flat with the negative image on top. After that, remove the excess water by running your hand over the back of the paper. Then turn on the room (white) light for a trial exposure of one second. Develop the fresh paper the same as you did the first. If the positive image is too light, or underexposed, increase the time you leave the room light on. If the positive is too dark, or overexposed, either shorten the exposure time or move the paper farther away from the light source.

To make a positive after the negative has been dried, place a clean piece of glass on top of the two sheets to ensure close contact between the negative and the unexposed paper. Again, work under safelight conditions. Make sure that the negative is on top. Expose the paper to room light as before and then develop the image.

Photograms offer a unique way of expression. Experiment with different shapes and sizes of objects. After you learn the technique of photograms, try using objects that are not completely opaque. These will add different tones of gray in your photograms instead of stark black-and-white silhouettes. You may also want to try varying your light source—for instance, use a small flashlight instead of an overhead light. The effects that can be achieved add another dimension to the photograms.

Another method that can be employed involves the use of a sheet of Plexiglas or glass and a bottle of black and gray drawing ink. This ink is sold under the trade name of Pelikan. In an emergency, a waterproof India ink can be used.

To begin, first draw the image on the Plexiglas using a brush. Remember that the gray ink is translucent, which means some light will pass through it. The black ink, on the other hand, will be opaque, thus no light will be able to penetrate it. The gray-inked areas will produce a gray image on the paper. The black will appear white while the areas not painted over will be black in the photogram. After the ink has dried, lay the glass on the photographic paper and expose as before.

brushing India ink on glass

It is possible to use more than one layer of glass. A multi-layer photogram is accomplished by putting the first layer directly in contact with the photographic paper. The second glass layer is raised up a few millimeters from the first layer by using small pieces of cardboard in each corner. More layers can be built upon the second layer in the same manner. After you have decided how many layers are to be employed, make your drawings on each layer using the ink. It is also possible to use opaque or translucent sheets of paper on a layer of glass. After the glass layers are in place, expose as before. Then, very carefully, remove the top layer so as not to disturb the glass below it. Next, with the top layer removed, re-expose as before. It will be necessary to keep re-exposing each time you remove a layer. The only exception is the layer that was directly

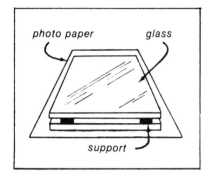

photo paper *glass*

support

in contact with the paper. There would be no need to re-expose the paper without that layer, since the entire photogram will just turn out black.

After you have developed the photogram, notice that each layer of glass is represented by a shade of gray. Generally the layer that was in direct contact with the photographic paper will contain the most intense white, while the layer that was removed first will contain the darkest shades of gray to black. However, this will depend on the design drawn on the glass due to the amount of overlapping designs. The exception to this is the layer closest to the photographic paper in opaque areas, which will remain white, since no light was able to pass through it.

In Chapter 6, you will learn how to make photograms using the enlarger as the light source. An enlarger will allow for more precise control of the exposure time, which in turn will allow for more control over the final results. There are endless possibilities with photograms. They really have only one limitation, your imagination.

The chemical steps described earlier provide you with a working knowledge only. They are not intended as a complete description of the chemical process. More information can be found in Chapter 6.

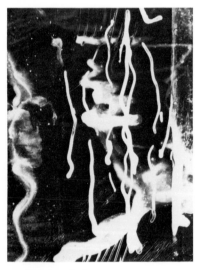

multi-layer photogram

CHEMICAL TIME CHART*

Step	Time	Additional Information
1. Developer	1–3 minutes for fiber-based papers; 1 minute for RC papers	Agitate constantly; safelight conditions only
2. Stop-bath	20–40 seconds for fiber-based papers; 5–10 seconds for RC papers	Agitate constantly; safelight conditions only
3. Fixer	5–10 minutes for fiber-based papers; 2–4 minutes for RC papers	Agitate constantly; safelight conditions for first half of time
4. Wash	1 hour for fiber-based papers; 20–30 minutes for RC papers	Empty tray of all water once every 5 minutes; wash no more than 15 prints at a time

*Chart provides guidelines only. When possible, refer to manufacturer's instructions.

In Focus/Photograms

1. Make several photograms using the printed-out method. Since the printed-out method is less predictable than the developed-out method, you will have to experiment to determine the correct exposure time and light-to-paper distance.

 Some photograms should be made with opaque objects (such as paper clips, coins, keys, etc.) and some should use a few objects

that are translucent (frosted plastic utensils, newspaper, or thick glass containers). We suggest using some translucent objects because they will allow some intermediate tones to form on the photogram. This will add variety to what would otherwise be strictly a dark-light composition.

2. Make at least three developed-out photograms. Try to use some of the same objects that you used in the printed-out photograms, but arrange them differently. Be sure that you include some of the translucent objects you used previously. This will allow you to compare the resulting tones produced between the developed-out and printed-out photograms. You should find that the contrast in the developed-out photograms is much greater than the contrast in the printed-out ones, provided they have been properly exposed and developed.

 Another way to produce gray tones in your developed-out photograms is to change the position of some of the opaque objects about halfway through the exposure. To do this, the exposure must be made in two steps. For example, if the overall exposure is 10 seconds, step one is to make the first exposure for 5 seconds. Next, remove some of the opaque objects. Step two is to expose the paper for the remaining 5 seconds. Since the objects have not blocked the light from the paper during the entire exposure, the area beneath the objects will be gray.

3. Make several photograms using multiple layers of plastic with gray or black ink, or tape flat objects of varying transparency to them. Experiment with a variety of exposure times. Vary the order in which the sheets are stacked above the photo paper. Keep a notebook with records of materials used, order of sheets, and exposure times. Keeping records will allow you to repeat an unpredictable effect. Many interesting effects may happen by accident, but the photographer must begin to exert control over the final product at some point in order to produce the best possible image.

photogram made with penlight

The Pinhole Camera 2

A camera is often compared to the human eye. Both a camera and the eye are enclosed chambers with an opening that allows light to enter the dark chamber from the front and then pass through a lens. Both have a light-sensitive area behind the lens.

The lens in both the camera and the eye serves the same function —to gather the rays of light from the scene being viewed and then transmit them, in an expanding cone, back to this light-sensitive area. In the eye, this light-sensitive area is called the retina; in a camera, it is the film.

In both the eye and the camera, a device in the lens controls the amount of light transmitted. In the eye, this device is a muscle called the iris. In the camera, the device is called the iris diaphragm. Both the eye and the camera work best when there is a moderate amount of light—too little light, and the details cannot be seen, while too much light is blinding.

Both the camera and the eye must be focused on a scene, or the image will be blurred. In the eye, the lens, controlled automatically by the brain, focuses the light rays on the retina. The brain also translates the image on the retina into something meaningful. In the camera, the lens focuses the image.

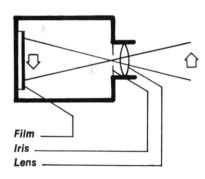

Film
Iris
Lens

The one very important difference between your eye and a camera is that the camera has no intelligence of its own—no brain to control it. Camera manufacturers try to make cameras easier to use by installing electrical circuitry that will make instantaneous calculations of the picture-taking situation, and equipping them with digital read-outs much like a calculator. Yet no camera, no matter how new or expensive it is, can see for you. The camera serves the photographer; it is not the master. The camera is like the photographer's paintbrush and the film is the canvas, but it is up to the photographer to recognize a good photograph. The earliest forerunner of the camera—the *camera obscura*—did not use a lens. Camera obscura is Latin for "dark chamber," and at first it was simply that, a dark room with a small hole in one of the walls. People sitting inside the room could see fuzzy images from the outside form on the white wall opposite. The image of the camera obscura was formed by unfocused light rays, and the sharpness of the image depended on

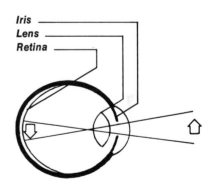

Iris
Lens
Retina

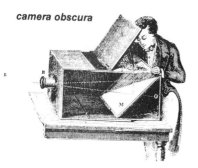

camera obscura

the size of the hole in the wall and the distance between the hole and the opposite wall. A large hole and a long distance combined to produce a blurred image. However, because a small hole meant a faint image, the camera obscura without lenses had to compromise between sharpness and brightness.

According to most historians, the camera obscura began to be equipped with lenses about the 16th century, making possible the development of portable models with a sharper, brighter image. However, one very simple type of camera still made today does not have a lens. It uses the basic principle of the camera—light entering a dark chamber and producing an image. It is called a *pinhole camera.*

How to Make a Pinhole Camera

The first thing needed to make a pinhole camera is a box that can be made light-tight so that no stray rays of light will enter and fog the film or photographic paper. Boxes that can be used for this purpose are shoeboxes, oatmeal boxes, or any similar box that has a tight-fitting lid and will hold a 4 inch by 5 inch sheet of photographic paper.

Next, you need to make the pinhole, which will serve as the lens on the camera. Take a smooth piece of aluminum foil about an inch square. Lay it on a flat, hard surface such as metal or glass and press only the top or point of a needle straight down through the foil. The hole should be perfectly round and free from ridges, and the foil should not be pushed out where the pinhole was made. The hole itself will be hard to measure, but it should be too small for the entire pin to fit through.

find a light-tight box

carefully puncture the aluminum foil

12

After you have selected the box, paint the inside of it flat black. If the inside remains a light color, it will reflect or bounce the light passing through the pinhole in all directions and fog your paper. Next, make a hole in the center of one side of the box and tape the aluminum foil with the pinhole securely over the larger hole, using an opaque tape such as black electrical tape or masking tape. Make sure that the pinhole is in the center and then take another piece of opaque tape and cover the pinhole. This piece of tape will act as the shutter of your camera.

tape aluminum foil over square hole

Loading the pinhole camera with photo paper must be done in darkroom conditions using a safelight. Use an unexposed fresh sheet of photo paper, like that used in making the photograms, and center it on the side opposite the pinhole. Make sure that the emulsion side is facing the hole. After this is done, tape the four corners down so that the paper won't move around inside the box. (See center illustration on the right.) Replace the lid on the box and you are ready to take a picture.

Taking the Pinhole Picture

"Exposure" in photography can mean two things: (1) the actual taking of the picture and (2) the time that light is allowed to enter the light-tight camera. For instance: "Elaine *exposed* 13 pictures today, each one having an *exposure* of two minutes. Luckily for her, it was a bright day—otherwise her *exposure* would have been eight minutes each and she couldn't have *exposed* as many pictures."

tape pinhole closed and position photo paper

To take a picture (or *expose* a picture) with a pinhole camera, place it on a firm support, such as a table, a windowsill, a rock, or a chair. Tape or weight it so it won't move accidentally. This is important, as any movement during the exposure will cause your picture to be blurry or out of focus. After your camera has been securely fastened to the support, open the tape that is covering the pinhole. Expose the picture for two minutes if it's very sunny outside, for about eight minutes if it's cloudy bright. You must then develop your picture in the darkroom as you did the developed-out photogram. The resulting image will, of course, be a negative. Making a positive is done in the same manner as with a photogram. If your negative is too light, or underexposed, then increase your exposure time. If your negative is too dark, or overexposed, shorten the exposure time. Just remember that the brighter it is outside, the shorter your exposure time should be; while the darker it is, the longer your exposure time will be.

secure box with heavy object; remove tape and expose

You may want to make three or four pinhole cameras so that you'll be sure of getting the correct exposure. With camera #1 make an exposure of two minutes, with camera #2 a four-minute exposure, with camera #3 a six-minute exposure, and so on. This procedure is called "bracketing" the exposure.

Movement (or lack of it) is the main consideration in choosing subjects for pinhole camera exposures. Most people can't sit still for a two- to eight-minute exposure; they move and cause a blurry image. It is best to shoot unmoving subjects like landscapes, buildings, or trees.

There are actually four variables that affect the exposure time: (1) the sensitivity of the paper or film to light; (2) the size of the pinhole; (3) the pinhole-to-paper distance; and (4) the lighting conditions.

All photographic papers and films are sensitive to light. However, some kinds of film and paper are more sensitive than others. In general, film is more sensitive to light than paper. Therefore, you may want to use film instead of paper in your pinhole camera, especially if you intend to photograph something other than a still-life. A pinhole camera, designed around a 126 film cartridge, is explained later in this chapter.

The size of the pinhole also affects the necessary exposure time. A small hole, of course, will allow less light to pass through it, while a larger hole will allow more light to enter. Then, why not just make a bigger pinhole? The reason is that many more rays of light will pass through the larger hole, and because there is no way to guide them, they will record themselves over a much larger and less well-defined spot of the paper or film. What about using a more sensitive film and a smaller hole to get a sharper picture? This would work if it were not for the effect of diffraction. Diffraction refers to the scattering of light rays as they pass close to any edge. As the hole is made smaller, the proportion of scattered rays of light to unscattered rays increases, thus, also producing a less defined image. In short, a pinhole camera cannot ever produce as clear or sharp a picture as a camera with a lens.

The shorter the distance from a pinhole to the paper (or film), the shorter the exposure time can be. Conversely, the longer the pinhole-to-paper distance, the longer the exposure necessary.

Distance can also be used to create an optical effect you may want to use in your picture-taking. A camera in which the pinhole-to-paper distance is substantially less than the diagonal measurement of the paper will produce a small image that includes a wider field of view. For example, the diagonal measurement of a 4 × 5 inch sheet of paper is about 6½ inches. If you put a 4″ × 5″ sheet of paper 2 inches from your pinhole, you'll get a "wide-angle" effect. That is, more area will be shown in your picture because the subject and its surroundings will be reduced in size.

Conversely, if the pinhole distance to the paper is much greater than the diagonal measurement, the image will be magnified to look so much greater in size than it really is. This is called a "telephoto" effect. If the pinhole-to-paper distance is about the same as the diagonal measurement, the effect will be "normal"—that is, about what your eye would see within the same space from the same distance as the camera.

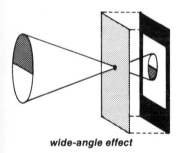

wide-angle effect

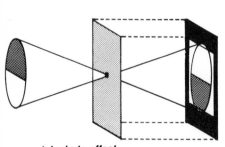

telephoto effect

The last factor that determines exposure is the amount of light. The more light, the shorter the exposure time. The less light there is, the longer the exposure time. Bracketing the exposure by making several pinhole cameras and photographing the same scene under the same lighting conditions with different exposures will help you in getting a properly exposed picture.

Experimental Pinhole Cameras

Pinhole cameras can be made in many other sizes and shapes. For instance, a 20″ × 30″ cardboard drum can be used to make a 16″ × 20″ pinhole photograph. The requirements needed are a tight-fitting lid for the container and large sheets of photographic paper. However, since photographic paper that large tends to be costly, it is advisable to practice with smaller size images first. It will be necessary to increase the exposure time with a large image, a ten-minute exposure time is a reasonable starting point.

Multiple-Image Pinhole Cameras

Another interesting area that can be explored is the use of the multiple-image pinhole camera. A multiple-image camera will allow you to record more than one image on the same sheet of photographic paper. It is much like a double exposure except that the different images do not necessarily have to overlap.

In constructing a multiple-image camera, the major item needed is a long tube that again has a tight-fitted end cap. The tube should measure approximately between 20″–36″ long with a 3″–4″ inside diameter. Mailing tubes, such as the type sold in most stationery stores and art supply stores, fit the requirements and will generally cost between $1.50–$3.00. The major difference between constructing this type of camera versus the other pinhole cameras will be that a multiple-image camera will utilize more than one pinhole.

After securing a tube, paint the inside flat black as before. Next, measure out two- or three-inch intervals in a row on the front of the tube. It is at these two- or three-inch spaces that the pinholes will be placed. For example, if your tube is 20″ long, you will need to make 10 pinholes if you use two-inch intervals. When making the individual pinholes, be careful to make each pinhole the same size. After installing each pinhole at the pre-determined intervals, cover the pinholes with an opaque tape.

The camera is now functional and all that remains to be done is to load the camera with the photographic paper. The paper should be cut so that the length equals the length of the tube. Thus, it is recommended that you use a tube no longer than 20″ as photographic paper larger than that is hard to come by. The height of the paper should be cut to half of the inner diameter of the tube. For example, if your tube is 20″ × 4″, your paper should measure 20″ × 2″.

pinhole photograph

tube pinhole camera

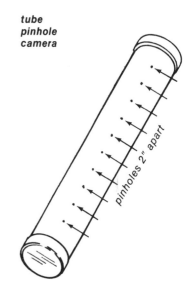

pinholes 2″ apart

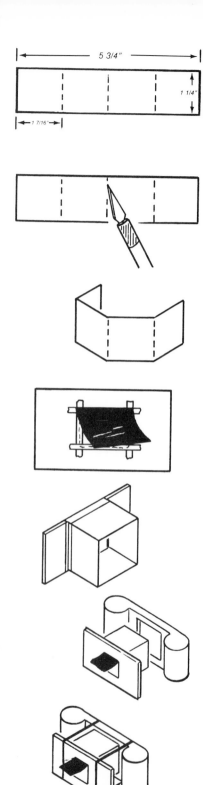

The exposure will be a little shorter than the earlier cameras because the pinhole-to-paper distance will decrease. It will be possible though, to control each pinhole separately if you desire to give some areas of the picture a different exposure. It will also be possible to record an image in sequence by exposing through one pinhole at a time instead of having them all open at the same time. Also, by re-positioning the camera, and if each pinhole is controlled separately, it will be possible to record entirely different images next to each other. There are endless variations with which to experiment.

Cartridge Film Pinhole Cameras

As explained earlier, film is generally more sensitive to light than photographic paper. Thus, the exposure time can be reduced to a few seconds rather than a few minutes. This is especially important if your images were fuzzy because of camera movement during the long exposure due to the relatively low sensitivity of the photographic paper to light, or because you want to photograph something that won't remain still for more than a few seconds. A cartridge of film will also allow you to take twelve pictures without having the need to unload the camera after each exposure. The following materials will be necessary to make this type of pinhole camera: A cartridge of Kodak Verichrome Pan film, size 126, (Instamatic size), a piece of thin black cardboard cut to 1-1/4 × 5-3/4 inches, a piece of thick black cardboard cut to 1-1/2 × 2-3/4 with 1/2 inch opening cut in the center, a one-inch square of aluminum foil for the pinhole itself, an opaque piece of paper cut into a one-inch square, two rubber bands, and some black masking tape (or cloth tape).

To assemble the camera, first measure and mark the large black cardboard into four equal sections. Each section will measure 1-7/16 inches wide. Next, using a knife or one-sided razor blade, cut through the top layer of the cardboard along each of the lines you made when measuring the equal sections. Do not cut through the cardboard! You just want to score the top layer. Next, fold the cardboard into a box and tape the edges together with the black tape. Now, make the pinhole in the foil and attach it over the opening in the smaller piece of cardboard. Once your pinhole is secure, put the small piece of opaque paper over the pinhole and tape it along the top edge. Use a smaller piece of tape on the bottom edge to hold the flap down after the exposure has been made. You can now tape the cardboard with the pinhole to the box. Be sure to use an opaque tape (electrical), making sure all the edges are taped together so that no light can get into the box. Install the camera box into the grooved recess of the square opening of the film cartridge. Make sure that the box fits snugly so that no light enters the camera box. Once this is done, use two rubber bands, one on each side of the pinhole to secure the camera box to the film cartridge. To advance the film for each picture, insert the edge of a coin into the round opening on the top of the cartridge and turn it counter-clockwise. The yellow paper,

which is visible from the outside of the cartridge, will begin to move. The yellow paper has numbers printed on it. Turn the coin slowly until the third and fourth numbers in each series show in the window on the outside of the cartridge. The film will then be in the correct position to take the picture.

The exposure time for this type of pinhole camera will be considerably faster than it was for the photographic paper. Again, in order to get a sharp and clear image, it is essential that the camera remain very still when you are making the exposure. Since this camera is very small, you might try taping it down to a firm support, such as a chair or table. It is, of course, advisable to experiment on the amount of time to give the film the necessary exposure. As a guide, you might try a 2–4 second exposure if it is a bright sunny day, or an 8–16 second exposure if it is cloudy-bright.

The Simple Camera

Although primitive by today's standards, a pinhole camera does allow us to take pictures. However, these photographs lack the clarity and quality of images made from the most inexpensive camera, and the physical construction and convenience of a pinhole camera does not compare favorably to inexpensive cameras. The primary reason is the one feature that separates pinhole cameras from all others— a *lens*.

Lenses in cameras vary in quality; but they all serve the same purpose of focusing the light that passes through them onto the light-sensitive film. Lenses in many inexpensive cameras are made of plastic. Better quality lenses are generally made from glass, which can be polished to a finer degree than plastic and so produce a sharper image. A pinhole camera has no lens to focus the light rays to a common point. Because the pinhole lacks a lens, the image it produces lacks sharpness and clarity.

Most cameras with lenses share certain basic features. They include (1) a light-tight box to keep out all stray light and to serve as a frame to hold other parts; (2) a lens opening to control the amount of light that reaches the film; (3) a shutter to control the length of time the film is exposed to the light; (4) a trigger to release the shutter; and (5) a viewfinder to look through and frame the picture.

1. *light-tight box*

2. *lens opening*

3. *shutter*

4. *trigger release*

5. *viewfinder*

positive pinhole photograph

negative pinhole photograph

In addition, most lens cameras allow for more than one picture to be taken at a time and thus provide a device to advance the film.

The frame, or body, of many cameras today is made of plastic, although metal is also used. The frame is designed so that other parts, like a lens, can be attached to it without destroying its light-tight body.

The lens opening, or aperture, controls the amount of light that reaches the film, much like the diameter of the pinhole. In inexpensive cameras, the aperture size remains the same and does not vary even if lighting conditions change. This situation is similar to that of a pinhole. However, more sophisticated (and expensive) cameras have diaphragms that can change in size. This diaphragm works much like the iris in your eye which adjusts the size of your pupil to let in more or less light depending on the lighting conditions.

While the lens opening (aperture) controls the amount of light that reaches the film, the shutter of a camera controls the amount of time that light is permitted into the dark chamber. Some inexpensive cameras have shutters that do not vary in speed. Thus, if there is not enough light available, the resulting negative may be too light (underexposed). In many newer cameras, the shutter is controlled electronically so that the speeds vary from very fast (1/2000 of a second) to very slow (four or more seconds). The shutter release in most cameras is simply a button that releases the shutter so that the light can enter the camera.

A viewfinder is built into most cameras so that the photographer can see what the picture will include. This feature allows the photographer to frame and compose the photograph. In some cameras, known as the single-lens reflex, the photographer looks through the picture-taking lens directly.

A film advance lever or a motor drive (in many newer cameras) moves film through the camera, making it possible to take many pictures on a roll of film.

In Focus/Pinhole Camera

1. Construct a pinhole camera, using a shoebox, oatmeal box, or any similar box that has a tight-fitting lid and will hold a 4-inch or 5-inch sheet of photographic paper. Remember that all loading and unloading of the pinhole camera must be done under a darkroom safelight. Expose your paper according to the general guidelines given in this chapter (2 minutes on a sunny day and 8 minutes on a cloudy one). Keep in mind that there are four variables that affect exposure time: (1) the sensitivity of the paper or film to light; (2) the size of the pinhole; (3) the pinhole-to-paper distance; (4) the lighting conditions. Thus, you may want to make three or four pinhole cameras so that you'll be sure of getting the correct exposure by varying the length of exposure in each camera.

2. Develop the pinhole camera negatives in the same manner as was described in Chapter 1 (see chemical steps). A properly exposed negative should neither be overexposed (too dark) nor underexposed (too light). To judge if the negative is properly exposed, look at the shadow areas of the negative only. If the shadows (or light areas) appear dense, the negative is underexposed. If they appear thin, with little or no detail, the negative is underexposed. A well-exposed negative will have enough density (shades of darkness) to render detail in the shadows.

3. Select a properly exposed negative and make a positive print from it. This method was described in Chapter 1 (Negative-Positive Relationship). In making a positive print from the negative image made from the pinhole camera, you are reversing the tonal scale of the negative. Remember that exposure is just as important at this stage as it was when taking the actual picture. Overexposure during this stage will result in a print that is too dark. Underexposure will result in a print that is too light.

Camera Controls 3

In the previous chapter you learned that cameras with lenses share several basic parts: (1) a light-tight box or body; (2) an aperture or lens opening to control the amount of light that reaches the film; (3) a shutter to control the length of time that the film is exposed to light; (4) a trigger to release the shutter; (5) a viewfinder to look through and frame the pictures; and (6) a winding mechanism to advance the film through the camera. You may now be asking, if most cameras share these basic parts, why are there so many different types of cameras, and why do these cameras seem to have so many different controls on them? To answer both questions, various cameras are designed for special purposes and to be used under specific conditions. Thus, different needs require different types of cameras. While the controls on a camera are remarkably similar from one camera to the next, these precise controls allow the photographer the technical means to record the photograph and ultimately decide what the photograph will look like.

Focusing Methods

Your eyes are constantly focusing and refocusing as they "see" a subject. If your eyes focus improperly and you wear glasses, then you know how blurry things look without them. This gives you a good idea of how a camera will record subject matter if it is not focused properly.

There are at least six basic systems of focusing found in different types of cameras: (1) non-adjustable; (2) estimation of distance and "zone-focus"; (3) rangefinder; (4) twin-lens reflex ground glass; (5) single-lens reflex; and (6) automatic focus.

In a non-adjustable camera, there is no device on the lens to control focus. These cameras are set at the factory to be in acceptable focus at a distance of around 10 feet. Usually as long as the subject isn't closer than 6 feet or farther away than 15 feet from the camera lens, the image will look sharp. Pictures taken with these types of cameras at too close a range are unrecognizable blurs.

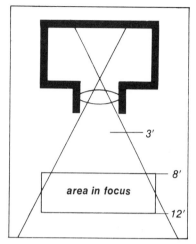

area in focus

non-adjustable

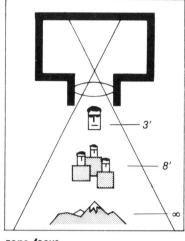

3'

8'

∞

zone focus

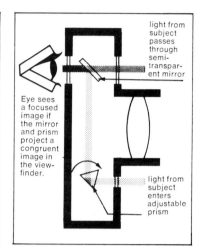

light from subject passes through semi-transparent mirror

Eye sees a focused image if the mirror and prism project a congruent image in the viewfinder.

light from subject enters adjustable prism

rangefinder system

rangefinder camera

If the lens on a camera can be moved to compensate for changes in distance, but has no device to see the actual focusing, then the photographer must estimate the distance. This second method ranges from pure guesswork ("That looks like about 6 feet, so I'll set the scale there") to a zone-focus scale on the camera. The scale for zone focus usually shows three or four drawings. If your subject is between 3 and 5 feet away, the scale will show a picture of head and shoulders, which correspond to that approximate distance. For subjects between, say, 6 and 15 feet away, you would set the scale to the focusing picture of the group scene. Anything beyond 15 feet is "infinity," and thus the focusing scale would be set on a mountain scene. Cameras with slightly finer scales may have settings for close-ups (about 4 feet), for medium shots (up to about 8 feet), for groups in a background (to about 17 feet), and for distance of infinity, such as shots of scenery. Both the zone focusing and the non-adjustable focusing cameras supply only relative sharpness. However, even just estimating distance will produce a sharper image than having a camera with no means of focusing.

A rangefinder is an opto-mechanical device that produces two images in the viewfinder of the camera. One image is usually tinted a light color (yellow or red) for better visibility. To bring the camera

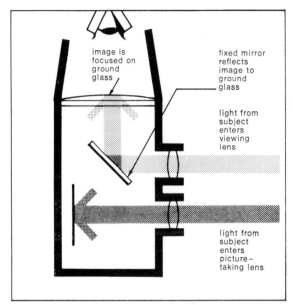

Fig. 3-1 *twin-lens reflex (TLR)*

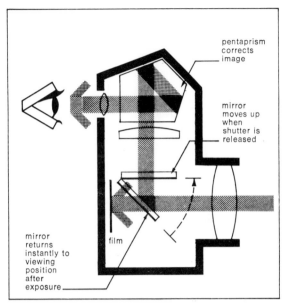

Fig. 3-2 *single-lens reflex (SLR)*

into focus, rotate the lens until the two images coincide with each other. A rangefinder allows you to see the actual focusing of the lens. Rangefinder cameras are usually 35 mm. (There are some Instamatic-type cameras with rangefinders on the market, as well as larger formats.)

The twin-lens reflex method of focusing is used in many larger roll film cameras. These cameras have two lenses, one for focusing and the other for exposing the film. The lenses are attached to the camera so that they move simultaneously. (See Fig. 3-1.) A mirror installed at a 45° angle behind the upper lens reflects the image onto a "ground glass" where the photographer can see it. A hood over the ground glass keeps out strong light and makes the image easier to see. Sometimes a magnifying glass is built into the hood for more critical focusing. In this type of focusing, the camera is held about waist level (the other ways of focusing are usually done at eye level) and the photographer looks down into the hood.

The single-lens reflex (SLR) is the most common method of focusing more sophisticated cameras, whether they use cartridge, 35mm, or roll film. A single-lens reflex camera allows one to view a subject through the actual picture-taking lens. A single-lens reflex camera works much like its older cousin, the twin-lens reflex. (See

matte fresnel screen with split-image rangefinder

matte fresnel screen with clear ground glass

matte fresnel with microprism

matte fresnel with microprism and split image

Fig. 3-2.) A mirror is placed behind the actual picture-taking lens at a 45° angle. The light that forms the image comes through the lens and is reflected upward by the mirror to a viewing screen or ground glass. Then it passes through a prism that turns the image right side up and right side around and delivers that image to the eye. The type of ground glass used determines the manner of focusing. Although there are many modifications in the various types of ground glass used, they generally fall into two categories: split-image and microprism.

A split-image screen or ground glass is one in which the subject is divided into halves. The idea is to restore the image so that the top half does not overlap the bottom half of the screen. In using this type of screen, it is helpful to find a straight line to focus on somewhere in the scene.

The other type of screen found in today's single-lens reflex cameras is the microprism. A microprism screen consists of many small dots that cause the image to appear shimmering where it is out of focus. As the image is focused, the pattern phases out until the dots are no longer visible. The image is then in correct focus.

Practice focusing your camera until you focus naturally. Try to develop the ability to focus with no more than two motions—one on either side of correct focus—so you don't waste time and possibly miss the best moment to take the picture.

Automatic Focusing Cameras

Automatic focusing is a recent technological development in cameras. At present, most auto-focusing is limited to cameras that do not have lens interchangeability. However, it will only be a matter of time before technology changes that. Essentially, there are three types of automatic focusing systems in use at present: Sonar, Visitronic Module, and Infrared.

With a sonar-focus camera, as you press the shutter release button, the sonar device releases sound waves. These sound frequencies, traveling at the speed of sound (1,100 feet per second), are beyond our own range of hearing. The fraction of a second that it takes for the sound to reach the subject and bounce back is fed into a very small electronic computer inside the camera. The computer in turn will use this time measurement to calculate the distance between the sonar device and the subject. It will then signal a motor in the camera to turn the lens so that that image is in focus.

The Visitronic module was developed by Honeywell Photographic Products and is currently used on many of the automatic focusing cameras. The module system, unlike the Sonar focusing, is not a distance measurer. Instead, it analyzes the subject and then matches up two images of that subject. The main signal peak is then translated

into positive voltage that will finally cause the lens to rotate into proper focus.

The Infrared system was recently developed by Canon, and it, too, is used on many cameras. Like the Sonar focus, the Infrared system measures the distance, but by sending out an invisible infrared signal rather than a noise signal.

A camera that has automatic focusing is equipped with a viewfinder that has an area in the center to show what part of the scene the camera will focus on. This focus area in the viewfinder is usually indicated by a small rectangle or oval. To focus, aim the camera so that the main subject (for example, a person) is centered in the viewfinder focus area. The camera will then focus automatically as you press down on the trigger or shutter release button. Be sure to keep your fingers from covering the rangefinder window on the front of the camera so the focus is not affected.

Many automatic focusing cameras provide a focus lock. A focus lock allows for minimal override. In order for this technique to work, the camera-to-subject distance must not change. The distance within the camera's focus is usually indicated by symbols in the viewfinder, much like those with zone focus.

One precaution to remember when using an auto focus camera is not to photograph your subject through a fence or with other objects, like trees or bushes, in front of the subject because the camera will focus on these objects if they are in the focus area of the viewfinder. The resulting photograph would show the near objects in focus with the main subject out of focus. The focusing system in the camera must have a clear view of the subject to focus correctly. Another problem is that most auto focus cameras do not focus correctly in low light or on flat, gray surfaces. These cameras also will not focus closer than three feet. Because of their convenience, many people aim the camera too close to their subjects resulting in out-of-focus pictures.

These problems will be overcome as technology improves. At present, automatic focusing is designed as a convenience feature for those who wish nothing more than an easy-to-use camera without knowing any of the fundamentals of photography or for those who find speed important, such as in sports photography.

autofocus camera

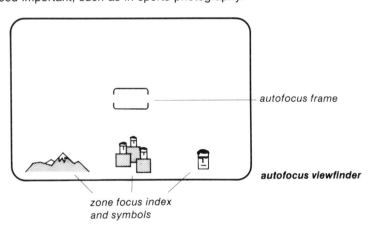

autofocus frame

autofocus viewfinder

zone focus index
and symbols

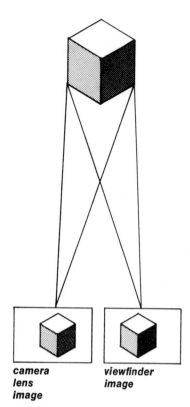

**camera
lens
image**

**viewfinder
image**

The difference in angle of
view is not critical when
focusing on distant subjects.

The difference in angles of view
increases as the distance between
subject and camera decreases.
Each lens sees the subject slightly
differently.

Parallax

All cameras except the single-lens reflex and the view camera (which will be discussed in Chapter 11) have viewfinders that are separate from the actual picture-taking lens. Although the distance between the lens and the viewfinder may be only one or two inches, it does create a problem: you see one image through the viewfinder, while the camera lens "sees" the same scene from a slightly different angle. This problem increases as you get closer to the subject. For example, you may be puzzled to find that someone's head has been cut off in a picture when you know you saw it in the viewfinder.

To counteract parallax, some viewfinders, especially those with rangefinders, are marked off with corners. The entire image you want should be framed within these corners. Check your camera's viewfinder to see if there is a built-in parallax correction. If there is none, then just become aware of the problem and learn to compensate for it.

Exposure Controls

As you learned by using the pinhole camera, exposure is the length of time that the film receives light after it has passed through the lens and shutter of the camera. In an adjustable camera, the photographer manually controls the amount of light that reaches the film. A "correct" exposure is the amount of light needed to produce a usable image upon the film. *Overexposure* results when too much light has been allowed to reach the film. *Underexposure* occurs when too little light comes through.

As you know, the two devices on the camera that control the amount of light that strikes the film are the shutter and the aperture, or lens opening. The size of the opening is usually referred to as the *f*/stop.

Shutter and Shutter Speeds

There are different types of shutters built into cameras. In the single-lens reflex, the most common type of shutter is an opaque piece of cloth or metal that moves across the lens opening at a predetermined speed, thus controlling the length of time that light falls on the film. This type of shutter is called a "focal plane" shutter, since it is located in the back of the camera where the light rays are focused, that is, where the "picture" or image is formed on the film. The device for setting the shutter speed on a camera with a focal plane shutter is usually located on the top or front of the camera. In some cameras, mainly those with rangefinders, the shutter is located within the lens housing of the camera and so is called a "between-the-lens" shutter.

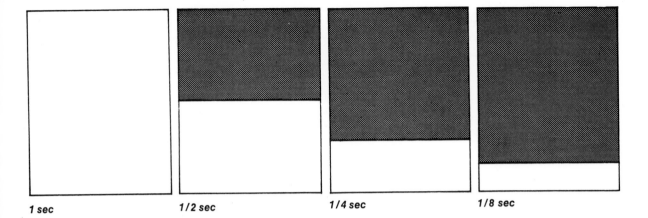

1 sec **1/2 sec** **1/4 sec** **1/8 sec**

In the pinhole camera, using photo paper, the exposure could vary between 2 and 8 minutes, so that a difference of 30 seconds did not change the image much. However, photographic film is much more sensitive to light than photographic paper. Because of this, the necessary exposure time to produce a correctly exposed negative is more critical, more precise, and usually shorter. Thus, shutter speed is usually measured in fractions of a second, rather than in minutes. The shutter speeds ordinarily found on today's cameras are expressed as 1000, 500, 250, 125, 60, 30, 15, 8, 4, 2, 1 and B. Each of these numbers represents a fraction of a second. For example, a shutter speed indication of "4" means ¼ of a second; a shutter speed of "250" means 1/250 of a second, and so on. A shutter speed of 1/30 second allows twice the amount of light to reach the film as does 1/60. The speed of 1/60 permits about twice as much light to enter as 1/125. Similarly, by selecting 1/125 over 1/250, you allow twice the light to reach the film. Conversely, using the speed 1/500 instead of 1/250 means that only half as much light will reach the film. The setting of 1/500 is twice as fast as 1/250, and therefore only allows half as much time for light to enter. In other words, using a faster shutter speed lets in only half the light that the next slower speed does; and conversely, the slower shutter speed permits twice as much light to enter as the next fastest speed.

"B" is the only exception; it is a variable speed. When the dial controlling the shutter speed is set at the "B" (for "bulb") position, the shutter remains open for as long as the shutter-release button is depressed. This position is used only for long exposures (called "time exposures") such as are used when photographing the stars at night. Under normal conditions, a shutter speed slower than 1/30 is not common because the normal vibrations of a hand-held camera cause a blurred picture at slower speeds. A rigid support, such as a tripod, is necessary when slow shutter speeds are used.

The white portion of these rectangles symbolizes the segments of time during which the film is exposed to light.

F/Stops

The f/stop diameters illustrated below are exaggerated in order to emphasize the increase in diameter as the f/stop number is decreased.

The second device used to control light in a camera, the *f*/stop, is the opening (aperture) or hole in the adjustable iris diaphragm that controls the amount of light that passes through the shutter and onto the film. (See Fig. 3-3.) This diaphragm is very much like the iris that controls the size of the pupil of your eye. You can see the pupil getting larger or smaller as more or less light strikes it. Try this experiment: Look into a mirror in a dim light. You will see that the opening (the pupil) is rather large in order to let in as much light as possible. Then, turn on a bright light, and you will see the pupil suddenly getting smaller as the iris automatically adjusts the opening to the brighter light. Some cameras with an automatic exposure system adjust the opening in the diaphragm automatically when the amount of light changes. On a manual or adjustable camera, the *f*/stop must be set by the photographer. This setting is often made with the "*f*/stop ring," which is usually located around the lens housing of the camera.

There are usually six or seven *f*/stop positions on an adjustable camera lens, each designating an opening of a different size. Some common *f*/stop numbers are 16, 11, 8, 5.6, 4, 2.8, 2. The large

Fig. 3-3

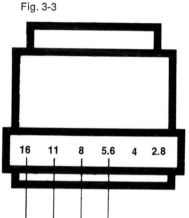

16 11 8 5.6 4 2.8

f-numbers produce small lens openings, and the small *f*-numbers produce large lens openings. This may be confusing at first, but remember that each *f*-number is really a fraction: since ⅛ is smaller than ¼, an *f*/stop of "8" is smaller than an *f*/stop of "4". The numbers used to designate the *f*/stops and the corresponding lens openings they produce may not seem to fall into any regular order or relationship, because the *f*-numbers express the ratio between the diameter of the lens and the focal length of the lens. What is more important to understand, though is that *f*/1.8 lets in more than twice as much light as *f*/2.8. Similarly, *f*/2.8 allows twice as much light to pass through the lens than at *f*/4, and so on down. Conversely, *f*/16 allows only half as much light to enter the lens as *f*/11, while *f*/11 permits only half as much light as *f*/8. In other words, opening the lens by one *f*/stop permits twice as much light to pass through the lens. By opening the lens two stops, four times the amount of light will reach the film. Closing the lens down a stop allows only half as much light to reach the film. This is the same correlation that exists between the shutter speeds. It is also important to understand that on a lens of any focal length, the same *f*/stop delivers proportionately equal amounts of light to the film.

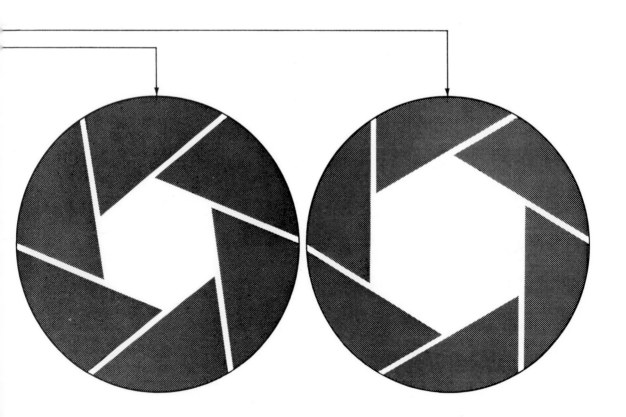

Film Speed

The film speed indicates relative sensitivity to light. The speed is expressed as an ISO/ASA speed number. The higher the speed, or number, the more sensitive or faster the film; the lower the speed, the less sensitive or slower the film. A fast film requires less light for proper exposure than a slow film. For example, a film speed of ISO/ASA 400 is more sensitive to light than a speed of ISO/ASA 200. Therefore, ISO/ASA 400 is faster than ISO/ASA 200 so that it requires less light, or shorter exposure, for a properly exposed negative.

There is a correlation between these numbers. Suppose we start with a base of ISO/ASA 100. ISO/ASA 200 would be twice as fast as ISO/ASA 100. ISO/ASA 400 would be twice as fast as 200 and four times as fast as ISO/ASA 100. This is precisely the same correlation that exists between shutter speeds and f/stops. So another way of expressing how much more sensitive one film is than another would be in terms of how many more stops are gained. For example, ISO/ASA 400 is one stop faster than ISO/ASA 200.

Although not in common use, ISO speed numbers have also been given. ISO speed numbers are numerically the same as ASA speed numbers. However, because ISO numbers are not widely used, film speed will be referred to only as ASA numbers to avoid possible confusion.

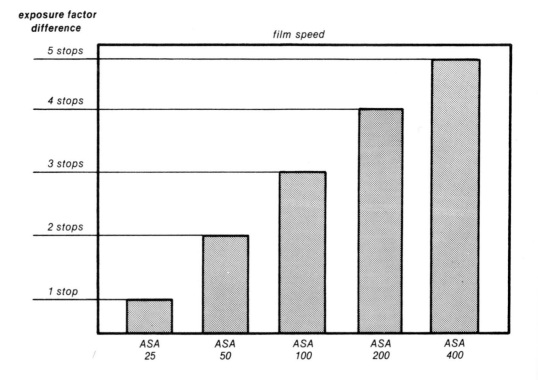

F/Stop-Shutter Speed Relationship

Why does a camera have two different devices for controlling exposure? Sometimes enough light cannot be obtained with either the f/stop or the shutter alone. For example, if you are shooting with a hand-held camera with a fixed lens opening at a shutter speed of 1/60, you may not be able to let in enough light for a proper exposure. But you can enlarge an adjustable lens opening to increase the amount of light that will strike the film and increase the picture-taking range of the camera.

The same reasoning applies to situations in which there is too much light for a proper exposure. When you are able to adjust the camera lens to a very small opening and a fast shutter speed, you can reduce the amount of light much more than with a fixed lens opening. Your chances of getting a proper exposure in bright light are increased.

We have used an example here of a fixed and an adjustable lens opening. An adjustable lens opening and a fixed shutter speed would be as limiting as an adjustable shutter speed and a fixed lens opening.

Shutter speeds and lens openings (f/stop) always work together to determine exposure, and exposure must always be expressed in terms of *both* shutter speed and f/stop.

Assume that the following shutter speed-f/stop correlation is correct:

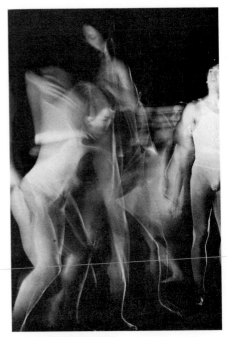

slow shutter speed

1000	500	250	125	60	30
f/2.8	f/4	f/5.6	f/8	f/11	f/16

If you are taking a picture of a person running very fast and want to "freeze" the action, a very fast shutter speed is needed. Because a fast shutter speed "stops" the motion of the runner, the selection of 1/1000 at f/2.8 is a good choice. However, if you want to capture the motion of the runner by letting the image of the runner become slightly blurred, select a slow shutter speed. Because he moves across the picture plane while the shutter is open, the image is blurred. The selection of 1/30 at f/16 would be good. *Both combinations let the same amount of light reach the film; each is a proper exposure.* However, each combination produces a different picture. Your choice depends upon what effect you, as the photographer, want to communicate to the viewer.

Depth of Field

A second variable in the shutter speed-f/stop relationship deals with changes in the picture caused by the use of different f/stops. "Depth of field" is the amount of space that is in focus both in

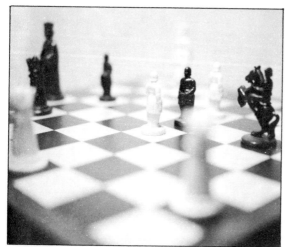

1 shallow depth of field at f/2.8

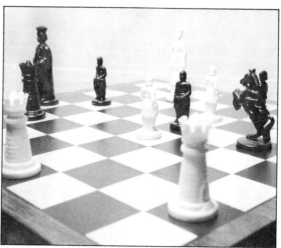

2 deeper depth of field at f/11

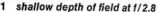

Focused at 2 feet at f/11.
Background is out of focus.

Focused at 7 feet at f/11.
Background is in focus.

front of and behind the exact point at which the camera lens is focused. *The larger the lens opening, the shorter the depth of field. The smaller the lens opening, the longer the depth of field.*

In photograph 1 (1/1000 at 2.8), only a single object is in sharp focus because a lens opening of f/2.8 gives a very short depth of field. Compare this with photograph 2 (1/60 at f/11) to see how much more space is in sharp focus because the lens has been "stopped down" four f/stops. Backing away from the subject will also increase the depth of field. *When depth of field is more important than movement, choose an exposure that gives more consideration to f/stop than to shutter speed.* These examples of photographs (chess board) illustrating the f/stop/depth of field relationship show that the photographer can control the camera so that it will produce a picture of the same situation in different ways.

Two other factors also affect depth of field: distance and focal length. The closer you are to the subject on which you are focusing the shorter the depth of field. More depth of field is achieved the farther out the lens is focused. Compare the background area of the two photographs on the left.

The first photograph was taken at a distance of two feet. Notice that the background is not in sharp focus even though the picture was taken with a small lens aperture. The second photograph was shot at a distance of seven feet. Notice that the background is in good focus.

Focal length can be broadly defined as the distance between the optical center of the lens, when it is focused at infinity and the focal point—the point where the image is in focus in the camera. The film is placed in the camera at the focal point, in the area known as the focal plane.

28mm wide-angle lens

50mm normal lens

200mm telephoto

33

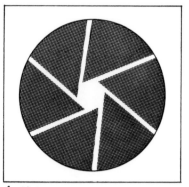

1 *f/stop*

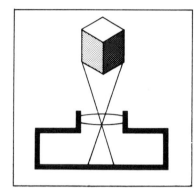

2 *subject-to-camera distance*

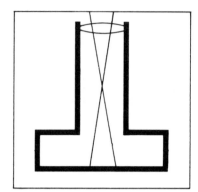

3 *focal length of lens*

Three factors that determine depth of field.

You will recall that you could create wide-angle and telephoto effects with the pinhole camera by varying the pinhole-to-paper distance. When that distance was shorter than the diagonal measurement of the paper, the result was a wide-angle effect. Wide-angle lenses are made for most cameras. They are a short focal-length lens because the distance between the lens and the film is shorter than the film's diagonal measurement. Conversely, when the distance between the lens and the film is longer than the film's diagonal measurement, the result is a telephoto effect. The telephoto, then, is a long focal-length lens.

Depth of field is greatest with a short focal-length lens (wide angle). In other words, the shorter the focal length, the greater the depth of field. Compare the three photographs on the preceding page. All were taken in the same light and with the same shutter speed (1/250) at *f*/16. The first photograph was taken with a short focal-length lens—notice that both the background and the foreground are in focus, indicating a greater depth of field. The second picture was shot with a normal focal-length lens, probably the same length as the one in your camera. Here, though, the background fades out of focus. A long focal-length lens (telephoto) was used in the third photo. Only the subject is in focus—the background directly behind the subject is completely out of focus.

To summarize, three factors determine depth of field: (1) *f*/stop (also called aperture or lens opening); (2) focus; and (3) focal length. The smaller the aperture, the greater the depth of field. The greater the distance between the lens and the subject, the greater the depth of field. Finally, the shorter the focal length, the greater the depth of field.

(Chapter 10 will introduce more technical information about lenses.)

In Focus/Camera Controls

Chapter 3, unlike the previous chapters, does not require you to do or make something. It does, however, require you to understand basic camera controls and how they relate to each other. This understanding is crucial because these controls provide the technical means to record the photograph and to control the results.

In the section on shutter and shutter speeds, you learned that the shutter speed markings on cameras represent fractions of a second. For example, a shutter speed indication of "30" means 1/30 of a second. You also learned that a shutter speed of 1/30 allows twice the amount of light to reach the film as does 1/60. Also, a shutter speed of 1/500 instead of 1/250 means that only half as much light will reach the film.

In the section on f/stops, you learned that these numbers also represent fractions. For example, 1/8 is smaller than 1/4, an f/stop of 8 is smaller than an f/stop of 4. Also, f/2.8 allows twice as much light to reach the film as does f/4. In other words, opening the lens by one f/stop permits twice as much light to reach the film. Closing the lens down a stop allows only half as much light to reach the film. That this is the same correlation that exists between the shutter speeds is evident.

Finally, this same correlation exists with the film speed numbers. ASA 400 is twice as fast as 200 and four times as fast as ASA 100. Thus, ASA 400 is one f/stop faster, (or one shutter speed faster) than ASA 200 and two f/stops faster (or two shutter speeds faster) than ASA 100.

By deciding what film speed, f/stop, and shutter speed to use, you are deciding what photographs you will be able to take and how those photographs will ultimately look.

Film Exposure and Exposure Meters

4

In Chapter 3, you learned that there are two primary settings on adjustable cameras that control the amount of light that reaches the film and exposes it—the shutter speed and the lens opening. The correct setting of these two variables results in a properly exposed negative. Thus, the shutter speed and lens opening always work together to determine exposure, and exposure is always expressed in terms of both shutter speed and lens opening.

Film exposure is the most important technical step toward a good print. In order to produce a good print, you must start with a good negative. A good negative is a properly exposed negative, neither overexposed nor underexposed.

In order to secure a properly exposed negative, the photographer uses a tool, the light meter. A light meter, or exposure meter, is an instrument that measures the amount of existing light and expresses that amount in the photographic terms of shutter speed and f/stop. A light meter may be built into the body of a camera or may be a separate, hand-held device.

General Information

To use any light meter, first set the meter to correspond to the type of film you have. Find the ASA dial on the meter or on the camera, if the meter is built into the body. The ASA of a film is the numerical rating of the film's sensitivity to light (see previous chapter). It is printed either on the box in which the film is packed or on the information sheet the manufacturer provides. To learn how to set the ASA number, refer to the operating manual of your meter.

The meter is then pointed in the direction of the subject to be photographed. This is called a *reflected light meter* reading because it measures light that is bouncing or reflecting back from the subject. Some meters, called *incident light meters,* read light falling onto the subject; they are discussed later in this chapter.

set the film's ASA rating on the ASA scale of the meter

typical hand-held meter

built-in meter

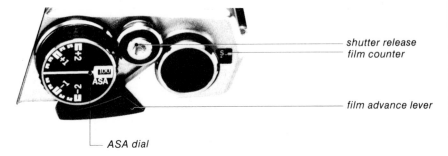

shutter release
film counter

film advance lever

ASA dial

Once the meter reads the light, it indicates the appropriate f/stop and shutter speed combination. Some meters, (usually hand-held meters) indicate a variety of f/stop and shutter speed combinations. Each combination that the meter indicates yields the same exposure to the negative. For example, if a meter indicates an exposure of f/8 at 1/60, any equivalent exposure, such as f/5.6 at 1/125 or f/4 at 1/250, will be the same.

Camera Meters

Most cameras today have built-in meters. There are three broad classifications of cameras with built-in meters: (1) manual, (2) semi-automatic, and (3) automatic.

Manual. In a manual camera, both the f/stop and the shutter speed must be chosen and set manually with the aid of a separate light meter. In older cameras, a light meter may have been built onto the body of the camera but not integrated into the workings of the camera.

Semiautomatic cameras. With some semiautomatic cameras, the photographer selects the lens opening, and the meter automatically selects the correct shutter speed. This system is called *aperture-priority.* In *shutter-priority* cameras, the photographer chooses the shutter speed first, and then the meter automatically selects the correct f/stop.

Automatic cameras. With completely automatic cameras, the meter selects both the shutter speed and the lens opening.

Many camera models combine features. There are some automatic cameras that have both aperture-priority and shutter-priority exposure systems. Some automatic cameras have a manual override so that you can set the shutter speed and aperture manually.

Each model has advantages and disadvantages, but serious photographers retain as much control over film exposure as possible. Thus, we do not recommend completely automatic cameras that feature no manual override for learning purposes.

Through-the-Lens Meters

Today a multitude of meters are designed for different functions. For our purpose, we will discuss two major categories: through-the-lens meters and hand-held meters.

Through-the-lens (T.T.L.) light meters are light meters built into the camera, and they read the light that passes through the picture-taking lens. The reading is then translated into an f/stop, shutter-speed combination in several ways, depending on the make and model of the camera. The most common systems for these purposes are matching needles, electronic diodes, or the newer digital readouts.

In a match-needle system, the viewfinder contains two needles on one edge of the viewfinder frame. One needle moves up and down depending on the intensity of the light reaching it, while the other needle moves up and down as either the f/stop or shutter-speed selections are made. The needles match with the correct combination.

A variation of this system involves a single needle that moves as f/stops and shutter speeds are set. The proper exposure results when the needle is centered between a stationary marking inside the viewfinder.

Newer cameras have electronic diodes instead of needles. One system has three diodes placed vertically on the right-hand side of the viewfinder. The center diode lights up when the correct exposure combination is selected. The top diode indicates underexposure while the bottom diode indicates overexposure. A variation of this system has three diodes placed horizontally on the bottom of the viewfinder. When the correct combination is made, the center diode shows green. The diodes on either end light up red to indicate over- or underexposure.

Digital readouts in the viewfinder are found increasingly on newer cameras. Usually, the readout displays the f/stop and shutter speed.

An important consideration to remember is that different models of cameras with through-the-lens metering systems read light from different areas of the picture. There are basically three categories of through-the-lens metering systems: (1) the *averaging meter;* (2) the *spot meter;* and (3) the *center-weighted meter.*

The main difference between the averaging meter and the spot meter is the difference in the angle of light each reads. Most averaging meters read a large angle of light, usually 30° to 50°, while spot meters read a much narrower angle of 1° to 10°.

The center-weighted meter is a combination of the spot and averaging meters. These meters read light through the lens and assume that the subject in the center of the viewfinder is more important for exposure than other areas. Thus, the light in the center of the frame is weighed more heavily than surrounding areas.

Note that the terms "average" and "spot" are somewhat misnamed. Both meter types average light because they record all the light values, light and dark, in a subject, and they average them together for an exposure. The difference is that a spot meter simply averages

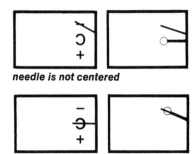

needle is not centered

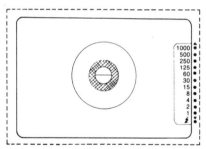

needle is centered

viewfinder with digital readouts

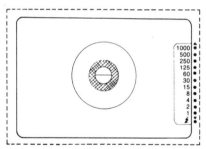

viewfinder with electronic diodes

averaging meter

spot meter

center-weighted meter

the light values off a smaller area of the subject than an average meter. With a spot meter, it is especially important to know the tonal area that is most important in the photograph.

Photographers should guard against getting carried away with, or confused by, the new technologies. The variety of through-the-lens metering systems is endless and always changing. For example, one manufacturer recently introduced a metering system with a programmed memory capable of comparing four thousand light variations with the one seen in the viewfinder at the time of exposure. However, most, if not all, through-the-lens metering systems work well.

Hand-Held Meters

Hand-held meters are separate from and work independently of the camera. Some older cameras have light meters attached to the camera body that work like hand-held meters. These light meters do not read the light through the lens, nor are they coupled to the camera in any way.

To use a hand-held meter, first set the ASA given for the film and then point the meter at the subject. The meter reads light reflecting off the subject and translates that reading into one or more exposure combinations.

Like through-the-lens meters, some hand-held meters have a needle to indicate exposure while others use a digital readout. A typical hand-held meter operates in the following manner.

After pointing the meter at a subject, the needle on the meter moves to indicate how much light reflects off the subject. The greater the intensity of the light reflecting back, the further the needle swings. The needle then points to a scale, known as a *light-intensity scale.* This light-intensity scale is usually rated numerically. These number ratings vary depending on the brand of the meter. Usually, the low numbers represent dim light while the high numbers represent bright light. After the numerical value of light has been determined on the light intensity scale, it is matched up to a dial. A marker on the dial can then be matched up to the light value and the various f/stop and shutter speed combinations can be implemented.

Some hand-held meters do not use light value numbers. Instead, the needle points directly to a possible exposure combination.

Digital hand-held meters have no needle. Instead, they provide a direct readout of a shutter speed and f/stop combination.

The debate over hand-held meters versus through-the-lens meters has been raging for years. Photographers who prefer hand-held meters argue that they provide more accurate exposure information, such as a wider range of exposure choices. In the past, hand-held meters have been more sensitive to light than through-the-lens meters. However, technology has changed that and newer cameras with through-the-lens systems have become very sophisticated and

sensitive. However, a hand-held meter can be brought up close to the subject for precise reading more easily because it is independent of the camera. In addition, hand-held spot meters read a far narrower angle of light than through-the-lens meters. Finally, if a hand-held meter should break, you still have use of the camera, but with many of the newer, electronic cameras you lose camera function.

Considering Exposure

The key to understanding how light meters work is that they read for a middle gray. That is, meters average whatever light they read, whether from a light, dark, or gray subject. The average represents the gray, or halfway between black and white.

This reading usually works well enough since most subjects have equal amounts of light and dark areas. However, meters are fooled when the subject is primarily either light or dark. Meters do not discriminate between important subject matter and unimportant areas. They are calibrated only to average the light. For this reason, the photographer must do the choosing.

When you see an object, you are really seeing the light that is reflecting off the subject. The more light that falls directly on the subject, the brighter that object seems. All objects reflect a certain amount of light. However, a light-colored object reflects more light than a dark-colored object. Stated another way, a dark-colored object *absorbs* more light than a light-colored one. For instance, suppose you are taking a reading of an outdoor scene that contains a house, ground, and sky. Part of this house has sunlight directly on it while part of it is in shade. If the meter is pointed only at the shaded part of the house, the meter may give a reading of $f/4$ at 1/125.

If, instead, the meter is pointed at the sky (the lightest area of the scene), it will read on the high end of the light scale and indicate more light reflecting back. This is because light areas reflect more light. Therefore, the meter reading would indicate an exposure combination geared to compensate for the intensity of light by allowing less light to reach the film. In this case, the meter would indicate an exposure of $f/16$ at 1/125 as being correct.

A meter reading made off the exposed side of the building would provide a reading of $f/11$ at 1/125. This setting would reflect less light than the sky but more light than the shaded area of the building.

In effect, we now have three entirely different readings for the same subject, depending on where the meter was directed. Readings from the darkest and lightest areas would each produce incorrect exposures because meters read for a middle gray where they are directed. Most subjects provide enough dark and light areas to simulate gray. However, when light meter readings are made from either extremely light or extremely dark areas, devoid of any middle gray, the resulting exposure is incorrect.

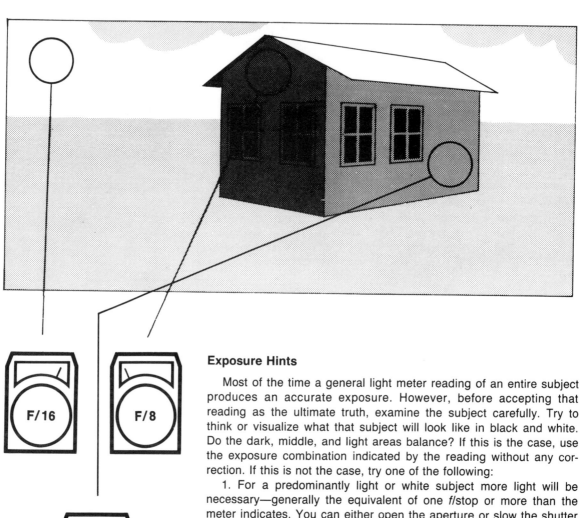

Exposure Hints

Most of the time a general light meter reading of an entire subject produces an accurate exposure. However, before accepting that reading as the ultimate truth, examine the subject carefully. Try to think or visualize what that subject will look like in black and white. Do the dark, middle, and light areas balance? If this is the case, use the exposure combination indicated by the reading without any correction. If this is not the case, try one of the following:

1. For a predominantly light or white subject more light will be necessary—generally the equivalent of one f/stop or more than the meter indicates. You can either open the aperture or slow the shutter speed to obtain the added light. For example, if the meter indicates an exposure of f/8 at 1/250, use f/5.6 at 1/250 or f/8 at 1/125 instead.

2. For a predominantly dark subject do the opposite—close the aperture or make the shutter speed faster. If the meter reading is f/5.6 at 1/125, use f/8 at 1/125 or f/5.6 at 1/250 instead.

3. Use a gray card. An 18 percent gray card is useful to determine a correct exposure. An 18 percent gray card has a medium gray surface that reflects 18 percent of the light that reaches it. Thus, gray cards reflect an average amount of light falling onto the subject rather than the light reflected off the subject.

To use a gray card, simply place it in front of the subject and aim it toward the camera position. Take the reading off the card only since you will be close to the card and take care not to cast a shadow on it. Use the exposure indicated by the meter without additional compensation.

4. Expose off the skin. Skin can be measured in the absence of a gray card. One method involves taking the light meter directly off the palm of the hand which is positioned directly in front of the subject and pointed toward the camera. Another method entails taking the reading directly off the subject's face. Again, be careful not to cast a shadow over the hand or face when taking the reading.

Needless to say, skin tones do vary and thus exposure adjustments may be necessary. For average Caucasian skin, add one stop more to the exposure indicated by the reading. Dark skin will probably need no exposure compensation, while extremely dark skin may require one-half to one f/stop less exposure than the meter suggests.

5. Average the shadows and highlights. Since meters read for middle gray, the correct exposure will fall somewhere between the readings for dark and light areas of the subject. To obtain this exposure first meter a dark area, then meter a light area of the same subject. For example, if the reading for the dark area is f/5.6 at 1/125 and the reading for the light area is f/11 at 1/125, then the average reading would be f/8 at 1/125.

6. Exposure bracketing. To bracket an exposure, first determine the exposure using a light meter. Take a picture at that setting. Next, take another picture at one stop less exposure and a third picture at one stop more exposure. For example, if the recommended f/stop and shutter speed combination is f/8 at 1/60, take a picture at that setting, but also take one at f/5.6 at 1/60 and another at f/11 at 1/60.

Bracketing is not always practical, such as with candid or moving subjects. Also, the method becomes expensive, so learn to expose well and bracket only when realistic and with especially important pictures.

Problem Exposures

In a backlighted scene, the background reflects more light than the subject. The light behind the subject may also shine directly into the light meter. Both of these factors cause the exposure meter to read too high, resulting in underexposure of the subject. The pictorial effect is a silhouetted subject.

One solution to this problem is to take a close-up meter reading of the subject while you shade the meter with your hand. If that is not possible, then add the equivalent of one or two f/stops to the meter reading (depending on how dark the subject is). For example, if the subject is a person lit by the sun from behind and the meter recommends f/22 at 1/125, use f/11 at 1/125 instead. If the sun is especially bright use f/8 at 1/125.

Another problem area that requires attention is photographing a scene that includes a large proportion of sky. Since the sky is usually brighter than other parts of the scene, the light meter may indicate too little exposure. As a result, any subject that is darker than the sky will be underexposed. This effect is more common with overcast skies than with blue skies. In this case, take your exposure with the meter pointed downward slightly to avoid undue influence from the sky.

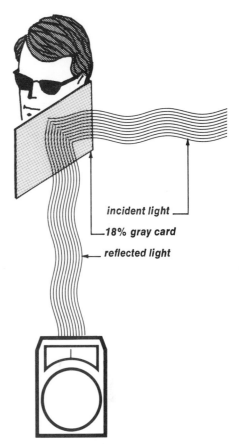

incident light

18% gray card

reflected light

gray cards reflect an average amount of light falling onto the subject

exposed at f/22

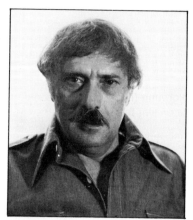

exposed at f/8

exposed at f/11

Meter the backlight and subject light. Average the two meter readings and expose.

Scenes that have large areas of snow, white sand, or concrete present certain problems. If you expose according to an overall meter reading, chances are your negative will be underexposed. The light areas would come out gray. To avoid this problem, add one stop more to the exposure indicated by the meter.

Overriding an Automatic Meter

With some cameras the automatic operation will not allow you to manually control the f/stop or shutter speed. Some automatic cameras, however, do have a memory-lock button. This lets the user make a meter reading and lock the reading while the camera is being repositioned. For example, if a close-up reading is needed, the photographer could move in close to the subject, take the reading, press the lock button, and then move back to the original position to take the picture.

If the camera you are using doesn't have this feature, it may have a shutter release that will hold the meter reading as long as the release is held partway down. If this is the case, use the release in the same manner as a memory-lock button. Just remember not to let up on the shutter release.

Another feature on some automatic cameras is the exposure compensation dial. This dial is capable of changing the exposure determined by the camera plus or minus two stops in half-stop increments.

Instead of a dial compensation control, some automatic exposure cameras have an exposure compensation button that increases exposures by a fixed amount usually one-half to two stops. This nonvariable exposure compensation is most commonly used for backlighted subjects.

If your automatic camera doesn't have any of these exposure controls, you can change the film speed (ASA) setting to a different number to compensate for subject brightness or darkness or due to some unusual lighting situation. For example, if you're photographing a dark subject against a very light background (like a person standing in snow or sand), divide the speed of your film by two and set the resulting lower number on the ASA dial of your meter. If you were using a film with an ASA of 400 in this situation, you would set your meter at 200 instead. This would allow the film to receive 100 percent more light either by opening the lens by one stop or forcing the shutter to remain open the next speed lower.

Sometimes you may be photographing a light subject against a dark background. If this is the case, then multiply the ASA of the film by two and set the meter accordingly. For example, suppose you were photographing a person wearing a very light colored outfit standing in front of a dark foliage background. A normal meter reading would "see" mostly the dark area and thus indicate an exposure that would be too much for the subject. The result would be that the subject is overexposed. If you were using a film speed of 100 in this example, you would multiply that number by two (in other words, double it), and use 200 instead. The result would be to cut the exposure time in half. In either case, remember to reset your ASA dial back to the normal setting when you finish photographing the scene.

ASA dial. For a film speed of ASA 64, you can set the dial on 125 to obtain 1 stop less exposure or 32 for 1 stop more exposure.

Incident Light Meter

Until now, we have been discussing meter readings based on reflected light. A reflected light meter reads and measures the light that is reflected off from the subject. There is a second type of light meter called an *incident light meter*. An incident light meter measures the light illuminating the scene. In other words, it is measuring the light falling on the subject from one direction rather than the light being reflected by the subject. An incident light reading requires the use of a hand-held meter. The meter must be equipped with an incident light dome or diffuser. This diffuser extends the angle of acceptance or coverage of the light meter. In a reflected light meter that coverage is normally somewhere between 30° and 50°. In an incident light meter the angle of acceptance is generally 180°. This allows the light meter to measure most of the light coming toward the subject from the direction of the camera.

incident light meter

Taking an Incident Light Reading

To take an incident light reading, you must position your meter in the same light that is illuminating the subject and point the light meter toward the camera.

An exposure that is determined by an incident light meter assumes that the scene to be photographed has average reflectance. Because an incident light meter measures the illumination or light-source, rather than the reflectance, dark or light areas in the scene will not influence the reading. Be sure then that a very dark or very light area is not important in your photograph. If, however, a very dark or very light area is important then it is necessary to modify the exposure. For instance, if a bright area is important, use a lens opening one stop smaller than the meter indicates. An example of that situation would be a snow scene. Suppose an incident light reading indicated that 125th at *f*/11 was correct. By using *f*/16 instead of *f*/11, the detail and texture of the snow will still be seen in the photograph. If a dark area was important, just the opposite would be required. You would use a lens opening one stop larger than your meter indicated.

It is possible to average an incident light reading of the area receiving the most light and the area receiving the least light. It is done in the same manner that you average a reflected light reading. Do not, however, use an incident light reading of a subject that emits light such as a lamp or neon sign.

taking an incident light reading

In Focus/Film Exposure and Exposure Meters

1. This suggestion is for those using cameras with through-the-lens light metering systems. There are basically three categories of through-the-lens metering systems: (1) the averaging meter; (2) the spot meter; and (3) the center-weighted meter. Be sure you know what kind of metering system your camera has. If you do not know, read your camera manual or check with a local camera shop. If all else fails, write to the manufacturer. Addresses can be found in Chapter 11.

2. Light meters read for a middle gray. Meters average whatever light they read, whether from a light, dark, or gray subject. The average represents the gray, a half-way between black and white. However, meters can be fooled when the subject is primarily light or dark.

 For this exercise, find a house to photograph on a clear, bright day. Take three photographs of the house using three different exposure readings. The first photograph should be based on a reading obtained from the shadow area of the scene. The second exposure should be based on a reading obtained from a highlight area, like the sidewalk. For the third photograph, average the two previous readings together. The negative that will have the most detail is the one in which the exposure was averaged. This is because the reading based on the shadow area is overexposed. The negative for which the reading was based on the highlight area is underexposed. Be sure you understand why this is so.

3. Find a backlighted situation to photograph. In a backlighted scene, the background reflects more light than the subject. Also, the light behind the subject may shine directly in the cell of the light meter. Take an exposure reading based on the highlighted area only.

 Then, step back and photograph both the subject and highlight area together without changing that initial reading. Now, take a second reading based on a close-up reading of the subject. Move back and take a second photograph at this reading.

 The negatives will show the results of this selective exposure reading. When the highlight area is favored, the subject will be underexposed. When the light reading is based on the subject, the highlight area will be overexposed. Study the negatives for these pictures, as well as those from exercise two, and compare them to the prints made from them. Look at the areas of highlight and shadow in your negatives and see how they were affected by the way the exposure reading was made. Eventually, you should get in the habit of studying your negatives in order to evaluate your decisions with regard to film exposure (and film development).

Film Development 5

After you have taken a picture, curiosity alone will make you want to see it, even if you suspect it is overexposed, underexposed, or out of focus. Developing the film is the halfway point between taking the picture and printing the negative. It makes visible and permanent the latent image that is recorded on the emulsion of the film. Film development is a chemical process, involving a very definite series of steps. If the exposure was correct, this procedure, followed carefully, will produce a good quality negative. That negative, in turn, will determine the quality of the resulting print.

There are two methods of film development: one using open trays of chemicals, the other, a closed tank. The tank method is more efficient for roll films and does not require total darkness after the film is loaded into the developing tank. It gives you a better chance of getting a good quality negative. The tray method is seldom used for developing roll film because all the steps must be carried out in complete darkness. However, it is useful when developing cut film (sheet film).

The Tank Method

The basic developing tank consists of: the tank itself, the lid (to make it light-tight), and the reel (to hold the film). Tanks are made of either plastic or stainless steel; many different brands are available.

Plastic developing tanks usually are cheaper than stainless steel. Most of them have reels that adjust to accommodate film sizes from 35mm up to 120. To load the plastic tank, (see Fig. 5-1) first adjust the reel to the size of the film. For Instamatic-type cartridges or 35mm, the flange of the adjustable reel is to be moved down as far as it will go. For 127 film, the reel is locked into the second notch. When using 120 or 620 film, spread the reel out as far as possible until it locks into position.

The next steps must be carried out in total darkness. Make sure the reel is clean and dry before attempting to load the film into it. To load 35mm, first remove the cartridge that encloses the film, using a bottle opener to remove the flat flange on the top of the

Fig. 5-1

plastic adjustable reel

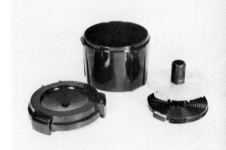

plastic reel, tank, and top

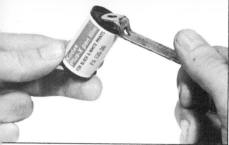

open cartridge

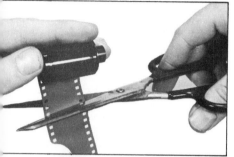

cut off tapered film leader

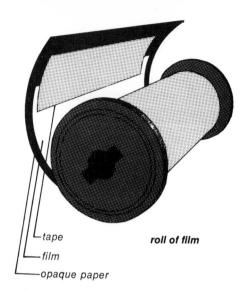

tape
film
opaque paper

roll of film

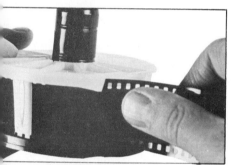

insert film through slots

rotate sides in counter directions

remove tape

cartridge. Do it with care. Take the spool of film from the cartridge, but leave the film on the spool. (Keep the film perpendicular rather than letting it swing back and forth like a pendulum.) With a scissors, cut off the tapered beginning of the film (the leader).

With roll films (sizes 828, 127, 620, 120), you need only break the seal to load it. The film curls as it is separated from the paper backing, and it should be handled only by the edges to prevent fingerprints on the emulsion. The film is attached to the paper with tape, which must be removed before the film is loaded into the reel. Otherwise it will prevent proper loading.

If 126 film is used, remove the film by gripping the cartridge with both hands and twisting it until it breaks in half. The film is in the larger of the two chambers. After that chamber is broken, separate the film from the paper backing in the same manner as roll film.

After the film has been removed from its container, insert three or four inches of the film into the reel by pushing it carefully through the entrance slots (the thickest part of the flanges). As you do this, follow the natural curl of the film so that the emulsion side will face toward the core of the reel and be less likely to be scratched and will be easier to load. Take hold of the edges of the reel. With the plastic tank, you should hold the flange (the movable section) in the left hand and the other flange in the right hand. Twist the movable flange forward (away from you) as far as it will go; then twist it back (towards you) as far as it will go. Continue this procedure until the film is wound on the reel. If you are loading 35mm film, this action will stop when the spool reaches the entrance. Cut the film at the edge of the spool and continue winding it onto the reel. If you are using a plastic reel, you will need to use your thumb to push the film forward onto the reel. You can make sure that all the film is wound on the reel by running your finger around the entrance slots. The edge of the film should be past the entrance.

50

If the film does not go on the reel smoothly, do not force it, or you may mar the film permanently. Do not try to pull the film back through the film entrance. Instead, pull off the adjustable flange, remove the film, readjust the reel to the film size, and start again. After all the film is on the reel, place it in the tank, keeping the clear flange on top. Put the lid on the tank by turning it clockwise. The room light may now be turned on since the tank is light-tight.

The Stainless Steel Tank

Loading the stainless steel reel and tank is slightly more difficult, and so it is suggested that you practice loading in daylight before attempting the real thing. Like plastic tanks, stainless steel tanks are made by different manufacturers and so many differ slightly. To be sure you load the reel properly, read the instruction manual. The instructions given here cover loading a typical stainless steel reel. The photographs on the right illustrate three important steps in loading such a reel.

Remove the film from its protective container as described earlier. Hold the reel in your left hand so that the opening of the retaining device on the core points upward. Hold the beginning of the film, following the natural curvature between your thumb and forefinger, and curving it slightly so that the film vaults out a bit. Don't curve the film too much or the film will buckle. Lift the retaining device on the reel with your index finger and let the film enter the slot until it stops. Use a little pressure on the retaining device, which will spike through the film, locking it to the reel. Having done this, hold the reel with one hand and turn it slowly counterclockwise, using the thumb and forefinger of the other hand to curve and guide the film along the edge of the reel.

After all the film is wound onto the reel, check to make sure that it is loaded correctly. Simply feel the top and bottom of the reel—if no film is projecting above the spirals, you're ready. If the film is projecting through, then start over again. When the film is loaded properly, close the top end of the tank and turn on the lights. Some manufacturers make automatic loading devices for their reels. These devices automatically curve the film for you.

One advantage of the stainless steel tank is that you usually buy the reels and tank separately. This allows you to buy a tank big enough to hold one, two, three, four, or even eight rolls of film at the same time. Another advantage of stainless steel is that the tank can hold different sizes of reels, letting you develop several sizes of film at the same time.

Equipment Needed

In addition to the film tank, bottle opener, and scissors, the following equipment is needed for film developing: thermometer, graduates or measuring containers, storage containers, funnel, photo sponge, timer, film clips, and negative envelopes.

stainless steel reel

retaining device holds film

curve and guide film as reel is rotated

correctly loaded reel

Thermometer. Because the temperature of the chemicals is critical and must be checked often, a good thermometer is very important. Decent thermometers have a temperature range from 30° to 120°F and measure chemicals accurately within one degree. Do not trust thermometers that come preshipped with some plastic tanks—they have been known to be off by as much as six degrees.

Graduates. Chemical-resistant plastic or glass graduates measure the chemicals. At least one large (32 to 64 ounce) and one small (8 to 12 ounce) graduate is required. The small graduate measures one ounce of solution accurately.

Storage containers. Photographic containers are sensitive to air and light, so storage containers should be dark and kept filled to capacity. Do not use a one-gallon container to hold a quart of solution, since the excess air in the container shortens the life of the chemical. Be sure all containers are resistant to chemical contamination.

Funnel. A funnel aids pouring solutions into the film tank as well as back into the storage container.

Photo sponge. A specially designed photo sponge is available to wipe the wet film while it is hung to dry. Be sure to use a photo sponge only, as regular sponges cause severe damage to the negative.

Film clips. Film clips are used to hang the wet film, allowing it to dry.

Timer. Since the chemical steps must be timed, select a timer that measures both seconds and minutes. Photographic timers are helpful, but a clock or a watch with a second hand will work.

Negative envelopes. After the negatives dry, keep them protected from damage and dust. Several types of envelopes are made to suit various budgets.

The Chemicals

The chemicals needed to develop the latent image on film are similar to those used to bring out the latent images in pinhole photographs and photograms. Again, they are (1) the developer, (2) the stop bath, and (3) the fixer.

The job of the developer is to convert the silver halides (which make up the latent image on the exposed emulsion) to blackened particles of silver that clump together during development to form a visible photographic image. Because the job of the developer is so complex, it contains a mixture of several chemicals. Chemical formulas of the developers on the market today vary. However, most of them contain (1) a solvent, (2) a reducer, (3) an activator, (4) a preservative, and (5) a restrainer. In most, the solvent is water, because in order to work, the other chemicals must be in solution. The reducer causes the actual chemical breakdown of the exposed silver salts. The activator in the developer does two things. First, it renders the developing solution alkaline rather than acid; and second, it helps the water to soften the gelatin of the film so that the reducer can separate the exposed silver salts. The preservative agent in a

developer reduces or retards the oxidizing (combining with air) of the reducers. Without it, reducing agents will deposit rust-colored stains on the film. The job of the restrainer is to control the action of the developing agents, which could attack the unexposed as well as the exposed silver grains, causing a chemical fog on the film.

One last note about developers: film manufacturers usually tell you on the film information sheet which developers work best for their films. It is best to trust their judgment and not experiment too much with unknown developers. Some developers are made specifically for films, while others are made to be used with photo papers. Ignoring this difference will result in a poor negative or a poor print.

The next chemical used in the developing process—the stop bath —stops the action of the developer. Some stop bath solutions (such as Kodak's Indicator stop bath) contain a chemical indicator that lets you know they are no longer working effectively. When the stop bath is yellow, it's okay. When the indicator turns the bath a purple color, then it is time to use a new mixture. A stop bath has one other function—to preserve the life of the next chemical, the fixer. The fixer removes the unexposed silver deposits, thereby eliminating the sensitivity of the film to light. The fixer also contains a hardener that makes the emulsion of the film harder and less likely to be scratched.

These are the basic chemicals used in developing film. Two other chemicals are also often used in this process. The hypo eliminator is a solution that neutralizes the fixer, greatly reducing the time that negatives must be washed. Unless the negatives are washed thoroughly, the hypo that remains on them will continue to affect the emulsion and will bleach out your negatives. After the wash, a wetting agent can be employed. To explain this simply, a wetting agent makes the water "wetter" so that the film will dry without water marks and streaks.

Mixing the Chemicals

Chemicals are packaged in liquid or powdered form. Powdered chemicals are generally cheaper but must be mixed with water to make a *stock solution.* Stock solutions are usually the form for storing chemicals. Those chemicals that are packaged as liquids are usually premixed stock solutions. The major benefit of premixed liquid stock solutions is convenience.

Most stock solutions must be diluted with water before use. The usable form of the chemical is called a *working solution.* Thus, the working solution is the final form of the chemical prior to use. In general, a stock solution stores for a longer period of time than a working solution. We advise that you always store liquid chemicals in dark, well-filled storage containers.

Always follow the manufacturer's instructions when mixing photographic chemicals. For example, a popular type of film developer in powdered form is Kodak's D-76. The mixing directions read: "Start with 112 fluid ounces (3.32 liters) of water at 125°F (52°C)." If cold water was added instead of hot, the granules that form the developer would not dissolve completely in the water. The result would be catastrophic to the negative.

Stock solutions of developer can be used in different ways, depending on the type and the brand. Some solutions must be diluted with water while others can be used straight or undiluted. Still others can be applied either way to affect the result of the negative. For example, the Kodak developer D-76 can be used straight or can be further diluted with water at a ratio of one part developer to one part water (1:1). The resulting mixture, now the working solution, is called a one-shot or one-use since after the chemical is used it must be discarded. Many people prefer adding D-76 at 1:1 because it yields a sharper negative than if that developer was used straight.

The ratio for mixing a stock solution to a working solution is important to understand. In the previous example D-76 was mixed 1:1—that is, one part stock solution to one part water. In other words, an equal amount of water was added to an equal amount of stock solution. If directions call for mixing a stock solution 1:2 to make a working solution, it means mixing one part stock solution to two parts water. If we need 8 ounces of working solution and the ratio called for 1:3 dilution, we would add 2 ounces of stock solution to 6 ounces of water.

Photographic chemicals must be handled with care so it is essential that you follow these general rules:
1. Always read labels and follow instructions carefully.
2. Store all chemicals and solutions safely.
3. Avoid skin contact with chemicals whenever possible. If necessary, wear rubber gloves.
4. Maintain proper breathing ventilation.
5. Always dispose of used chemicals safely.
6. Call a physician at once should any chemical be swallowed!

The Developing Process

Pour the chemical solutions in and out of the tank in the following order: developer, stop bath, and fixer. Then wash the processed film, preferably treating it with a fixer remover and a short wash. Then treat the film with a wetting agent and hang it to dry.

Practice these steps until you become totally familiar with them before beginning. The developing process needs to be timed so it moves smoothly from one step to the next.
1. Take the temperature of the developer and determine the correct developing time for that temperature by referring to the time-

temperature charts printed later in this chapter or referring to manufacturer's instructions. The developer should be at about 68°F, although anywhere between 65° and 75° is acceptable. Temperatures of the other chemicals, including the wash water, should be near that of the developer. If the film is subjected to drastic changes in temperature, large grains might form a textured image in the negative. In some cases, drastic temperature changes cause reticulation—the physical cracking or wrinkling of the emulsion.

2. Pour the developer into the tank while holding the tank at an angle to facilitate pouring: begin timing the developer once it is all in the tank.

3. Gently tap the bottom of the tank against a sink or counter. Rapping the tank will release any air bubbles in the developing solution. Air bubbles can adhere to the emulsion causing tiny clear spots on the negative.

4. Agitate the tank for the first 30 seconds of development. To agitate, gently rotate the tank in a circular motion, then turn it upside down. Repeat the rotation and inversion for the first 30 seconds. At the end of that time stop all agitation. For the remaining time in the developer, agitate the tank for 5 seconds out of every 30 seconds.

load reel and place inside tank

Many plastic tanks do not have caps on the top, so inversion is not possible. If a rod is provided with the tank, then agitate by gently turning the rod back and forth.

Agitating the film too much may cause streaks to appear on the negative or cause the film to become overdeveloped. If using the agitator rod from a plastic tank, do not spin the rod like a screw because it will no doubt cause overagitation.

**developer
68°
pour into tank**

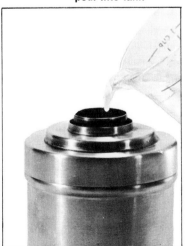

agitate as indicated

pour out developer

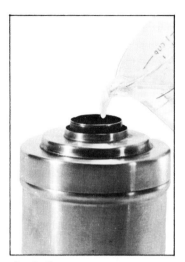

**stop bath
68°
pour in/agitate**

pour out stop bath

**hypo
68°
pour in/agitate**

5. Pour the developer out of the tank approximately fifteen seconds before the developing time ends.

6. Pour the stop bath into the tank as soon as all of the developer is emptied. The stop bath usually remains in the tank for no longer than 45 seconds. Agitate the tank once during this immersion. Be sure that the stop bath is within the 65° to 75° temperature range.

7. Pour the stop bath out of the tank.

8. Pour the fixer into the tank.

9. Agitate the tank for one-half the recommended fixing time. Most regular fixers work in 5 to 10 minutes, while rapid fixers work in 2 to 4 minutes.

10. Pour out the fixer. Although the film can now be viewed in normal room light, it is not recommended. Instead, proceed to the next step.

11. Rinse the film with water for 1 to 2 minutes.

12. Pour in a fixer-eliminator (hypo neutralizer) solution to help facilitate the washing process. Generally, this takes about 2 minutes with most brands. Agitate for at least half that time.

13. Pour out the hypo neutralizer.

14. Wash the film by allowing water to run directly into the open tank. Keep the film on the reel and in the tank so that all parts of the film are washed equally. Empty out the water in the tank

pour out hypo eliminator

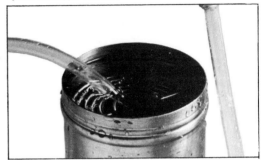

pour out hypo

**hypo eliminator
68°
pour in/agitate**

**water
68°
wash film**

once a minute to insure a complete change of water. The temperature of the wash water should be within the 65° to 75° range. Wash for approximately 20 to 25 minutes. If a hypo neutralizer is used, wash for 5 to 10 minutes.

15. Pour the wash water out of the tank once the cycle is completed.

16. Take the film reel out of the tank and place it gently in a container of the diluted wetting agent. Do not agitate. The film remains in the wetting agent solution for about 30 seconds.

17. Take the reel out of the wetting agent solution. Do not pour the solution out of the container while the reel remains in the container. This may cause streaking on the surface of the film.

18. Carefully remove the film from the reel and hang it to dry in a dust-free place. Always handle the film by its edges to avoid damage since wet film scratches easily. Use one film clip on the top to hang the film and a second clip on the bottom to keep the film from curling as it dries.

19. Wipe the wet film gently with a photographic sponge to remove excess water which may cause streaking. Be sure the photo sponge is clean or it will damage the film.

20. After the film is dry, cut it into strips of about six inches long. Never cut it into individual negatives. These cut strips should be stored in negative envelopes. Always keep the negatives in a clean, dry place.

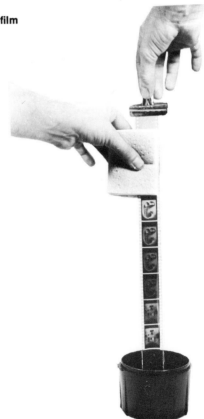

sponge film down gently

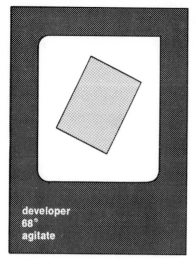

developer
68°
agitate

stop bath
68°
agitate

hypo
68°
agitate

Each processing step is labeled with the chemical, temperature, and activity required during that step. Follow manufacturer's instructions for the specific time each step requires. Gray background indicates total darkness.

The Tray Method

The tray method of developing film works best for sheet film (cut film) and should be used for roll film only in an emergency.

Arrange three trays, large enough to handle the size of film being developed, on a table. The first tray is for the developer, the second for the stop bath, and the third for the hypo fixer. Pour about ½ inch of chemical solution into each of the trays. Take the temperature of the developer to determine the length of time the film is to be immersed. After this is known, test the other two chemicals to make sure they are within the usable temperature range of 65° to 75°. From this point on, work in total darkness. Now completely immerse the film in the developer tray. If you are using sheet film, be sure that the notched edge of the film is to the right facing the top edge of the tray.

Agitate the tray constantly, but not rapidly. Just rock it back and forth a few times. The film will move from one side of the tray to the other while developing. Keep your hands out of the developer until you are ready to immerse the film in the stop bath. The film stays in the stop bath for 30 seconds. After this time is up, move it to the fixer. Handle the film very carefully, touching only the edges, since it is very soft and can scratch very easily. After the film has been in the fixer for one minute, room light may be turned on to view the negative. The film should remain in the hypo for the prescribed time, after which it should be handled as in the final steps of the tank method.

inspect negative

hypo eliminator
68°
agitate

running
water
68°
wash film

Manipulation of Negative Contrast

A good negative is the essential key to a good print. A well-exposed and well-developed negative prints easily, while a poorly exposed film and poorly developed negative is difficult to print. Generally, normal film exposure and normal film development produces a printable negative. However, sometimes altering film exposure and development yields an even better negative.

Contrast is the comparison of tonal values in a negative. Tonal value, or tonal range, is the range of grays in the negative. Thus, contrast refers to the tonal range between highlight and shadow areas. High-contrast subjects have very dark shadows and very bright highlights, such as happens on bright, sunny days (called hard). A normally exposed and normally developed negative of a subject taken on a sunny day will have high contrast.

Low-contrast subjects are gray and lack either the very dark shadows or very bright highlights of high-contrast subjects. Lack of contrast often results from cloudy or overcast days. A normally exposed and normally developed negative taken with this type of light (called flat) will be low in contrast.

Shadow areas of a negative are controlled by the exposure, or the amount of light that reaches the film. Highlight areas are also affected by exposure but are controlled primarily by the developing time. Thus, shadows represent areas of little exposure. Keep in mind that dark parts of a subject reflect less back to the film than bright parts

of a subject. Because of this, shadow areas form much faster on the negative during development than do the highlights.

For example, if the normal developing time for a roll of film is 10 minutes, then the shadow areas will form in about half of that time, or 5 minutes. The other 5 minutes of development primarily influences the highlights. Thus, the longer the development time, the denser the highlights.

Because shadows are determined by exposure, they are not affected a great deal by development time. So if the film is developed for 15 minutes instead of 10, the highlights rather than the shadows will become denser. This increased development time means a change in the contrast, or the differences between the highlight and shadow densities. Thus, the longer the development time, the greater the contrast of the negative.

Conversely, if the developing time is shortened to 7 minutes instead of 10, the highlight areas become less dense. Since the shadow density would remain unchanged, the difference between the highlight and shadow density is reduced, and the overall contrast of the negative is decreased. In other words, the shorter the film development time, the lower the contrast of the negative.

Negative contrast can thus be controlled by changing the amount of time the film is in the developer. More time increases the contrast and less time decreases the contrast. Negative contrast can be altered even more by changing both film exposure and film development. In general, to decrease contrast, overexpose and underdevelop the film. To increase contrast, underexpose and overdevelop the film.

To decrease contrast a general formula is: overexpose by 100 percent (one f/stop) and underdevelop by 20 percent the recommended time. If you are dealing with extreme contrast try overexposing by two stops and underdeveloping by 40 percent.

To increase contrast the general formula is: underexpose by one f/stop and overdevelop by 50 percent. With extreme cases try underexposing by two stops and overdeveloping by 100 percent.

Overexposing and underdeveloping are useful when photographing on bright, sunny days. The shadow areas of the subject tend to be quite dark and the highlights quite bright. Thus, overexposing and underdeveloping decrease the contrast. For example, a meter reading made on this type of day may read f/16 at 1/500. To overexpose by one stop use f/11 at 1/500 or f/16 at 1/250. In the development stage it is necessary to decrease the highlight density, so underdevelop the film. If the normal development time is 10 minutes, underdevelop by 20 percent and use 8 minutes instead.

Underexposure and overdevelopment are useful when photographing on cloudy or overcast days. This lighting is low in contrast, with an overall gray quality that reveals little or no bright or dark areas. To increase the lack of contrast, underexpose and overdevelop. For example, a meter reading on this type of day may read f/5.6 at 1/125. To underexpose by one stop use f/8 at 1/125 or f/5.6 at 1/250 instead.

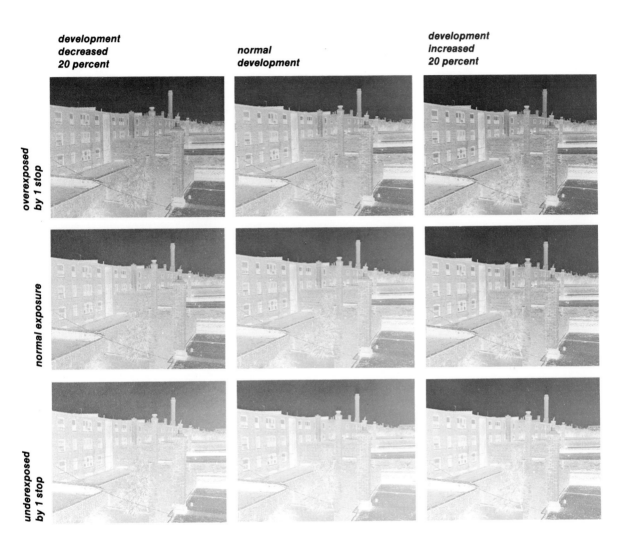

These negatives show the results of changing the camera exposure and the time of development. The negative in the center received normal exposure and normal development.

To increase the highlight density, overdevelop the film. If normal developing time is 8 minutes, overdevelop by 50 percent and use 12 minutes instead.

Temperature is a factor affecting density. The rate of development changes with the temperature of the developer. The developer works faster at higher temperatures and slower at lower temperatures. In other words, warm developers require shorter developing times. Cold developers require longer developing times. For example, a negative being developed in a certain developer may require 10 minutes at 68°. If, however, the temperature was raised to 75°, the time would be cut down to 8 minutes. If the time was not adjusted, the result would be an overdeveloped negative.

These are time and temperature charts for the various Agfa, Ilford, and Kodak developers and films. Use an accurate thermometer to measure the temperature of the developer. Most developers work best at 68°F. Always check the film/developer data sheet to see if any changes were made regarding these times. Agitation is continuous for the first 30 seconds and then 5 seconds out of every 30. Please note that these times are only suggestions for starting your own tests. Each photographer may vary actual development to fit individual needs and processing procedures.

Agfa
Rodinal Developer

Film Type	ASA	Dilution	Time* (Minutes)
Agfapan 25	25	1:25	4
Agfapan 100	100	1:25	5
Agfapan 400	400	1:25	7
Ilford FP–4	125	1:25	4.5
Ilford HP–5	400	1:25	6
Panatomic–X	32	1:25	6
Plus–X	125	1:25	7
Tri–X	400	1:25	8

*Temperature 68°F.

Atomal Developer

Film Type	ASA	Dilution	Time* (Minutes)
Agfapan 25	25	None	7–8
Agfapan 100	100	None	7–8
Agfapan 400	400	None	10–11
Panatomic–X	32	None	8
Plus–X	125	None	8
Tri–X	400	None	8
Ilford FP–4	125	None	8
Ilford HP–5	400	None	8

*Temperature 68°F.

ILFORD

Developer	Dilution	PAN F ASA	PAN F Time*	FP4 ASA	FP4 Time*	HP4 ASA	HP4 Time*	HP5 ASA	HP5 Time*
Microphen	None	64	4½	200	5	650	5	640	6
	1 + 1	80	5	200	8	650	9	640	9½
	1 + 3	80	9	200	11	650	18	640	21
Perceptol	None	25	11	64	10	320	9	200	11
or	1 + 1	32	12	100	11	320	13	200	14
Microdol–X	1 + 3	32	15	100	16	320	21	200	22
D–76	None	50	6	125	6½	400	7	400	7½
or	1 + 1	50	9	125	9	400	12	400	12
ID–11	1 + 3	50	14	125	15	400	20	400	23
DK–50	1 + 1	—	—	100	4½	—	—	400	6½
HC–110	1 + 7	—	—	125	5½	—	—	400	6

*Temperature 68°F.

KODAK FILMS

KODAK Packaged Developer for KODAK Films		Developing Time (in Minutes)—Small Tank				
		65°F (18.5°C)	68°F (20°C)	70°F (21°C)	72°F (22°C)	75°F (24°C)
PANATOMIC-X	ASA					
D-76	32	6	5	4½	4¼	3¾
D-76 (1:1)	32	8	7	6½	6	5
MICRODOL-X	32	8	7	6½	6	5
MICRODOL-X (1:3)	32	13	12	11	10	8½
VERICHROME Pan	ASA					
D-76	125	8	7	5½	5	4½
D-76 (1:1)	125	11	9	8	7	6
MICRODOL-X	125	10	9	8	7	6
MICRODOL-X (1:3)	125	15	14	13	12	11
PLUS-X Pan	ASA					
D-76	125	6½	5½	5	4½	3¾
D-76 (1:1)	125	8	7	6½	6	5
MICRODOL-X	125	8	7	6½	6	5½
MICRODOL-X (1:3)	125	—	—	11	10	9½
TRI-X Pan	ASA					
D-76	400	9	8	7½	6½	5½
D-76 (1:1)	400	11	10	9½	9	8
MICRODOL-X	400	11	10	9½	9	8
MICRODOL-X (1:3)	400	—	—	15	14	13
DK-50 (1:1)	400	7	6	5½	5	4½

Push-Processing

Suppose a situation arises containing the following elements: You are taking pictures at an indoor sporting event like a basketball game. The film in the camera is ASA 400. A light meter reading was made. The correct exposure would have to be 60th at f/2. The lens on your camera will not open up any further than f/2 but you need to shoot a faster shutter speed to avoid a subject movement that would create a blur. In this case, you would "push" the film or shoot it at a higher ASA rating than is recommended. By changing the ASA you are consistently underexposing by the same amount an entire film. Thus, a film with a normal ASA of 400, could be taken at an ASA 800, thereby underexposing by one stop. It is necessary to increase developing time to push-process.

When you push-process a film, you really are overdeveloping it to compensate for the underexposure. As you have already learned, overdeveloping an underexposed negative will not increase the detail in the shadow area. It will, however, increase the overall density. Thus, the contrast will be increased.

The chart below is intended as a guide only. It is recommended that you run your own tests to determine the best time for you.

All temperatures below are at 68°.

Manufacturer	Film-Type	Normal ASA	Push	Developer	Time
Kodak	Tri-X Pan	400	1250	D-76	13½
Kodak	Tri-X Pan	400	1250	D-76 1:1	17½
Kodak	Tri-X Pan	400	1250	HC-110 Dil-B	12½
Kodak	Tri-X Pan	400	1200	Acufine	5¼
Kodak	Tri-X Pan	400	1600	Rodinal	18½
Kodak	Tri-X Pan	400	3200	HC-16 Dil-B	14¼
Kodak	Tri-X Pan	400	3200	Acufine	7¾
AGFA	AGFA-Pan1000	1000	2400	Acufine	9
AGFA	AGFA-Pan400	400	800	Acufine	7¾
Ilford	FP4	125	320	Microphen	9
Ilford	FP4	125	650	Microphen	17
Ilford	FP4	125	800	ID11 or D76	20
Ilford	HP-5	400	800	Microphen	8
Ilford	HP-5	400	1600	Microphen	12
Ilford	HP-5	400	3200	Microphen	18
Ilford	HP-5	400	800	ID11 or D76	11½
Ilford	HP-5	400	1600	ID11 or D76	22½

Evaluating the Negative

To evaluate film exposure, look at the shadow areas of the negative only. If the shadows appear dense, the negative is overexposed. If they appear thin, with little or no detail, the negative is underexposed. Well-exposed negatives have enough density to render detail in the shadows.

To evaluate film development, look at the highlight areas of the negative only. A well-developed negative is dense but not opaque. If the highlight areas are thin, the film is underdeveloped, and the negative lacks contrast. If highlight areas are too dark, the film is overdeveloped and will probably have too much contrast.

Film development is a little harder to judge than exposure since highlight density is affected by film exposure. Underexposed negatives will have both thin shadows and thin highlights. Overexposed negatives have dense shadows and dense highlights.

The best judge of what makes a good negative is the photographer who has experience and practice in the darkroom.

Care of Negatives

Negatives are delicate. They can be wrinkled and scratched very easily. Scratches on a negative will appear as black or white marks on the final print. To avoid scratches, it is best to handle the film only by the edges. After the film is dry, roll film should be cut into strips about six inches long. Never cut it into individual negatives, since they are too hard to handle. These cut strips should be stored in negative envelopes, which are available at any camera shop. Keep your negatives in a clean, dry place.

keep negatives clean and filed

Problems in Development

If all the steps in the process of development are followed precisely, and if your film was exposed correctly, the result should be a high quality negative that can become a high quality print. However, mistakes can happen. The photographs that follow illustrate some common mistakes in developing and how they will affect the final negative.

Agitation. The purpose of agitation in the developing process is to move the solution inside the tank so that a steady supply of fresh developer reaches the emulsion of the film throughout the developing period. If the tank (or tray) is not agitated enough, the negative will be underdeveloped. But if there is too much agitation, then overdevelopment will occur, especially at the edges of the film. Normal agitation is five seconds out of every thirty seconds.

Fixer. Certain ingredients in the fixer make the timing of the film's immersion important. If the negative is immersed in the fixer for too short a period, unexposed silver will remain on it and the negative will be too opaque to be printed. In the event that the negative remains in the fixer too long, then the fixer begins to attack not only

uneven agitation can be seen in sky area

65

Improper fix *poor washing*

\rightarrow 9 \rightarrow 9A ——— \rightarrow 10

the unexposed portions of the negative, but also the parts that were exposed.

Washing. If the negative is not washed and dried properly, two things may go wrong. First, the negative may start to turn yellow and fade because some of the fixer is still acting on it. Second, the negative may have spots on it. Wash and dry your negative carefully and thoroughly. There are no shortcuts in film development.

If part of your negative is not developed, it indicates that parts of the film stuck together during development. This is caused by improper loading on the reel. Sometimes, when loading a stainless steel reel, the top loop of the film rests against the loop next to it. The result is that the developer will not reach that part of the film. Practice loading the reel before attempting the real thing.

Finally, make sure that the chemicals you are using to develop your film are fresh. An exhausted developer produces underdeveloped negatives. An exhausted fixer produces a grayish fog over the negative.

In Focus/Film Development

1. In addition to giving you the basic instructions for film development, this chapter contains information about the control of negative contrast through the manipulation of *exposure* and *development.*

 To complete this exercise, you will need to shoot and develop two or four rolls of film. One would be shot under low contrast conditions and the other should be shot under high contrast conditions. Since we assume these rolls are being shot only to

film stuck together during development

complete this exercise, we suggest using a roll with the fewest exposures possible.

Shoot one roll of film on a cloudy day when there is not a sharp distinction between highlight and shadow (low contrast conditions). *Underexpose* this roll by one *f*/stop. When you develop the roll, increase the development time *(overdevelop)* by 50 percent. This process should *increase the contrast* between highlights and shadows (see section in this chapter called Manipulation of Negative Contrast for a complete explanation). Now shoot a second roll of film under the same conditions. Expose and develop this roll in the usual way so you can compare the *normal* to the *manipulated* negatives.

Next, on a sunny day (high contrast conditions), shoot a roll of film in which you try to *decrease the contrast* by *overexposing* by one *f*/stop and *underdeveloping* by 20 percent. Shoot a second roll of film at the same time. Expose and develop this roll normally for comparison.

2. This exercise requires only that you have successfully developed several rolls of film so that you can evaluate the results. When evaluating film exposure, look at the shadow areas of the negative only. If the shadows appear dense, the negative is overexposed. If the shadows appear thin, the negative is underexposed. When evaluating film development, look at the highlight areas of the negative only. If the highlight areas are thin, it is underdeveloped and the negative lacks contrast. If the highlight areas are too dark, the film is overdeveloped and will probably have too much contrast. The best judge of what makes a good negative is the photographer who has experience and practice in the darkroom.

Printmaking

6

In painting, the finished product is displayed, not the preliminary sketches. In silk screen printmaking, the prints are framed and viewed, not the screen used to make them. So it is true in photographic printmaking, that is, it is not the negative that is viewed, but the print.

The photographic printmaker interprets each negative. He or she can influence the final result by understanding and using technical manipulations to raise the quality of the photograph to an artistic level. The printmaker can correct for shortcomings in the negatives—emphasizing a composition by eliminating part of the image, subduing unwanted light areas, or making areas lighter. In the safelight illumination of a darkroom, the photographer can make the print that will communicate to the viewer the essence of the idea recorded on the film.

For many photographers, enlarging the negative is the climax of the creative process that began when they first decided to take the picture. The first contact print of the negative transforms that image into a recognizable form. It can be a moment of complete triumph over the technical considerations of photography, or it can be a moment of discouragement. Enlarging the negative can increase the beauty of the image—or may just magnify its deficiencies.

The chemical processes of enlarging are essentially the same as those of film development. The enlarger is the printmaker's tool for transforming the negative image, through interpretation, to the positive image, the enlargement.

The Equipment

Printmaking requires a longer list of equipment and materials needed than film developing. Among those tools are the enlarger, enlarging lens, easel, enlarging timer, processing trays, print tongs, safelights, brush, print washer, print dryer, print squeegee, and glass. *Enlarger.* An enlarger is basically a camera in reverse. Rather than absorbing light, the enlarger projects it. The purpose of the enlarger

enlarger

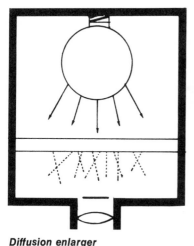

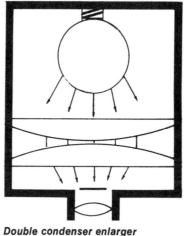

Diffusion enlarger

Double condenser enlarger

Diffusion enlarger
A frosted glass plate scatters the light falling on the negative, causing the enlarger lens to project a softer image. It is important to remember, however, that the bulb used in a condenser enlarger may not be the same type as used in a diffusion enlarger.

Double Condenser enlarger
Condenser lenses collect light and direct it coherently towards the negative and lens.

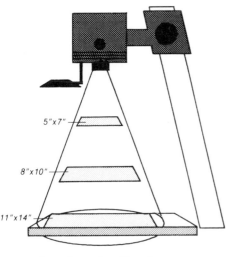

5"x7"

8"x10"

11"x14"

raise enlarger head to enlarge image

is to increase the size of the negative image that is being projected. Thus, from a very small negative, prints can be made to measure 8″ x 10″ and even larger.

Enlargers can look menacing but are simple to use. A long post or column holds the enlarger housing that in turn holds a light bulb, an optical system, negative carrier, bellows, and a lens. The post is attached to a baseboard.

Light from the bulb (a special enlarger bulb) travels through the optical system, the negative, and the lens to project the negative image onto the baseboard. The purpose of an optical system in an enlarger is to spread the light evenly before it reaches the negative. A condenser (one or two glass lenses) or a diffuser (a translucent piece of glass or plastic) is located between the light source and the negative to diffuse the light. Condenser enlargers produce a higher contrast print than diffusers.

The negative is positioned in the enlarger with the use of a negative carrier. Most negative carriers consist of two pieces of metal that fit together and hold a strip of negatives. The carrier has a cut-out the size of the negative. A few carriers have glass covering the negative to keep it flat during enlarging. However, glass carriers must be handled carefully to avoid scratching the glass and, harder still, must be kept free of any dust.

In most enlargers, a bellows is located under the negative carrier. A bellows focuses the image. As the bellows expands or contracts, the lens, which is attached to it, moves closer to or farther from the baseboard until the projected image is in focus.

The size of the projected image is controlled by the height of the enlarger above the baseboard. The greater the distance between the baseboard and the lens of the enlarger, the larger the magnification.

selecting an f/stop

enlarging easel

The size of the projected image changes by raising and lowering the enlarger housing on the post.

Enlarging lens. All enlargers have lenses. The size of the lens (focal length) depends on the size of the negative being enlarged. Generally, the focal length of the lens on the enlarger matches the normal focal length on the camera for a particular size of film. For instance, the normal size focal length lens for a 35mm camera is 50mm. Thus, a 50mm lens is used on the enlarger. A normal lens for a 2¼″ x 2¼″ camera is 75 to 85mm; this lens size would also be used on the enlarger. If a 50mm lens is used to enlarge a 2¼″ x 2¼″ negative, it might not cover the full area of the negative, but it might cut off the corners of the image. On the other hand, if a 75mm lens is used to enlarge a 35mm negative, then it would produce a smaller magnification than a 50mm lens, assuming that the enlarger-to-paper distance is not changed.

Image brightness is controlled by the iris on the lens. The more the lens is *stopped down,* the less light passes through it. Brightness also decreases as the enlarger is raised to give greater magnification.

use red filter to preview light coverage

Easel. Photographic paper must be kept perfectly flat during the exposure or else one area of the paper will be out of focus while the rest is in focus. Enlarging easels are designed to hold the photo paper completely flat during exposure. Most easels adjust by moving the thin metal strips to form a mask; they can be masked off for various standard paper sizes, such as 3½″ x 5″, 5″ x 7″, 8″ x 10″, and 11″ x 14″. Printing paper is inserted from one end and is slid along the easel guides until it is centered within the mask. The emulsion side of the paper faces up toward the enlarger lens.

Timer. A special enlarger timer controls the amount of exposure. Most timers on the market have a range from 1 second to 60 seconds.

timer

electric print dryer

focusing magnifier

Usually, there is a manual light switch to turn the enlarger on for focusing. Once the timer is set for the period of exposure, a button is pushed to begin the timing. The timer then automatically turns on the enlarger light and turns it off when the exposure is completed. Although it is not as accurate, a switch on the enlarger line also can be used to turn the enlarger on and off to control the exposure. In this case, check the exposure time with a wristwatch.

Processing Trays. Trays hold the chemicals for print processing. At least three, usually four, trays are needed. These trays should be a little larger than the paper being used, since it is important that the entire print be immersed in the chemical solution at the same time.

Print Tongs. Use print tongs rather than your hands when moving the print from one tray filled with solution to the next. Tongs help prevent you from getting skin rash or irritation from the chemicals.

Another important reason for keeping your hands out of the chemicals is that you must not contaminate the solutions, especially the developer. While the print will contaminate the stop bath with developer and the fixer with stop bath, it will not immediately ruin those chemicals. However, if the stop or fixer gets into the developer, its capacity to develop prints becomes greatly reduced. Also, contaminated hands can cause fingerprints and stains that ruin photo paper.

Safelights. Because photo paper is sensitive to most colors of light, safelights are used to illuminate the darkroom. Most safelights consist of simple 15- to 25-watt bulbs protected in a housing and covered with a specially colored filter, usually amber or red. Safelights should be positioned at least 3 or 4 feet from the enlarger and developer.

Brush. Dust is a major problem in the darkroom. Dust will accumulate on a negative and must be cleaned off or it will show up in the print. To eliminate dust, brush the negative with a soft, camel's hair brush. Canned air is very effective for removing dust, but it is expensive.

Print Washer. A tray or washer is needed for print washing. In addition, specially made print washers are available. A simple print washer may consist of one large tray with a tray siphon attached.

Print Dryer. Prints are dried by air or electric dryers. Electric dryers, although efficient, are not as popular as they once were. Many photographers prefer a blotter book or drying screen (plastic screening material stretched taut over a frame). In addition, prints can be hung on a clothesline by clothespins.

Print Squeegee. A print squeegee is a flat rubber blade (like a car wiper) or rubber roller. It squeezes excess water off a washed print to help it dry better. A sponge works also.

Glass. Two pieces of glass are needed: one to hold the print while it is being squeezed and the other for contact printing (explained later).

Although optional, the following equipment facilitates printmaking:

Focusing Magnifier. A magnifier enlarges the projected image to aid focusing. Another type of magnifier, called grain magnifier, enlarges the grain patterns in a negative, allowing for very precise focusing.

Paper Safe. A paper safe is an easily accessible light-tight box that stores the unexposed photo paper.

Print Trimmer. Sometimes, it is necessary to cut photo paper. A paper trimmer cuts the paper more squarely and accurately than a pair of scissors.

Photographic Papers

Photographic paper is classified according to five different qualities: (1) contrast, (2) surface, (3) base type, (4) thickness, and (5) tone.

Contrast is the comparison of values (light and dark) in a negative or print. Contrast in a negative is determined by exposure and development. An overexposed or overdeveloped negative is too dark or dense. An underexposed or underdeveloped negative is too thin—it looks flat. In printing, low-contrast prints are gray with few bright or dark areas; high-contrast prints are mostly light and dark with few gray areas.

Photographic paper is usually made in five contrast levels (grades). Papers are numbered from one to five, indicating the level of contrast: 1–low contrast, 2–average contrast, 3–slightly high contrast, 4–high contrast, 5–very high contrast.

Eastman Kodak uses a descriptive system to indicate the various contrast levels. This system is primarily for RC (see base type) paper. The conversion table is:

Soft	= 1	Extra hard = 4	
Medium	= 2	Ultra Hard = 5	
Hard	= 3		

Another type of paper, called *variable contrast paper,* allows for seven different contrast ranges with the use of filters. Eastman Kodak's paper is sold under the names Polyfiber, Polycontrast, and Polyprint while Ilford's is called Multigrade II. Variable contrast paper eliminates the need to buy several grades of paper. Instead, contrast is changed by inserting a filter in the enlarger or under the lens. These filters are numbered 1, 1½, 2, 2½, 3, 3½, and 4, corresponding to the levels of contrast. Variable contrast paper also permits intermediate contrast levels (like 1½), which cannot be achieved with regular stock paper. With variable contrast paper, exposure time must be readjusted for the different filters, for each increase in contrast also increases the density of the filter. Since the light passing through the negative must also pass through the filter, exposure time must be increased with the darker filters.

Surface. Surfaces of photographic paper vary. Because photographers have different tastes and produce photographs for many different purposes, Kodak alone offers eleven different paper surfaces. Generally, it is best to buy either an F (glossy), J (high lustre), or N (smooth semimatte) surface. These papers do not texture the photographic image. The F surface paper is most popular.

Base type. Photographic papers are available in fiber and RC. Resin-coated papers are coated on both sides of the paper with a very thin layer of clear plastic. Resin-coated papers are more convenient to

use than fiber-based papers, and they expose more quickly than fiber-based papers. Because they are coated in plastic, they take less time to process, wash, and dry. In addition, RC papers do not curl as much as fiber-based papers when drying.

Because of their convenience RC papers are especially useful to the beginner or to the person who does not have much time to use the darkroom. More advanced photographers tend to prefer fiber-based papers since they tend to yield prints with greater tonal range.

Thickness. There are three different paper *weights,* or thicknesses—single weight, medium weight, and double weight. Double weight paper is about twice as thick as single weight and also about a third more expensive. However, double weight papers work best for very large prints (11″ x 14″, 16″ x 20″) because these size prints have a tendency to curl. When beginning photography, purchase single weight paper to keep costs down. Resin-coated papers are the only type of paper available in medium weight.

Tone. The tone of a photographic paper is described in terms of being *warm* or *cold.* A warm-tone paper is one in which the blacks are brownish. A cold-tone paper is one in which the blacks are blue. Cold-tone papers usually have a purer, cleaner white base while warm-tone papers may have a creamier, off-white base.

Paper developers also affect the tone of a print, so corresponding warm-tone and cold-tone developers are made for different tones of papers. The following charts are based upon manufacturer's information on some of the more common paper developers and paper types.

Agfa Papers

Paper	Developer	Time (sec)	Image Tone	Surface	Weight
Brovira-Speed 310PE	a	60	cold	glossy	medium
Brovira-Speed 312PE	a	60	cold	semimatte	medium
Brovira-Speed 319PE	a	60	cold	lustre	medium
Brovira-1	a	90–120	cold	glossy	single
Brovira-111	a	90–120	cold	glossy	double
Brovira-112	a	90–120	cold	semimatte	double
Brovira-119	a	90–120	cold	lustre	double
Portriga-Speed 310PE	b	60	warm	glossy	medium
Portriga-Speed 318PE	b	60	warm	semimatte	medium
Portriga-111	b	90–120	warm	glossy	double
Portriga-118	b	90–120	warm	semimatte	double

a. Any cold-tone developer (Dektol, Ektaflo 1, LPD).
b. Any warm-tone developer (Selectol, Selectol Soft, Ektaflo II).

Ilford Papers and Developers

Paper	Developer[1]	Time (sec)	Image Tone	Weight
Graded Contrast				
Ilfobrom	Bromophen	90–120	cold	single double
Ilfospeed RC	Ilfospeed	60	cold	medium
Ilfospeed Galerie	Bromophen	90–120	cold	double
Variable Contrast				
Ilfospeed Multigrade II	Multigrade	60	cold	medium

[1]Manufacturer recommended. Other brands can be used. Many surfaces produced except for Galerie, which is made in glossy only.

Kodak Papers and Developers

Paper	Developer	Time (sec)	Image Tone
Variable Contrast			
Polyfiber	Dektol	60–180	cold
Polyprint RC	Ektaflo Type 1	60–180	cold
Polycontrast Rapid II RC		45–120	warm
Graded Contrast			
Ektalure	Ektonol	90–180	warm
Mural	Selectol	90–240	warm
Kodabromide		60–180	cold
Medalist	Dektol	45–120	warm
Kodabrome II RC	Ektaflo, Type 1	45–120	cold
Panchromatic[1]	Dektol,		
Panalure	Ektaflo, Type 1	60–180	warm
Panalure Portrait	Selectol, Ektaflo, Type 2	90–240	warm
Panalure II RC	Dektol, Ektaflo, Type 1	45–120	warm

[1]For black and white prints from color negatives.
Note: Kodak makes many different surfaces. Not all surfaces are available in all papers. Not all weights are available in all surfaces. Check with your camera dealer.

Printmaking Chemicals

The chemicals for processing prints are basically the same as those for film development. As explained earlier, the one exception is the developer. A film developer serves the same purpose as a paper developer—to develop the latent image—but its chemical make-up is slightly different, so it is necessary to use separate film and paper developers.

Stop bath, fixer, and fixer eliminator are all the same for film and paper. However, dilutions may vary so check with the instructions on the package. When storing these chemicals, do not mix them with the ones for film developing.

An acid stop bath should always be used for fiber-based papers. With RC paper, a plain water stop bath suffices.

Some fixers require dilution, others do not. A hardener is incorporated into some fixers and must be added separately to others. Resin-coated papers tend to scratch easily, so a hardener is necessary to protect the emulsion. Fiber-based papers are not as likely to scratch, so a hardener is not necessary. Prints that are not hardened dry flatter and wash more thoroughly than hardened prints. Prints that are subjected to heat, as in mounting (explained later), should be hardened to protect the emulsion.

Most darkroom workers use a fourth tray, called a holding bath, which consists of plain water. After fixing, fiber-based prints are held in the tray of water until the end of the printing session or until the tray fills. At that point, all the prints are removed to the print washer. The water in the holding tray should be changed every so often to minimize the accumulation of spent fixer in the water. A holding tray is not necessary for RC prints since they should be washed right after they have been fixed.

Processing trays holding the chemicals should be positioned in a line, with the developer in the far left tray followed by the stop bath, fixer, and water in the far right tray. The trays should be approximately one-half filled to capacity for an average work session. For

Each processing step is labeled with the chemical, recommended time in the chemical, and the action required during the recommended time. Gray background indicates safelight illumination.

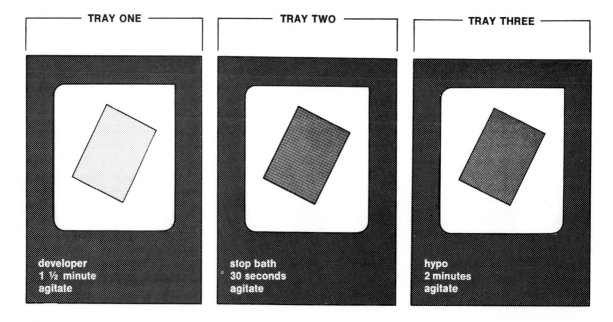

TRAY ONE

developer
1 ½ minute
agitate

TRAY TWO

stop bath
30 seconds
agitate

TRAY THREE

hypo
2 minutes
agitate

insert negative into the carrier

clean negative to remove any dust or lint

example, fill a 5″ x 7″ tray with 16 ounces of solution; an 8″ x 10″ tray with 32 ounces; an 11″ x 14″ tray with 64 ounces; and a 16″ x 20″ tray with a gallon.

Preparations for Enlargement

The photographic printmaker interprets each negative. The following are the first basic steps toward that goal. The ten steps outline the procedure for preparing a negative for enlargement.

1. Place the negative in the carrier of the enlarger. The emulsion side (dull side) of the negative should be face down toward the lens. If the negative is not face down, the print will be backwards (flopped). Since some enlargers can handle different sizes of negatives, they will have different sizes of negative carriers. Be sure to use the right size negative carrier for the size of film you are working with.

Some carriers sandwich the negatives between two pieces of glass. If you have this type, be sure not to handle the glass surfaces, as fingerprints will cause uneven lighting and a loss of sharpness in the prints. Always handle the negatives with care, touching them only by the edges, since they scratch and fingerprint easily.

2. Once the negative is in the carrier, it must be cleaned carefully. Even a negative carefully filed in an envelope will inevitably gather some dust. Unless this dust or lint is removed, it will cause little white spots in the print. To remove dust, use either a soft camel's hair brush or a can of compressed air. If you use a brush, be sure to brush both sides of the negative. If your negative carrier has glass in

Insert carrier into the enlarger quickly

the openings, clean all sides of the glass prior to inserting the negative. This is to remove all dust on the glass itself. When using air, point the nozzle with the snorkel tip at the negative and press the spray button.

3. After all dust is removed, place the negative in the enlarger immediately so that no new dust settles on it. In order to insert the negative carrier on some enlargers, you must raise the lamp housing of the enlarger. Usually the carrier will lock into a tight position, indicating that it is in place. The lamp housing can now be brought back down on the carrier. Always insert the negative with the enlarger off, so that the enlarger light will not spill into the darkroom.

4. Set the easel for the image size of the print. The image size is the size of the printing paper minus the borders. For example, a 7½″ x 9½″ size image on an 8″ x 10″ sheet of photo paper has a one-quarter inch border on each side. Some easels are nonadjustable and offer only one standard size.

5. Place the easel on the baseboard of the enlarger.

6. Turn on the safelight and turn off the room lights.

7. Turn on the enlarger.

8. Open the iris on the enlarging lens as wide as possible for easier viewing.

9. Raise and lower the enlarger housing on the vertical column until the image is the desired size. The position of the easel on the enlarger baseboard needs to be adjusted until the projected image is framed by the easel. Remember, as the housing moves up the column, the projected image becomes larger; as it moves down, the image becomes smaller.

10. Once the size of the image is set, focus the negative by turning a knob on the enlarger until the projected image on the easel looks sharp. If the size changes as you focus, it may be necessary to readjust the height of the enlarger.

To provide a better viewing surface and to compensate for the thickness of the photographic paper, place a sheet of printing paper in the enlarging easel during focusing. A magnifier makes the projected image larger and focusing more accurate.

Print Exposure

Exposure time in enlarging varies with the density of the negative, the size of the enlargement, the paper being used, the lens opening on the enlarger, and the enlarger itself. Because there are so many different variables, try to work with the same enlarger and to keep the lens set at a certain f/stop. Since a flat negative is enlarged on another flat surface, depth of field is usually not a problem in enlarging. Generally, there is no need to close the iris on the lens all the way down, since this only decreases the amount of light projected. A lens should be closed all the way only when a very light (thin) negative is enlarged. Otherwise, keep the lens opening constant at about f/8 or f/11.

Making a Test Print

A major consideration in printing a negative is how dark the print should be. This is a visual judgment. Making a test print helps you determine which exposure time works best for a particular negative. First, put the negative in the carrier and adjust the enlarger for size and focus. Then, insert a sheet of paper in the easel. If you use a timer, set it for 25 seconds.

In this test, prepare a number of exposures on a single sheet of paper. To make the test strips, cover all but 20 percent of your enlarging paper with an opaque sheet of cardboard. Expose the paper for 5 seconds. Now move the cardboard down another 20 percent and expose the paper for another 5 seconds. Repeat this procedure until you have gone through five successful exposures of 5 seconds each (with your enlarging lens set at f/8 or f/11). The result should be a full piece of enlarging paper with a series of strips exposed for multiples of 5 seconds. The first strip exposed (the top one) has a cumulative exposure of 25 seconds, the next 20 seconds, the third 15 seconds, and so on down the paper.

Processing the Test Print

The print developing process is the same for both test prints and final prints. Processing times that are included here are only suggestions. Always refer to the instruction sheets for the photographic paper and chemicals for specific recommendations. Processing temperatures are not as critical for prints as for film. However, try to keep the temperatures of all the chemicals as close to 68° as possible.

After the exposure, immediately slip the paper into the developer tray noting the time. Place the paper in the tray either face down or face up for the first few seconds, but turn the paper face up as soon

space out exposures uniformly in order to facilitate selection of proper exposure

79

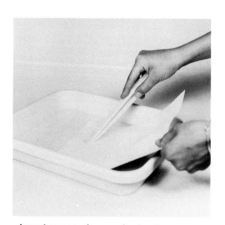

insert exposed paper in developer

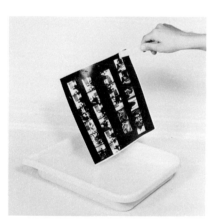

drain excess chemical off

as it is thoroughly wet. The important thing is to get the entire print into the tray quickly. Don't let one end of the sheet hang over the tray while the rest is in the developer. Also, until the paper has been completely saturated, be careful to keep the corners of the print in the developer, as they may tend to curl upward and develop unevenly. Once the print is in the solution, rock the tray gently back and forth. This agitation should not be violent or fast; its purpose is only to keep the solution constantly moving across the emulsion on the paper. Use print tongs occasionally to poke down the corners of the paper. If you do not use tongs, then try not to touch the surface of the print unnecessarily. Also, avoid continued pressure on one area of the print, because the heat of your body will warm the developer and make it work faster, causing a dark spot in that area.

The image on most paper will begin to appear in about 30 seconds if your print has been properly exposed. Even if the print looks too dark after a minute in the developer, do not remove it from the solution. The print must remain in the developer for 1 to 2 minutes. However, do not leave it longer than 4 minutes.

If you remove the print from the developer too soon because it appears to be getting too dark, the result will be a muddy, gray image lacking contrast. There will be no sharp blacks or whites in the print. One way to correct a print that is too dark after 1 minute in the developer is to shorten the exposure time. You can also close the lens down on the enlarger. If the print is completely black, then cut the exposure time in half and try again. If the print remains in the developer for 2 minutes and is very pale or completely white, then double the exposure time. Always remember this important point: lightness or darkness of a print is controlled by the exposure time and should not be manipulated by varying the time in the developer.

When the print has been in the developer for at least 1 minute and no longer than 4 minutes, hold it by one corner to drain for a few moments and then place it in the stop bath. Agitate the print in the stop bath for about 30 seconds. During this period you may hear a whistling sound coming from the solution—this indicates that the sodium carbonate from the developer is being broken down to carbon dioxide, which is being released as a gas. Do not leave the print in the stop bath longer than 1 minute, as it may start to stain out the image. After 30 seconds in the stop bath, drain the print as before and then immerse it in the hypo fixer.

A continued whistling sound after the print is in the hypo may indicate a weakened stop bath that should be replaced. The sound may also indicate that the print wasn't in the stop bath long enough or that you did not drain the print enough when changing from tray to tray.

Once the print is in the hypo, agitate it for about a minute and then let it soak in the solution for another minute before inspecting it in room light. If other prints are in the same hypo tray, agitate them every few minutes. The print should remain in the hypo for the time

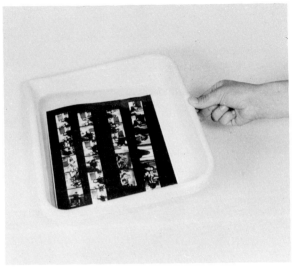

agitate print in the hypo

washing the print

recommended by the manufacturer. Generally, this is about 8 minutes. If the print remains in the hypo for too long (more than 10 minutes) the image may absorb hypo in such a way as to resist washing. Eventually, the hypo stains the print. If the print is exposed to white light immediately after immersion in the fixer, it will fog. However, if the print fogs under white light after 2 minutes in the hypo, then the hypo should be replaced as it is no longer working.

To examine the print, place it in a clean tray and out of the darkroom. The tray will prevent the hypo from dripping off the print. Dried fixer is difficult to remove from floors, cabinets, and other surfaces.

After the print has been in the fixer for the recommended time, place the test print in the holding bath until it is ready to be washed. (Print washing is described in detail later in this chapter.)

The processed test print will have a range of five exposures; some may be light and some dark. If all five exposures are either too light or too dark, make another test print. The ideal test print is dark on one side and light on the other. If the entire print is too dark, then shorten the intervals of exposure. If the entire print is too light, then increase the exposure time. Lighter negatives need less exposure time because light passes through them at a more intense level. Denser negatives require more exposure time. An exposure time of more than 60 seconds indicates that a negative is overexposed or overdeveloped. In this case, try opening the *f*/stop on the enlarger lens to shorten the exposure time.

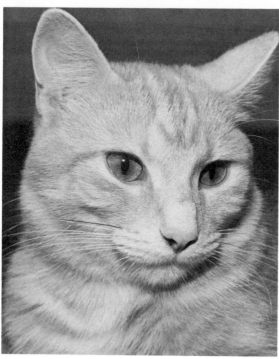

printed on a normal contrast paper (#2)

printed on next higher contrast grade (#3)

printed on next higher grade (#4)

printed on next higher grade (#5)

The Final Print

Once a good test print is made, examine it carefully and choose the exposure that looks best. Sometimes, the best exposure falls between two sections of the test print. If a 6-second exposure looks too light and the 9-second exposure looks too dark, use a 7- or 8-second exposure instead.

To begin, place a fresh sheet of photo paper in the easel and expose it for the time chosen. Do not change the f/stop setting. Develop the exposed paper exactly for the same times as the test print. To evaluate the quality of this print consider these factors: (1) exposure and (2) contrast.

1. Print exposure determines the overall brightness of a print. Too much exposure results in a print that has dark shadows and highlights; too little exposure results in a print that leaves the shadows and highlights too light.

A good test print helps determine correct exposure. However, once the initial print is made, it may need some slight adjustments in exposure. The two questions that every photographer must ask concerning exposure are, "Is the print too light?" and "Is the print too dark?"

2. Photographers sometimes confuse exposure with contrast. For instance, after making a test print in which all of the strips are too light, a beginning photographer may change to a lower contrast paper. This is the wrong thing to do. If a test strip is too light, the exposure time should be increased. Then, after a new test, decide whether the print has too much or too little contrast. There is no rule of thumb governing contrast selection. However, if a test print image is still stark white and black after the correct exposure strip and proper length of development time have been used, then the contrast grade is too high. If the strip has an overall gray (muddy) look, then the contrast grade is too low. The eye is the best judge of proper contrast.

One of the unique qualities of photography is its ability to capture a scene in a complete tonal range. In photography, tonal range is the scale of values ranging from white through a wide variety of grays to black. Tonal range is greatest if the negative is properly exposed and then printed on a number 1 or 2 paper. Higher contrast paper results in a loss of tonal range. This effect may be desirable if the negative has too much of an overall gray look, that is, if it lacks contrast from the original exposure. In other words, the lower the contrast of the paper, the greater the tonal range—the greater the number of gray tones the paper can reproduce. The higher the contrast of the paper, the shorter the tonal range—the fewer the number of gray tones the paper is capable of reproducing.

Sometimes, a photograph can be printed successfully on different contrast grades of paper. As the photographs show, each print communicates a slightly different conception of the same negative. Contrast in each print influences the way we respond to them. No single print is better than the others. From a technical standpoint, the first print has the largest tonal range. However, printing is not only a

unburned photo

burned-in photo

matter of technical considerations. The photographer must also consider what he or she wants to communicate. In the end, it is the photographer's point of view we see when we look at a photograph.

Corrective Manipulations

In theory, a well-exposed negative should produce a print with a long tonal range. However, this is not always the case. Film is capable of recording more subtleties in tone than can be printed. For instance, a light area in your negative may contain some detail, but if the exposure is based on the rest of the negative, that area will turn completely black in the print. If the exposure is timed to hold the detail in that light area, then the print will be too light.

In another negative, just the opposite may be true. A dense area of the negative contains detail visible to your eye, but a print based on the overall exposure makes that area completely white in the print. If the exposure is changed to gain back the detail in the dark area of the negative, the rest of the print will be too dark. There are two techniques you can use to change such areas in a print—"burning in" and "dodging." "Burning in" will darken an area, while "dodging" will lighten it.

To burn in an area, you must block out the rest of the picture while allowing more light to fall on the area you want to make darker. To do this, first determine the correct exposure based on the entire picture area. Then take a sheet of opaque cardboard and make a hole in the middle of it. Place this cardboard between the lens of the enlarger and the paper. With the hole over the area to be darkened, turn the enlarger light on and re-expose the part of the print that needs to be made darker. Move the cardboard about

burn in an area to darken

constantly, in a random way, or the final print may show the burned-in area as a dark, round circle. Move the cardboard closer to the lens to increase the size of the area covered or closer to the paper for a smaller area.

Dodging an area will lighten it. In other words, keeping light from the area will cause it to print lighter than it normally would. You can make a tool for dodging by cutting various shapes out of cardboard and fastening them to wires. The wire handles make it possible to dodge out areas near the center of the photograph without blocking out light near the edges. When dodging an area, it is important to keep the tool in constant motion so that the area blends in with the rest of the print. If a large area is to be dodged, your hand can be used to block off a portion of the light.

dodge an area to lighten

Timing either of these techniques is a matter of trial and error. As your experience increases, you will be able to determine more quickly the correct times for dodging or burning in.

Cropping an image will not be necessary if you have composed the image carefully in the viewfinder of the camera. However, sometimes it is desirable. One way to crop the image is to use larger paper than you want for your final print. Once the image is printed, the unwanted area is cut off. Another method is to blow up the image in the enlarger so that the unwanted portion of the negative is outside the area of the enlarging paper. You may also move the arms of the paper easel (if you are using the adjustable type) so that the unwanted area is masked out. Cropping should be a last resort. The larger an image, the less sharpness it has. Your cropped image will not be as sharp as a full negative print. You should learn to compose with the camera: if you take the picture five different ways or from five different viewpoints, cropping should not be necessary.

Vignetting is a combination of the above manipulations. You normally use it when you want to single out one area of the negative. Use the same cut-out cardboard tool that you made for "burning in." In this case, though, make only one exposure, with the hole over the area you want pictured. Keep the cardboard in constant motion during the exposure. When the print is developed, the subject will appear with everything around it fading off to pure white. Vignetting can be used when you have a portrait photograph with an unattractive or cluttered background.

A less common problem is that of distortion. For instance, if you photograph a tall building, the lines of the building tend to lean toward the center of your picture. This is a perspective problem, and usually you can do nothing to correct for it when taking the picture unless you use a view camera. However, in enlarging, "distortion correction" can save most of these pictures. To do this, raise one end of the enlarging easel about one or two inches. Then, after focusing on the halfway point of the image, close down the lens of the enlarger all the way, so that you achieve the greatest depth of field. This is one of the few times that closing a lens down all the way has any real function in enlarging.

uncropped photo *cropped photo* *vignetted photo*

Other manipulative processes also can be done in the darkroom. For instance, you can intentionally add texture to a photograph by the use of texture screens. You can make a sharp image look diffused or soft, and you can print more than one negative at a time. These last techniques generally do not enhance a good photograph, but only cheapen it. Gimmicks are no substitute for a creative statement. There is really only one way to make a good photograph, and that is by taking a good photograph. You can make a good photograph look better by burning in or dodging, but you can't make a bad photograph look good.

Washing and Drying the Prints

After the print has been in the fixer for the recommended time or in the holding tray, the wash cycle can begin. Prints must be washed sufficiently or they will deteriorate with age. A short water wash of 10 minutes is recommended for RC papers. However, fiber-based papers absorb more fixer than RC papers so they require a longer wash time of one hour. Although it is not a necessity, the hypo eliminator neutralizes most of the fixer, thereby shortening the washing time. Thus, a hypo eliminator is especially useful for fiber-based papers.

With a hypo eliminator, most manufacturers recommend a short water wash of 2 minutes before adding the hypo eliminator. After the water rinse, soak the prints in the eliminator for the recommended time. Directions usually suggest 2 to 4 minutes with some agitation. Limit the number of prints to fifteen. Washing time is thus cut to 10 to 20 minutes for fiber-based papers.

At the end of the time, drain each print briefly; then place them one at a time in the wash water. When washing either RC or fiber-based papers, use a good print washer that circulates a constant flow

of water. An inexpensive washer can be made from an ordinary processing tray with a tray siphon. A siphon is usually a plastic or rubber device that clips onto one side of the tray. It connects to any standard faucet with a rubber hose. Water from the faucet enters the tray at the top of the siphon, and tray water drains off at the bottom of the siphon. If holes are punctured on the opposite side of the tray, the water will drain even better.

When washing prints, agitate them by hand to keep them from sticking to each other. Again, wash only a few prints at a time to keep the prints from bunching. If a print washer is not available, empty all the water from the tray every 2 minutes during the wash. Continual changes remove any contaminated water. Never put an unwashed print into a tray of washed prints since this will contaminate the washed prints, and they will have to be rewashed.

Next, dry the washed prints. There are several ways to dry, depending upon the equipment available. The easiest method is to dry with a photo blotter roll or book. First, wipe off the excess water by placing the print on a sheet of glass and pressing with a photo squeegee, cellulose sponge, or clean window-wiper blade. Before doing this, place a tray underneath the glass to catch the excess water. If you are using a roll, place the prints on it and roll the print up, using a rubber band to hold both together. If you use a blotter book, place some heavy books on top of the blotter to keep the prints compressed. Leave the prints in the blotters for a couple of days to let them dry completely.

For quicker drying, use an electric dryer. At least two types of dryers are available, the rotary (drum) and the flat bed (double-sided). The drum dryer should be turned on at least 10 minutes before use and allowed to reach an operating temperature of about 275°F. After squeezing the water from the washed print, place the print on the dryer blanket face down. By turning the handle, the moving belt will carry the print around the drum. Leave the print in the dryer for approximately 10 minutes. Some dryers of this type are called continuous belt: turning the handle is unnecessary, since the dryer drum rotates automatically.

To use the flat-bed dryer, set the thermostat on the dryer to "medium." Wipe off the excess water and place the print on the bed of the dryer facing up. Pull the canvas over the print and lock the dryer closed. After five minutes, raise the thermostat temperature to "high" for another five minutes. Then remove the print from the dryer.

Dry only thoroughly washed prints in an electric dryer. If there is still some hypo, the print will contaminate the blanket or canvas of the dryer. This will in turn contaminate clean prints that touch the dryer.

Resin-coated paper should never be dried in an electric dryer, as the heat will cause the coating of the paper to melt on the dryer. The melted coating may ruin the dryer as well as the print.

Air drying is another method for drying prints. Hang each print by a corner from a clothesline. To reduce curling hang two prints back to back one on each corner with four clothespins. It is possible to dry RC paper by laying the print face up on a clean counter or table.

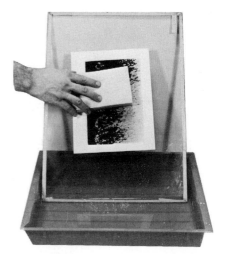

wipe down

blotter book

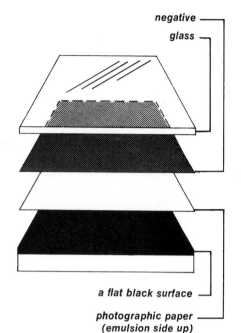

negative ——
glass ——

a flat black surface ——
photographic paper ——
(emulsion side up)

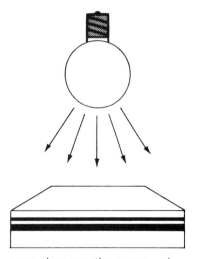

press glass, negative, paper, and board together firmly before exposing

Finally, a simple drying screen can be constructed for more efficient air drying. First, make a frame out of four wood strips using 1″ x 2″ stock and staple plastic screening to it. (Screens are available from hardware stores.) The screens do not need to be very strong since the prints weigh very little. The wood can be hammered or screwed together with metal corner braces to keep the frame square. Drying screens can be cut in any size to fit space requirements. Several screens can be stacked on top of each other to save space. The screen material should be washed periodically with a mild soap solution.

Place RC prints emulsion side up on the drying screen. Place fiber-based prints emulsion side down on the screen to minimize curling.

Contact Printing

A contact print is a print the size of the negative. For example, a contact print from a 35mm negative measures 1″ x 1½″; and a contact print from a 2¼″ x 2¼″ negative measures 2¼″ x 2¼″. Because a contact print is the same size as a negative, they are mostly made from larger size negatives like 4″ x 5″ or 8″ x 10″ so the image can be seen readily.

A contact sheet, or proof sheet, is a large sheet of paper (usually 8″ x 10″ or 8½″ x 11″), containing an entire roll of contact-printed film. This sheet allows the photographer to examine each print and decide which should be printed individually. The back side of a contact sheet is available to record information about the photograph (such as, where, when, or how the pictures were taken). Contact sheets are made with 35mm-size negatives or 2¼″ x 2¼″ negatives most often.

To make a contact sheet, first position the enlarger housing near the top of its column so it projects a wide circle of light when turned on. Next, place a sheet of 8″ x 10″ printing paper, emulsion side up on the baseboard of the enlarger. No easel is used. Now position the negative strips on the photo paper, emulsion side down. After positioning, gently lower a clean sheet of heavy glass over both the negatives and paper to keep them flat and in tight contact with each other. Then make the exposure and develop like any other print.

Keep in mind that over an entire roll of negatives some may print light and others dark. The exposure of a contact sheet is based on density of the average negative on the roll. If you can tell what you shot reasonably well, then the contact sheet served its purpose.

Toning

Toning is a chemical process that converts the silver image in a black and white photograph into a colored image. The photograph is usually immersed in a liquid solution with the desired color toner. In some cases, selective toning may be done using a brush.

contact sheet

Color toners are available in several colors: brown, red, blue, yellow, green, and gold. A print may be toned first in one color and then in another to achieve intermediate shades. A photograph that is to be toned should be completely washed to remove any excess hypo. If fixer is not entirely removed from the photograph, it may cause the toned color to fade, or in some cases, it may cause stains that discolor the image.

To begin, mix the toner according to the instruction on the package. Pour the liquid toner in a clean tray. Be sure that the tray you are using is ultra clean—any contamination will cause the print to stain. Place the print in the tray and agitate. At normal room temperature, this will produce a tone in 3 to 5 minutes. The color of the print will look brighter after the print is washed and dried.

Toning for long periods of time (15 to 20 minutes) will cause the color to become brighter until all the remaining silver in the print is used up. However, as long as any silver remains in the photograph, the picture can be toned first in one color, and then in another.

It is possible to tone a small area of the print. You may decide, for example, that the lips in a portrait should be colored red, while leaving the rest of the photograph in black and white. This would give the print a surrealistic quality. To do this, a waterproof masking is applied to the areas that are not to be toned. Rubber cement may be used for the purpose of masking. If the print is to be immersed in the toner, the rubber cement will repel the chemical so that the uncovered area will be affected by the toner. Also, the toner may be applied with a brush. The rubber cement will prevent the toner from spilling over to areas not be be colored. The picture should be wet before applying the toner. Small areas may be dampened with the use of a cotton swab. Keep in mind that different portions of

normal print

careless handling of the print

the photographs can be toned with different colors. It is thus possible to make full color prints from black and white photographs by controlled toning.

After the print is toned, it should be washed in running water for 5 to 10 minutes to remove some of the excess color in the highlight areas. Longer washing time will weaken the color of the toned image as will a direct stream of water hitting the toned area. Toned photographs may be dried in the usual manner.

One final note—not all photographic papers are suitable for toning. Generally, the RC papers are not recommended. Check with the information sheet packed with the paper, or check the toner instruction sheet to see if it is advisable.

Problems in Printing

The photographs on these two pages illustrate problems that may occur in printing. The following are suggested ways to avoid them.

White cracks are caused by mishandling a wet print. Only touch the white border area of the print. Handle it carefully.

Out-of-focus prints have several causes. The paper may not have been in perfect contact with the negative in contact printing. Or, in enlarging, the negative may not have been focused properly, or the enlarger may have vibrated during the exposure. Make sure that the negative is in fine focus, and never touch the enlarger during exposure.

If a print becomes too dark in the developer, reduce the amount of exposure. If it turns completely black within a few seconds after it is immersed in the developer, cut the exposure time in half.

If a print is too light, increase the amount of exposure. If it is completely white after two minutes in the developer, double the amount of exposure.

If a white fingerprint shows up on a print, it may be caused either by a fingerprint on the negative or by handling the paper with

enlarger out of focus

overexposed

underexposed

contaminated hands

too flat

uneven development

muddy print

hypo on your hands. A dark fingerprint usually means the paper was handled with developer on the hands before exposure. Always keep your hands clean and dry.

A flat print has no pure whites or deep blacks. It results from using the wrong contrast paper. The contrast should be increased by at least one grade.

A muddy print has a very poor tonal range. Again, there are no strong whites or blacks, just an overall gray. Muddiness is usually caused by overexposure and by pulling the print out of the developer too soon. Readjust the exposure so that the print remains in the developer for at least 1½ minutes.

Black marks on a print are usually caused by deep scratches or pinholes in the negatives. Always handle your negatives with care.

White spots are usually caused by dirt or lint on the negative. Always clean your negative before making a print.

Uneven development indicates that the entire print was not immersed in the developer at the same time. Be careful to immerse the print all at once and to agitate it right away.

Presenting Your Photographs

By viewing other people's work, we judge how they see. We judge how they see a scene through their composition. We judge their craftsmanship by the way the photograph is printed. And we also judge the effort made to display their photograph. If the photograph is loose and unmounted, we have a good idea that the photographer didn't care about other people seeing his or her work or was just too lazy to do anything about it. If, on the other hand, the print is clean and well mounted, we judge the photographer with more respect. If you, the photographer, want other people to respect your work, you must respect it yourself. This section, therefore, will deal with the presentation of a photograph—the final touches.

After the print is in the wash water, check it to make sure that

dirty negative

matted print with borders

there are no white or dark spots on it. If the print is covered with lint, then go no further. It's time to remake the print. However, almost any print will have a few little white or dark spots on it. These spots can usually be taken care of by a technique known as "spotting." White spots on prints are usually the result of dust or fingerprints on the negative. Small white streaks on the print are usually due to light scratches on the shiny side of the film. Because dust, lint, fingerprints, and surface scratches on the negative prevent light from passing through, they appear white in the print.

In spotting a print, you add a mixture of black dye and water to the white area to make it blend in with the rest of the photograph. This dye is a commercial product known as SpoTone,® which is available in three different colors of black, numbers 1, 2, and 3. Numbers 1 and 2 are used for warm-tone paper; number 3 is for cold-tone spotting. Besides the SpoTone, you need a fine camel's hair brush (grade 0 or 00), a palette for- mixing, and a container of water.

The dry print is placed on a clean surface to avoid getting dirt on it. The water and dye are mixed on the palette with the brush. To make sure that the tone of black is about the same as the area surrounding the white, brush a small amount of it on a piece of blank white paper. Compare the color with the print. If it is too dark, then add more water to the mixture. If it is too light, then add more SpoTone. Once the proper tone has been reached, apply it to the white area. Application of the SpoTone to the print is not like painting a watercolor. It is not brushed on, but placed dot by dot over the white area. Care is important, because if the SpoTone spills over the confines of the spot, it looks worse. One other thing to avoid when spotting is getting too much moisture on the tip of the brush. In this case, the drop of SpoTone will again spill over the white area. Remember, SpoTone is permanent, so use only a little at a time. It cannot be removed if you add too much.

Black spots on prints occur because of scratches on the emulsion of the negative or air bubbles during film development. Black spots are usually more difficult to remove than white spots. To begin with, the black spot has to be bleached white. To do this, use a toothpick with cotton wrapped around it and dip it into ordinary laundry-bleach or farmers reducer. Apply the solution to the dark spot until it turns white. This will usually take a few applications. Once the spot is white, use the dye as described above to tone it back down to normal.

Mounting a Photograph

After the print has been spotted, it is ready for the final stage of presentation—fastening it to the mount board. The first reason for mounting a print is that a photograph is otherwise difficult to keep flat. A print that has curled is hard to look at, and trying to flatten it may crack the emulsion. Second, a photograph looks better if it is mounted on a stiff board.

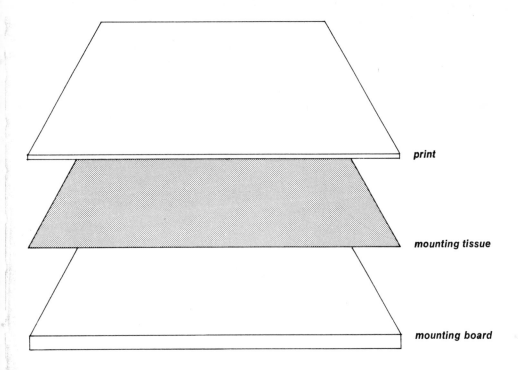

print

mounting tissue

mounting board

The Dry Mount Press. Dry mount tissue is usually a shellac-impregnated sheet that is placed between the photograph and the board. When pressed with even heat in the dry mount press, the shellac melts and forms a permanent bond between the photo and the board. Dry mounting must be done quickly and carefully. If normal photographic paper (not RC paper) is to be mounted, the temperature of the press should generally be set at 275°F. For RC paper, the temperature of the press should not normally be over 150°F. Be sure that the tissue you are using is designed for the type of photo paper that is to be mounted. Some tissue designed for RC will not work with regular fiber-base paper and vice versa. Check the manufacturers' instructions to see if the tissues you are using will work and at what temperature the press should be set.

After the temperature of the press has been set for the type of paper being mounted, attach the tissue to the back of the print, using a tacking iron. To begin, you place the print face down on a clean surface; lay a sheet of tissue on it, aligning at least two edges; and stick the tissue down with the tacking iron by making a short stroke in the center of the back. Then you trim off the white borders of the prints. It is important that none of the tissue extends beyond the photograph after it is trimmed. If it does, the photograph will stick in the dry mount press. Trim the photograph

when cutting off the white borders, use gloves to keep fingerprints off the print

when borders are desired, position mounting tissue before tacking tissue down

practice mounting unwanted prints

with a paper cutter or use a metal ruler and cut along its edge with a razor blade.

There are several ways to mount a photograph on a board. In the first method, the print is mounted on a white board so that white borders show (other colors can be used, although they generally distract from the photograph). First, place the trimmed print face up on the board. Space the print on the board so that the borders are about the same width on at least two sides. The print may have more space on the bottom than on the top. For a 5″ x 7″ print, for example, a good border would be about 3 inches on the top and sides and about 3½ inches on the bottom. After spacing, a corner of the photograph is lifted slightly and the tissue is stuck to the board with the tacking iron. Be sure that the iron never touches the surface of the print. If it does, the heat and the shellac left on the iron will ruin the photo.

The photograph is now ready to be inserted into the press. Place the board, print side up, on the pad of the press and cover the face of the print with a large, clean sheet of paper. It is important to cover the entire surface of the photograph with paper, since the print must never touch the heated metal of the press. The time that the press remains closed on the print will depend on the weight of the board, the press being used, the thickness of the cover sheet, and the type of tissue. Check the instructions on the tissue package and experiment a little. Generally, though, it is between 15 and 30 seconds.

Another popular method of mounting is called ''bleed-mounting.'' In this method, the white borders of the board are trimmed so that the edges of the board and the print are flush. After the print is mounted in the usual way, the borders of the board are cut off using a metal straight-edge (ruler) and a mat knife. Be sure you have a sharp blade, or your cut will be ragged. Do not attempt to cut through both the print and board in one stroke. Rather, use a series of light strokes until the excess border is separated. Don't try to pull apart a partially cut board as it will leave an unsightly rough edge.

Problems in Mounting

The problems that occur frequently in mounting are dirt particles under the mounted print, air bubbles, and the print not sticking to the board.

Dirt is the easiest problem to take care of. *Always* keep the print covered and carefully stored until you're ready to mount it. Don't let it sit on a dirty counter. If specks of dirt get trapped under the print after it's been mounted, they appear as little lumps in the surface. At that point, you can do little except try to press them down with the flat side of a fingernail. If you press too hard, you'll make a ''pimple'' on your print.

Air bubbles appear as blisters on the print. They are usually caused by moisture in the board. If the problem occurs often, place the bare board in the press for a few seconds before tacking the photograph down on it. As a remedy for those prints that do have air bubbles, you may try puncturing the bubble with a pin, through the back of the board, and reheating it.

Finally, if the print comes loose from the tissue, but the tissue is stuck to the board, it indicates that too much heat was used or the print was in the press too long. Usually the only solution is to remount the print on a fresh board.

Matting

Some photographers go one step further than just dry-mounting a photograph to a mount board. Not only will over-matting provide the print surface with more protection, it will also give the print a finished look. Thus, the viewer will have more respect for the photographer because of the extra time and energy spent in making the print a finished product.

The mat board used should be of high quality and cut to match the size of the board that the print is mounted on. Museum board or 100 percent ragboard is recommended since it will not yellow with age, nor will it cause stains on the print. These stains are caused by the acid contained in the mount, or mat board. Also, cheap board is usually made with a thin sheet of paper that covers a coarse cardboard center. The center is generally of a different color than the facing sheet and becomes highly visible and distractive when cut. Measure the borders from the dry mounted print, since this will be the size of the opening used for the over-mat. Next, transfer these measurements to the mat board by lightly marking in pencil the four corners of the opening. It is not necessary to make lines on the board.

The next step is to place the mat board on an oversized piece of thick cardboard, which should rest on a firm support like a counter top, or table.

Very simple tools are needed to cut a mat; a mat knife such as the type manufactured by X-ACTO (with a new blade), and a metal straight edge, like a metal ruler. The straight edge should be placed on the margins of the mat so that any mistakes made with the knife will affect the center area of the mat board being cut off. Align the straight edge with two of the pencil marks, remembering that each mark represents a corner of the opening. The knife can then be drawn along the straight edge using medium pressure. Do not attempt to cut through the board with one cut. So that the corners are sharp and free of the board fibers, be sure to cut precisely up to the corners. Continue this procedure until all four sides have been cut through the board. Do not attempt to push the center away from the board as this will cause a ragged edge. Instead,

measure dimension of the mounted photograph

cut the mat board with a razor knife and metal straight edge

check to see where the opening is still attached and use the knife to cut it apart.

The cut mat board may now be attached to the mount board. This is accomplished by using a cloth tape hinge. Lay the mounted print face-up next to the mat board face-down. The two boards should meet at their top edges. Next, place the cloth tape over the length of the separation. The mat board will now swing over the mount board forming a frame. Thus, the image of the print will reveal itself as though seen through a window.

Some experienced mat cutters prefer to make angle or bevelled cuts instead of the ordinary vertical cut. This requires that the knife be held at an angle when cutting through the mat board. There are some specially designed knives for making a bevelled edge. If you try to make a bevelled edge using a regular mat knife, remember to hold the knife at about a 15° angle from vertical. Don't try to cut at too steep of an angle, and practice on an old mat board.

In Focus/Printmaking

1. Select several well-exposed and well-developed negatives and print them on paper of at least three different contrast grades. Again, contrast is the comparison of values (light and dark) in a negative or print. Contrast in a negative is determined by exposure and development. An overexposed or overdeveloped negative is

too dark or dense. An underexposed or underdeveloped negative is too thin; it looks flat. In printing, low contrast prints are gray with few bright or dark areas; high contrast prints are mostly light and dark with few gray areas.

Personal preference can play a part in your decision to use a particular grade of paper. Assuming you start with a good negative, there may be no right and wrong contrast paper to use. Many decisions must be made in the darkroom with regard to the various interpretations of the individual negative. More of these variables will be dealt with in exercise two.

2. Print a few negatives until you feel that you are generally familiar with the steps involved in photographic printmaking. Select a negative that has given you a print which has areas that are very light and missing detail as well as areas that are so dark that the details are obscured. Review the section in this chapter titled Corrective Manipulations. Then try these techniques on the photograph you have selected. It will take some practice to find the best time range. In addition, you will need to practice blending the *burned in* and the *dodged* areas so that you do not have an obvious light spot or dark spot in your print. When these techniques are used skillfully, it should not be obvious in the final print.

How much you should *dodge* and *burn in* is a matter of personal preference. You should try different degrees of both techniques on the same negative so that you have four to six versions of the same print. Keep these for study and comparison along with notes on the exposure times for the various areas of the print.

3. Exercise one at the end of Chapter 5 (Film Development) gave instructions for varying the contrast of the *negative*. If you have completed exercise one, Chapter 5, you should print some of these negatives as well as some of the negatives from the roll of film that was exposed and developed normally. Make several sets of prints for comparison and future reference. Keep data on exposure, development, and printing on the back of each print.

Visual Aspects of Photography

<div style="text-align: right">

7

</div>

The goal of all photographers is to make a good photograph. What, however, are the elements that make a photograph good or bad? No two photographers will agree on all the elements that make a photograph good. You will find that many photographers, however, won't hesitate to point out what they consider a bad photograph. Therefore, it is sometimes hard to determine whether a photograph is good or bad. There is no single, complete, or uniform set of rules that serves as a foundation for judgments in photography.

We look to experts to tell us the difference between a good and bad photograph, or between an important or unimportant photograph. These experts may be friends who have had more experience in photography. More often, however, we base our judgments of good and bad, important and unimportant, on what we see in print. Thus, those pictures that are most often seen in newspapers, magazines, or books become important, or good, and become a basis of comparison for our own work.

Is this a fair method of comparison? Perhaps we are cheating ourselves, and limiting our own individuality by constantly comparing what we do to what has already been done. On the other hand, it's easy to say, "I like this photograph, it is good." It is just as easy to say, "I don't like this photograph, it is bad." In both cases, the viewer has made a judgment about a photograph. However, this type of judgment is only useful if the viewer adds, "I don't like this photograph because...", or "I like this photograph because...." The viewer is supporting his or her opinion by using the word, "because." Yet, before we can consider that opinion as a solid basis for judgment, we should try to understand some of the purposes and nature of photography.

In many regards, photography is similar to painting, or any of the graphic arts. This is because it is, for the most part, a two-dimensional visual medium. Like other artists, photographers usually want their pictures to be seen by other people. Thus, the photographer, like the writer, or the painter, is using photography as a form of communication. *What* they have to communicate, *why* they want it

A.L. Coburn

Edward Weston

Frederick Evans

communicated, and *to whom* they wish to communicate are just some of the questions that may help decide if a photograph is good.

If the book remains unread, or the photograph is unseen, then the communication is lost as a shared experience. Communication requires a sender, a message, and a receiver. It is presumed that the photographer has seen or created something he or she wants to share, and it is presumed that the viewer is willing to view it and thereby share that experience with the photographer.

Perhaps the more the viewer is able to share, empathize, or identify, the more he or she can "read" the photograph. Then, perhaps, that photograph is more successful. However, much is left up to the viewers. Are they qualified to view the photograph? Is any qualification needed? Are they basing their judgments on past experiences with the subject? What is the content of the photograph? Are the viewers sharing emotional ties with the contents? If the photograph is liked by many people, does that justify it being good? Can the photographer believe that his or her work is valid even if he or she is the only one who likes it?

If we, as photographers can define the purpose of our photographs, there will be a better chance for viewers to respond to them. If we, as viewers, understand more about the nature of photography, then perhaps our opinions will have more validity.

Although there is no dictionary of values for determining what makes a photograph good, a good photograph will probably have certain qualities that may either be technical or esthetic. The *technical aspect* refers to how the photograph was taken, printed, and presented. The *esthetic aspect* refers to the visual impact, appeal, importance, and type of photograph. These qualities may, and often do, overlap.

Jerry N. Uelsmann

Technical Qualities

If we assume that photography is a form of communication, then we can assume that the photograph has something to say. The clearer the message is stated, the more likely the viewer will understand it. You can liken this to watching a television set when the horizontal hold doesn't work. Who will sit in front of that for any period of time? Thus, the statement of the photograph will depend upon a certain amount of technique, which really begins before the shutter is snapped and eventually ends in the darkroom.

The photographer must always be in full control of the camera. The camera should serve as the tool of the photographer, not his or her master. To achieve the desired effect, for example, you must know the correct exposure in terms of f/stop and shutter speed. Depth of field, as another example, can be used to create either an indefinite plane of sharpness or one that gradually falls off into a blur. Without understanding the basic concepts, photography can become a haphazard venture. The taking of a photograph should not be accompanied by the supplication, "I hope this comes out," but rather the statement, "I know this will work." To reach that level of confidence, however, requires discipline. To become a skillful photographer you must have the discipline to work and experiment. Not that photography can't be fun; too much seriousness frequently leads to boredom and frustration.

In the darkroom, the photographer must know how to print, what grade of paper to use, and what exposure to give the paper. Technique, in itself, will not make a good photograph, unless the objective is perfecting the technique. For many people, "the message is the medium."

The educated viewer, in terms of pure craftsmanship, may base his or her judgments of your photograph on the following technical criteria: (1) the clarity of whites; (2) the richness of blacks; (3) intermediate gray tones; (4) the overall evenness of tonal scale; (5) the suitability of the grain for the image; (6) any presence or absence of mechanical blemishes; (7) paper surface; (8) contrast; (9) illusion of depth; and (10) mounting and finishing.

Taken one at a time, all of the above are simply a matter of discipline. If you spend time printing your photograph the way you interpreted your negative, then you probably will have good results. However, impatient novice photographers tend to shrug off one or two of these points with "Oh well, I've worked on this one long enough. I want to see what the others look like."

It could be argued that all of us take too many photographs; that the world is cluttered up with a mass of poorly exposed and poorly executed prints. There is some validity to that. We do take too many photographs, and we all want to see all that we took. Therefore, while we all want to see each photograph we take, we have to learn to be selective in what we print.

Perhaps after the film has been developed, you wait a period of time before printing. This allows you a bit more objectivity in your thinking. Of course, we all work differently; some of us shoot 36 pictures of 36 different subjects on a roll, while someone else may take 36 pictures of the same subject just to be sure of getting it down. One method is not better than the other. Some of us know people who print their negatives the same day they're shot, while other photographers may wait ten years to print. This is so sentimentality will not interfere with objectivity. The point is, whatever works for you is fine. In the last analysis, good technique should become as automatic as depressing the shutter button.

Walker Evans

Andrea Jennison

Esthetics

If technical ability is relatively easy to explain and understand, esthetic comprehension is just the opposite. While one may argue that a print might look better on a higher contrast paper, few, if any, will argue that the picture is a waste of film and paper. Both, of course, are opinions, and opinions are always subjective. Yet, subjectivity is often based upon one's experience at the time, whether it be personal, political, or problematical.

Many people have tried to pin a label on certain types of photography and photographers. The results have usually been to create a great deal of rhetoric that sometimes borders between the theatre of the absurd, and over-educated, pretentious gobbledygook.

Let us assume that certain, but rather broad, classifications do exist. For example, a photograph of Uncle Harry probably will not have the same universal appeal or visual impact as that of a photo-

graph of some natural disaster. Uncle Harry's picture is naturally important to you, as a member of the family, but how many other people will share your feeling? Probably not very many, unless Uncle Harry is a V.I.P. There is, however, a certain guarantee that the natural disaster photo will be in newspapers throughout the area. Which photograph are you going to keep? Uncle Harry's, of course. Which photograph, then, is the more important one?

Uncle Harry's picture is a snapshot. The natural disaster photograph is photojournalism. By far and away, the majority of the billions of pictures taken each year are snapshots. Snapshots are encouraged by all segments of the photo industry. In fact, you really can't go on vacation without a camera, for fear that you will feel guilty without it. Snapshots are essentially souvenirs for the photographer; records of places been, things that were done, events that were participated in, and most often, pictures of people like Uncle Harry.

Many times, snapshots are technically poor, although with today's automatic cameras, many more of them are technically excellent. Perhaps the only difference between the many snapshots and the many photographs that people consider art, is simply the matter of purpose, of audience appeal. There exists in snapshots a certain directness toward the subject. In many ways, the snap-shooter is free from the traditional boundaries that limit many photographers. The "formal values" that concern many photographers are of little or no concern to most snap-shooters. This is not an endorsement to go out and continue shooting unconsciously whatever appears in the view-finder of the camera. However, many snapshots do contain at least two elements that often get lost when the education process begins: directness of approach to the subject and a freshness that can just be awe or amazement that the picture came out great. Neither element should be forgotten.

Formal Values

Formal values may consist of some of these elements: (1) composition, (2) proportion, (3) focus, (4) balance, (5) rhythm, (6) texture, and (7) medium. When dealing with any camera image, it is important to remember that you are "translating" a three-dimensional subject into a two-dimensional representation. Thus, every photograph, regardless of subject content, is an abstract.

W. Eugene Smith

Karsh, Ottawa

Mark Jacobs

Mark Jacobs

F. P. Clatworthy

Edward Weston

Arthur Rothstein

You must become aware of the relationship between negative and positive space. All areas of a photo, shadow or highlight, geometric or free flowing, work together to create a feeling of design composition. In other words, after choosing your subject and deciding on the technical details, you have to come to grips with the visual impact that the photograph will produce. Consider its obvious visual attributes, such as shape and texture. By themselves, shape and texture may not create an interesting photograph. They can, however, create a pattern. Therefore, they become factors in the organization of a composition that will eventually determine the visual impact of a photo.

Bill Brandt

Perhaps then, the most formal of all formal values is composition. In a photograph, composition is the esthetic arrangement of shapes and space. However, there should be no rules concerning composition. Each photograph is made for a different purpose and by different people who see things differently. To quote one of the most formal of all photographers, Edward Weston, ''Now to consult the rules of composition before making a picture is a little like consulting the law of gravitation before going out for a walk.... When subject matter is forced to fit a preconceived pattern, there can be no freshness of vision. Following rules of composition can only lead to a tedious repetition of pictorial clichés.''

Alfred Stieglitz

Rhythm is the repetition of geometric shapes. The viewer's eye is lured into a photograph by whatever shape is being repeated. One photographer who often works with repeated shapes is Henri Cartier Bresson: "If a photograph is to communicate its subject in all its intensity, the relationship of form must be rigorously established. Photography implies the recognition of a rhythm in the world of real things.... In a photograph, composition is the result of a simultaneous coalition, the organic coordination of elements seen by the eye."

Bill Brandt

Balance and proportion are the relationship between objects in a photograph. Balance can be achieved very obviously, by having two identical shapes in a photograph. However, balance does not necessarily depend on exactly matching sizes and shapes. It may be helpful to think of a fulcrum that balances different size objects, which is essentially proportion. Two objects of different sizes, or proportions, will balance if the smaller one is further from the fulcrum. For extremely subtle balance of objects of different proportions, study the arrangement of objects in a mobile.

Focus is a definite factor that you can control. (There is no rule that pictures have to be sharp.) Try this experiment. Focus sharply on a subject and take a photo. Then turn the lens so that the image is slightly out of focus and take another photo. Try again, with the image completely out of focus. You may like one of the out of focus pictures better than the one that is sharp. If your picture is visually exciting, you've achieved part of the goal.

We now come to medium. The medium is the type of process used to make the photograph. At the moment, we have been talking about how to make silver prints; that is, a photograph made using standard photographic paper that contains silver. However, there are alternative methods one can use to make a photograph. For example, "Gumbichromate" is a process that was popular in the 1910s and 1920s. It does not require silver to reproduce an image. Also, one can manipulate a gumbichromate print by essentially moving around the emulsion. Another alternative is photo-silk screening, which is discussed in Chapter 12, "Special Processes and Techniques."

Finally, the best advice one photographer can give another is to go out and see other photographers' work. Make a point to go to the galleries and museums in your area and see the photographs of other people. As photographers, we do influence each other. That is good. It is impossible to steal anybody's ideas for very long. Sooner or later, your own personality will begin to replace those "borrowed" ideas. It is necessary, however, to see the work first. It is also necessary to show your work to others. Only then can you get feedback, and only then will you be able to accept or reject what advice is offered to you. In photography, like many other things, you'll get back as much as you put into it.

Edward Steichen

In Focus/Visual Aspects of Photography

1. Go through some magazines and find an example of a photograph in which a common subject has been shown in a new and interesting way through the unique viewpoint of the photographer.
2. As discussed in this chapter, the most formal of formal values is composition; that is, the arrangement and proportion of light and dark areas, shapes and textures within a photograph. When judging a photograph in terms of composition, the important concern may be that there exists a tension between round shapes and jagged shapes. These shapes could be people and buildings, or

rocks and tree branches. On a purely visual level, it does not matter whether the round shapes are human heads or rocks. It's their shape that is important.

Of course, we must also consider shapes on a more specific level, as faces or rocks, and our reaction to each will be different. However, most people have very little, if any, practice in seeing the world as a collection of shapes and tones to be arranged in an expressive way. Therefore, we suggest that you decide to shoot a series of photographs that deal with the following abstract themes:

a. rounded, organic shapes
b. mechanical shapes (straight edges)
c. a contrast of rounded, organic shapes and mechanical shapes working together in the same photograph
d. arrangements of different surface textures
e. emphasis on depth
f. emphasis on lack of depth
g. emphasis on stark contrast of light and dark
h. emphasis on subtleties of continuous tones

As you see, the combinations are almost endless. If you will train yourself to see the world in this way, you will be training your eye to see as a photographer does. However, remember that these are only suggested exercises, not formulas for good photographs. Use these exercises as a starting point for what we hope will be an original way of seeing things.

3. We have emphasized the importance of verbal feedback from photographers or other people working in the visual arts. Try to get together with others for the purpose of looking at each other's work and offering honest, constructive criticism.

Film and Filters

<div align="right">

8

</div>

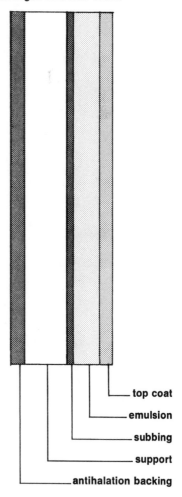

enlarged side view of film

Black and White

Photographic film is a relatively recent invention in the history of photography. For many years prior to the introduction of film in 1887, glass plates were used instead. In fact, many scientists and technicians today still use photographic glass plates for special purposes. The photographic films available today are the result of much research and are very different from the earlier types. Every roll of film has at least five layers, as shown in the enlarged cross-section in the illustration on the right.

The first layer is known as the topcoat. It is a protective layer of hard gelatin that helps protect the emulsion from scratches or other foreign substances.

The second layer, the emulsion, usually contains light-sensitive silver bromide and silver iodide. These light-sensitive particles in the emulsion layer are made more so by the addition of certain sensitizing agents. Upon exposure to light and chemical development, the silver is reduced to fine particles of silver metal that look black.

The third layer, the subbing, is a glue-like substance that holds the emulsion layer to the base. In the past, many unusual materials were used for this purpose. One of the most popular subbing materials was egg white (albumen).

The fourth layer, the support or base of the film, is generally a plastic, usually a cellulose acetate. Its purpose is to provide a transparent and flexible foundation for the emulsion. At one time the support was made out of nitrocellulose, a highly flammable early plastic. Nitrocellulose was commonly used in early motion picture films, resulting in frequent fires.

top coat

emulsion

subbing

support

antihalation backing

The fifth and last layer is the antihalation backing. The purpose of this layer is to prevent light from reflecting off the support layer or the back of the camera itself during exposure. If these reflections were not eliminated, light areas on the film would have halos around them, which would reduce the sharpness of the image. The antihalation layer appears as the bluish or grayish color on one side of the film. Both the antihalation backing and the topcoat layers are dissolved away during processing.

Characteristics

Film has at least six characteristics: (1) color sensitivity, (2) speed (ASA), (3) grain, (4) contrast, (5) latitude, and (6) resolving power. Black-and-white emulsions are classified into three groups in their ability to differentiate between colors—blue-sensitive, orthochromatic, and panchromatic. Blue-sensitive film uses the pure state of the silver bromide, which makes the emulsion sensitive to light. Blue-sensitive film is sensitive to blue and ultraviolet light. It is high in contrast, which makes it useful for copying manuscripts, drawings, and other materials that do not have a long tonal range.

Orthochromatic film is sensitive to green light, as well as to blue and ultraviolet. However, orthochromatic film is not sensitive to red. If a red object such as a fire hydrant were shot with orthochromatic film, it would appear as a black tone in the photo. Because ortho emulsions are not sensitive to red, they can be handled in red safelight illumination. Most black and white photographic papers are orthochromatic.

Panchromatic film is sensitive to all the colors of the spectrum. Because it is sensitive to all colors, it gives the most natural-looking interpretation of color in terms of black and white tonal scale. In almost all cases, the films that you have been using are probably panchromatic. To summarize, panchromatic films are sensitive to all colors, orthochromatic films are sensitive to all but red, and blue-sensitive films are sensitive to only blue and violet light (plus radiation).

Speed, the second characteristic of film, is the sensitivity of film to light. Speed is measured on a numeric scale and is referred to as the *ASA*. The higher the speed, or ASA number, of the film, the more sensitive it is to light. The lower the ASA number, the less sensitive the film is to light. For example, the ASA of Kodak's Tri-X® is 400. The ASA of another Kodak film, Plus-X,® is 125. Therefore, Tri-X® is "faster" than Plus-X®; that is, it requires less light for exposure. The faster the film, the less light needed for exposure.

There is a definite correlation between the ASA rating numbers. Suppose we start with a base ASA of 25. ASA 50 would be twice as fast as ASA 25. ASA 100 would be twice as fast as 50 and four times as fast as ASA 25. This is the same type of correlation that exists between shutter speeds, and *f*/stops. For example, given a certain lighting situation, let us presume that using an ASA 50 film at *f*/5.6 with a shutter speed of 1/125 will produce a correct exposure. If an ASA of 100 instead of 50 were used, the correct exposure

would be *f*/8 at 1/125 or *f*/5.6 at 1/250. In the case of the *f*/stop, you have to decrease the amount of light by one stop (half the amount of light) in order to get a correct exposure when the ASA is doubled. This, in turn, will increase the depth of field. In the case of the shutter speed, we have increased it by one speed; that is, we are allowing half as much light to pass through the lens. The result of this is that the subject will be frozen in action. Whenever a smaller lens opening is preferred for more depth of field, or a quicker shutter speed is desired to freeze action, a higher ASA film should be used.

There are other ways to rate film speed. The German system—DIN—is rarely used in the United States. ISO is an international standard and is numerically the equivalent of ASA speed numbers. For example, a film with an ISO of 400 is the same speed as ASA 400. ISO speed numbers are also assigned for DIN numbers. DIN film speeds identified under the ISO standard have a degree sign (°) by the number. For example, ISO (ASA) 64 speed is given as 19 DIN or ISO 64/19°.

The following table is for converting ISO (ASA) speeds to ISO (DIN) speeds.

ISO (ASA)/ISO (DIN) Film Speeds

ISO (ASA)	ISO (DIN)	ISO (ASA)	ISO (DIN)
6	9°	160	23°
8	10°	200	24°
10	11°	250	25°
12	12°	320	26°
16	13°	400	27°
20	14°	500	28°
25	15°	640	29°
32	16°	800	30°
40	17°	1000	31°
50	18°	1250	32°
64	19°	1600	33°
80	20°	2000	34°
100	21°	2500	35°
125	22°	3200	36°

Grain, the third characteristic of film, refers to the bunching or clumping of the reduced silver portions in the emulsion during development. Grain exists in all photographs. A "grainy" print is one in which the clumping of the silver particles is very noticeable. However, certain rules can be followed to control graininess. First, the higher the ASA of the film, the grainier it is. When image

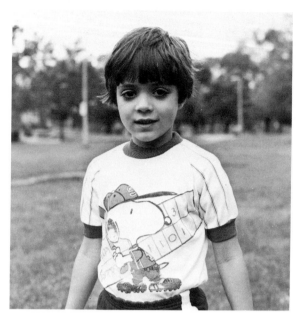

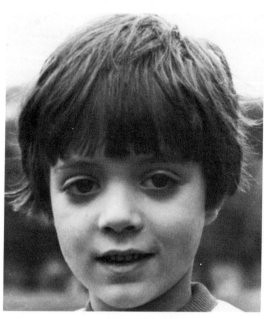

full negative enlargement

extreme cropping from same negative

smoothness is essential, use a slower (lower ASA) film. Second, overexposure and overdevelopment contribute to graininess. Third, enlarging an image to a high magnification will cause grain to be seen more readily. This is why cropping is not recommended. A 5″ × 7″ print made from a 35mm negative looks very good. However, if that same negative were enlarged to 16″ × 20″ size, it might look like sandpaper. Fourth, graininess is also controlled by the type of film developer used. Some developers are made to be used with fine grain films, while others produce very harsh grain.

The fourth characteristic of film is contrast—the ability of the film to distinguish between the tones or values of gray. Some films are high in contrast and are used only to copy line drawings or manuscripts. Most films that you will be using can reproduce a wide tonal range.

The fifth characteristic is *latitude.* Latitude, or exposure latitude of a film, is the range of camera exposure from underexposure to overexposure that will produce a negative capable of producing a picture of acceptable quality. In other words, exposure latitude is the amount of deviation from the correct exposure that will produce decent pictures. Latitude depends on the type of film being used, the subject brightness, and the criteria of the photographer. You always obtain the best quality with any film when your exposure is correct. However, negative films generally have greater latitude for overexposure than for underexposure.

The sixth characteristic is called *resolving power.* The ability of a film to record fine detail is referred to as resolving power. Resolving

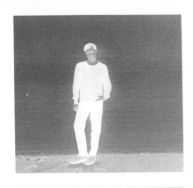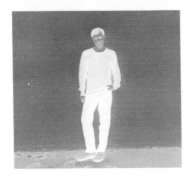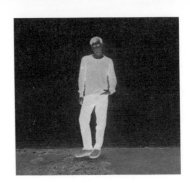

**underexposed negative
and resulting print**

**normal exposed negative
and resulting print**

**overexposed negative
and resulting print**

power is measured with the use of a parallel line test chart. The chart is first photographed at a great reduction in size. The lines of the test chart are separated by spaces of the same width. The negative is then examined under a microscope at a certain pre-determined magnification, and the number of lines per millimeter that can be seen as separate lines are then counted. Lines closer together than this number (in other words, more lines per millimeter) are indistinct from each other on the film and appear as a mass of gray.

The resolving power of the film is altered by incorrect exposure. This is one reason to have properly exposed negatives. Because resolving power is measured by the eye, it is subject to some variation depending on the person making the measurement. By looking at the data sheet packed with the film, one can determine what the resolving power of that film is.

Resolving Power Reference	
Resolving Power	*Lines per mm*
Ultra High	630 or above
Extremely High	250 to 500
Very High	160 to 200
High	100 to 125
Medium	63 to 80
Low	50 or below

Film has other characteristics: *definition* and *sharpness.* Briefly, the term definition in photography refers to the overall appearance of detail. Sharpness is a factor in determining definition, and describes the appearance of edge sharpness between details.

The factors that affect definition are sharpness, resolving power, and grain. As a general rule, resolving power and sharpness increase as graininess decreases. To insure maximum definition when taking the picture one should remember the following points: (1) Expose correctly, as overexposure increases graininess; (2) Hold your camera steady, or use a tripod to reduce camera movement; (3) Focus carefully; and (4) Use a high-quality lens that is free of fingerprints and dirt. To insure maximum definition when printing a photograph, these points should be realized: (1) Use a high quality enlarger lens free of fingerprints or dust; (2) Make sure that the enlarger doesn't vibrate when making the exposure; (3) Choose a smooth surface enlarging paper; and (4) Print on a paper grade that will not cause excessive or low contrast.

Sharpness is the visual impression of good edge contrast between details. There are several factors that affect sharpness. They are the thickness of the emulsion, the thickness of the film base, the type of emulsion, and the type of antihalation backing employed in the film. Sharpness measurements are made by the manufacturer of the film, although the sharpness of some films can be increased when developed in diluted developers. This is one reason why many photographers favor using D-76 1:1.

The science of sensitometry is related to the study of film characteristics and exposure. If you are interested in this field, there are many fairly technical reference books on this subject.

Brands of Films (Black and White)

There are many different film manufacturers both in the United States and abroad. Because film is constantly being improved and changed, it is wise to check the information sheet packed with each individual roll to obtain the newest data about a film. The following is a list of the more popular black-and-white roll films manufactured by Eastman Kodak, Ilford, and Agfa. The descriptions following are based on manufacturers' published information and do not represent an endorsement of any product.

Kodak Panatomic-X Film and Kodak Panatomic-X Professional Film

An extremely fine grain panchromatic film (ASA 32) with very high sharpness. It has adequate speed for many picture-taking situations. This is an excellent film to use when you want prints made with a very high degree of enlargement. With special processing, the 135-size film will produce positive black-and-white slides.

DEFINITION

Graininess	Resolving Power	Sharpness
Extremely Fine	Very High	Very High

Kodak Verichrome Pan Film

A fast panchromatic film (ASA 125) with extremely fine grain. Its excellent gradation and wide exposure latitude make it ideally suited to most picture-taking situations. It is the first choice among black-and-white films for general use in most types of roll-film and cartridge cameras—from simple cameras to the most advanced models.

DEFINITION

Graininess	Resolving Power	Sharpness
Extremely Fine	High	Very High

Kodak Plus-X Pan Film

A general-purpose panchromatic film (ASA 125) for 35mm cameras that offers the optimum combination of a fast speed, extremely fine grain, and excellent picture sharpness even at high degrees of enlargement. It's ideally suited to most picture-taking situations.

DEFINITION

Graininess	Resolving Power	Sharpness
Extremely Fine	High	Very High

Kodak Tri-X Pan Film

A high-speed panchromatic film (ASA 400) with fine grain and excellent sharpness. Its high speed makes it especially useful for photographing dimly lighted subjects, such as those in existing light; fast action; subjects requiring good depth of field and high shutter speeds; and for extending the distance range for flash pictures.

DEFINITION

Graininess	Resolving Power	Sharpness
Fine	High	Very High

Kodak Royal-X Pan Film

A panchromatic film (ASA 1250) for 120-size cameras that has extremely high speed and medium grain. Use Royal-X Pan Film for situations where the highest film speed is essential, such as for taking action photographs by existing light, for taking pictures in interiors of buildings when you need the shortest possible exposure times, or for obtaining adequate depth of field under poor lighting conditions.

DEFINITION

Graininess	Resolving Power	Sharpness
Medium	Medium	Very High

Kodak Recording Film 2475 (Estar-AH) Base

An extremely high-speed panchromatic film (ASA 1000) for 35mm cameras that has extended red sensitivity and coarse grain. Use this film in situations where the highest film speed is essential and fine grain is not important to you, such as for taking action photographs when the light is extremely poor, for taking pictures in interiors of buildings when you need the shortest possible exposure times, or for obtaining adequate depth of field under poor lighting conditions.

DEFINITION

Graininess	Resolving Power	Sharpness
Coarse	Medium	Very High

Kodak Technical Pan Film 2415

This is a variable-contrast panchromatic film designed for making reduced (35mm or smaller) copy negatives of printed matter, such as books, newspapers, maps, documents, and similar originals. For pictorial photography this film has the potential for great size enlargements if developed in a special developer to lower contrast.

DEFINITION

Graininess	Resolving Power	Sharpness
Extremely Fine	Extremely High	Extremely High

Kodak High Speed Infrared Film (2481)

A moderately high-contrast, infrared-sensitive film that has high speed and fine grain. With a red filter, it gives striking and unusual effects. This film is commonly used for distant landscape photography to show detail ordinarily obscured by atmospheric haze. It is also useful in aerial, scientific, industrial, legal, and documentary photography, and in photomicrography.

DEFINITION

Graininess	Resolving Power	Sharpness
Fine	Medium	Medium

Ilford Pan F

Pan F film is an extremely fine grain panchromatic emulsion (ASA 50) which is recommended for artificial light and daylight photography, particularly where sharpness and lack of grain are more important than film speed. Similar to Kodak Panatomic-X.

DEFINITION

Graininess	Resolving Power	Sharpness
Extremely Fine	Very High	Very High

Ilford FP4

Ilford FP4 films are exceptionally fine grain medium-contrast panchromatic films with a speed rating of 125 ASA to daylight. FP4 films have a high acutance emulsion and exposure latitude. Similar to Kodak Plus-X.

DEFINITION

Graininess	Resolving Power	Sharpness
Extremely Fine	High	Very High

Ilford HP5

HP5 is a fast black and white film. When given standard development it has a rating of 400 ASA 27 DIN to daylight. HP5 has the fine grain, excellent edge contrast and sharpness to give high image quality.

DEFINITION

Graininess	Resolving Power	Sharpness
Fine	High	Very High

AGFA Agfapan 25 Professional

A slow negative film of extra fine grain and outstanding definition; particularly suitable for rendering subjects rich in detail.

DEFINITION

Graininess	Resolving Power	Sharpness
Extremely Fine	Very High	Very High

AGFA Agfapan 100 Professional

A universal, high-definition and fine grain film with good processing latitude specially suited for flash.

DEFINITION

Graininess	Resolving Power	Sharpness
Extremely Fine	High	Very High

AGFA Agfapan 400 Professional

A high-speed film for available-light photography; recommended for occasions demanding short exposures (such as, sports photography).

DEFINITION

Graininess	Resolving Power	Sharpness
Fine	High	Very High

screwing a filter into the front diameter of a lens

Filters and Light

Although all panchromatic films are sensitive to every color in the spectrum, they are more sensitive to certain colors. Because of this, filters are used to lighten or darken objects of a particular color.

A filter is usually a colored piece of glass that is placed in front of the lens. Usually, it screws into the diameter of the lens. Like any filter, it absorbs what is not wanted and passes or transmits what is wanted. Understanding filters requires some knowledge of the behavior of light. Light is radiant energy that travels in waves. In visible light, the longest wave is red, the middle length, green, and the shortest violet. With those wavelength groups are the various hues of red, orange, yellow, green, and blue. If there are no waves, then there is no light. When all the waves travel together, the result is white light.

In a way, any object we see as having color is acting like a filter, because it is absorbing part of the white light. The color we see is part of the light that is reflected back to us. For example, a red apple seems to be red because it absorbs blue and green light and reflects red light. Yellow paper looks yellow because it absorbs blue light and reflects both green and red. The table that follows lists certain types of color as they appear in white light and colors of light that are absorbed.

Color seen in white light	Colors of light absorbed
red	blue-green
green	red and blue
blue	red and green
yellow (red plus green)	blue
magenta (red-blue)	green
cyan (blue-green)	red
black	red, green, blue
white	none
gray	equal portions of red, green, blue

Understanding filters is quite easy once you understand the principle that they always *subtract* some of the light from a scene. Remember that you are dealing with negative-positive relationships. When a filter absorbs a color, the area of that color will appear to be lighter in the negative. However, when the negative is printed, that color will appear darker.

128

no filter *red filter* *green filter*

Filters that are used for black-and-white pictures can be classified into three groups: (1) correction filters, (2) contrast filters, and (3) haze filters. Although panchromatic film is sensitive to all the colors of the spectrum, it is not sensitive to all of them equally. For instance, blue sky generally prints out to be very light in tone. To compensate, use a correction filter, which changes the tonal response of the film so that all colors are photographed at about the same brightness values as the eye originally saw. The most popular correction filter is a medium yellow (No. 8). A photograph, taken with a yellow filter, reproduces the clouds as they were seen in their relative brightness values. They appear "bolder" because the blue sky appears darker. The yellow filter absorbed some blue light, thereby making blue appear darker in the print.

A contrast filter can either increase or decrease (lighten or darken) the contrast between colors. To make an object appear lighter than it is, use a filter that is the same color as the object. To make an object appear darker than it really is, use a filter that will absorb the color of the object. For example, compare these three black-and-white photographs of a red flower against green leaves. In the first photograph, no filter was used. Both the red and the green appear about the same tone of gray. In the second photograph, a red filter was used. A red filter transmits red light and absorbs green. Therefore, the red flower appears light while the color green, which was absorbed by the red filter, appears dark in the print.

photograph made using No. 8 (medium yellow) filter

photograph made using No. 29 (deep red) filter

130

In the third photograph, a green filter was used. Green absorbs red light, thereby making the red flower appear darker than the green leaves. Keep in mind that a filter transmits its own color, making that color lighter. To make a color darker, use a filter that will absorb that color. Refer to the chart to help you select an appropriate filter.

Contrast filters are also used to darken the sky. The medium yellow (No. 8) filter is used to reproduce the sky as your eye would see it if you saw things in black and white instead of color. The deep yellow (No. 15) filter will make the sky seem even darker than it normally appears. For even more dramatic effects, a medium red (No. 25) filter can be used. A deep red filter (No. 29) will make the sky almost black.

When you photograph landscapes in the distance or from high altitudes, the picture tends to lose a certain amount of detail. This is caused by the bluish atmospheric haze that is caused by very small particles of dust and water vapor. The haze scatters ultraviolet light to which film is very sensitive although the eye cannot see it. To reduce atmospheric haze when photographing, you can use haze filters to filter out some of the ultraviolet light. The amount of haze is decreased with the following filters: No. 8 (medium yellow), No. 15 (deep yellow), No. 25 (medium red), and No. 29 (deep red).

with polarizing filter

One filter that can be used to eliminate both haze and reflections or glare is the polarizing filter. As light is reflected from nonmetallic surfaces, it is polarized. That is, the light vibrates in only one direction. The light from the sky is polarized because it is reflected from nonmetallic particles in the atmosphere. The polarized filter removes glare by stopping the path of the polarized light. The angle of the light source is important when using a polarizing filter. To get the maximum effect from such a filter, the angle at which you view the reflecting light must be equal to the angle at which the light strikes the reflecting surface. For instance, if the sun were at approximately a 60° angle from a scene, you would get maximum effect with the polarizing filter if you took the picture at a 60° angle.

Most polarizing filters are double-threaded. One thread screws into the camera, while the other one lets you rotate the filter. If the camera you are using is not a single-lens reflex or view camera, place the filter to your eye and rotate it until the desired effect is obtained. Note that a marking on the filter, usually a white dot, is used to indicate the position of the rotation. After the desired effect is produced, place the filter on the camera, making sure that the marking is in the same position. If you have a single-lens reflex camera, you can see the effect by looking through the viewfinder while you rotate the screen.

without polarizing filter

The polarizing filter is useful when photographing water, glass, or most other shiny surfaces. The reflections are eliminated, allowing more detail to be seen.

Filter Designations for Black and White Films

Recently, the designation system used to identify filters was changed from a letter code (like K2 for medium yellow, A for red), to a numerical code. Below is a conversion chart since you will probably encounter both designations.

Current Designations	Old Designations
No. 6	K1
No. 8	K2
No. 11	X1
No. 15	G
No. 25	A
No. 47	C5
No. 58	B

Filters for Black & White Film

Filter Type	Color or Description	f/stop Increase		Applications
		Daylight	Tungsten	
No. 8 (K2)	Yellow	1	2/3	Renders an accurate tonal reproduction of daylight scenes as the eye sees them. Natural rendition of contrast between sky and clouds, flowers and foliage.
No. 11 (X1)	Light Green	2	2	In portraiture, renders an exact tonal reproduction of skin as the eye sees it. Increases contrast between blue sky and clouds; lightens foliage and darkens flowers.
No. 15 (G)	Deep Yellow	1-2/3	1	Emphasizes contrast between blue sky and clouds, increases brilliance of sunsets. Special applications in architectural photography.
No. 25 (A)	Red	3	2-1/3	Darkens blue sky to create spectacular contrast with clouds, simulates moonlight scenes in daytime with slight underexposure, increases contrast between foliage and flowers. Special applications in document copying and with infra-red film.

132

Filter Factors

Because filters absorb some light, you must increase the exposure to compensate. The number by which you multiply the exposure is called the filter factor. If a filter has a factor of 2, you must either double your exposure time by decreasing your shutter speed by one speed or open the lens one stop. For example, a yellow filter has a factor of 2. If the proper reading without the filter were 1/250 at f/8, then with the filter it would be either 1/125 at f/8 or 1/250 at f/5.6. Generally, it is best to change the f-number rather than the shutter speed. If two filters are used together, the filter factors are added together. For example, the filter factor of a yellow (No. 8) is 2. The filter factor of a polarizer is 3. If both are used together, your factor will be 5. You should then multiply your exposure time by 5 or increase your lens opening by 2-1/3 f/stops.

Filter factors depend on the type of light and the film being used. The deep yellow (No. 15) filter has a daylight factor of 2.5 with Kodak Plus-X® film. However, when you use artificial light (tungsten), like that from photofloods, the factor is 1.5. The reason for this is that sunlight contains more ultraviolet and blue light than photofloods give out. Therefore, outdoors in sunlight the deep yellow filter absorbs a greater portion of the light, and additional exposure is needed to compensate for this loss.

If your camera has a through-the-lens metering system, you generally do not have to figure filter factors. Most meters of this type read the light after it has already passed through the filter; the exposure reading is therefore based on the reduced amount of light.

However, with some filters, usually the polarizer, the built-in meter may require some correction in the film speed. Therefore, if in doubt, check with your instruction book or write the manufacturer. The address can be found in Chapter 11, "The Camera."

The following chart is a conversion table that lists the equivalent f/stop corrections for filter factors.

Filter Factor	f/stop	Filter Factor	f/stop
1.2	+1/3	5	+2-1/3
1.5	+2/3	6	+2-2/3
2	+1	8	+3
2.5	+1-1/3	10	+3-1/3
3	+1-2/3	12	+3-2/3
4	+2	16	+4

Chromogenic Black and White Film

Unlike standard black and white film, chromogenic films employ chemical dyes rather than silver compounds to form the negative image. Chromogenic film emulsion contains both silver-halide crystals (like regular black and white films) and dye couplers (as in color negative film). During processing, the developer (which is actually the same as for color negative film) becomes exhausted from working on the exposed silver-halides which, in turn, activate the dye couplers. Next, these activated couplers produce a dye density, creating layers on the film according to the amount of silver halides that have been exposed and processed. After the dye layers are created, the remaining silver is bleached out. Thus, unlike a standard negative, the chromogenic negative is silverless.

Photographers who like chromogenic films claim they produce finer grain and sharper negatives with longer tonal ranges than conventional films. One interesting quality of chromogenic film is the ability to change the ISO/ASA rating from exposure to exposure. For example, the first exposure can be shot at ASA 400, the second at ASA 100, and the third at ASA 800. While all the negatives remain printable, the slower speeds tend to produce the best negatives.

The processing steps needed to develop chromogenic films are the same as those for color negative films. Thus, their processing temperatures (about 100°F) and times are more critical than for standard black and white films. Currently, two chromogenic black and white films are made, Agfa's Agfapan Varo-XL and Ilford's XP-1.

Bulk Loading Film

Bulk loading your own film has two main advantages: it is less expensive than buying prepackaged film and it allows a choice of different exposure lengths. For example, you can load a 5, 10, or 25 exposure length into a cassette depending on your need.

In order to bulk load film, you will need a daylight bulk-film loader, reusable film cassettes, scissors, masking tape, and bulk film.

Bulk film is made in different lengths, the most common being 27½-, 50-, and 100-foot rolls. One hundred feet of film is equal to about 18 rolls of 36 exposure film. The longer the bulk-film length, the greater the savings.

A bulk-film loader is a light-tight container that allows the bulk-film to be loaded and spooled into empty, reusable film cassettes in normal room light. Different models offer slightly different features.

The reusable film cassette looks like any other type of film cassette. However, the ends of the reusable cassette either screw on or pop off, while the ends of packaged film cassettes peel apart to open.

Cleanliness is necessary when using bulk film. Any piece of dirt or sand on the felt side of the cassette can scratch an entire roll of film as it is being loaded onto the film spool. A fleeting light leak will fog an entire roll. To compound problems, neither problem will be known until the film is developed.

a 35 mm cassette

To prevent these problems, be sure that the inside of the loader is clean before installing a roll of bulk film into the chamber of the loader. Compressed cans of air can blow the dust from the felt on both the loader and the empty film cassette. Also, empty cassettes should not be used more than five times since it is inevitable that they will pick up some dust.

The steps for bulk loading vary somewhat from brand to brand of bulk loaders, so read the manufacturer's instructions. Here are some general guidelines to follow:

1. Unwrap the package of bulk film in total darkness, and drop the film into the chamber designed for it in the bulk loader.

2. Pull the end of the roll through the light trap in the loader so that the film sticks out to the compartment where the film cassette fits.

3. Close the top of the loader (usually the top will screw on). Room light can be turned on after closure.

4. Take apart the cassette, and tape the end of the bulk film to the spool with masking tape.

5. Reassemble the cassette. Make sure the ends of the cassette fit tightly on the cassette shell.

6. Be sure the cassette fits properly in its compartment. Close the compartment door.

7. Put the knob on the loader in place.

8. Turn the knob slowly. The spool inside the loader will begin to rotate. The number of times the knob is rotated determines the length of the roll. On most loaders, one turn indicates one exposure. Some loaders have frame counters.

9. Once the film length has been loaded, remove the cassette from the loader. Cut the exposed end of the film into a curved shape to form a film leader. Remember, the beginning and end of each roll of spooled film was exposed to light. Therefore, waste a couple of shots at the beginning of each roll and don't shoot the last two frames. If you loaded a 20-exposure length of film, only use 18.

Storage and Care of Film

Photographic films are highly perishable products and can be damaged easily. Some of the characteristics of film such as speed, contrast, and fog level change gradually after manufacture. Adverse storage conditions accelerate these changes.

For best results, handle and store unprocessed film with adequate protection against heat, moisture, and harmful gases before and after exposure. Unprocessed films must be protected from x-rays and radioactive substances.

Protection from Humidity. Film is usually supplied in special packaging which protects it from high humidities. Do not open a package of film until you are ready to use it. Otherwise, the protection originally provided is no longer effective.

Protection from Heat. Special packaging around film is not heatproof. Do not leave films near heat registers, steam pipes, radiators,

or any other sources of heat. When you are traveling in a car, do not leave your film in a closed car parked in the sun on a warm, sunny day. The temperature can quickly reach 140°F or more.

The coolest area in a car for protecting your film from sun heat is in the passenger compartment with the air conditioner on or the windows open, especially when the car is moving. The best location is on the floor in the shade away from hot areas over the exhaust system. Never keep film in the glove compartment or in the rear window shelf or in areas of direct sunlight inside the car.

Protection from X-rays. X-ray equipment can fog unprocessed film when the radiation level is high or the film receives several low-level doses. The effect of exposure to x-rays is cumulative. Film that has been processed is not affected.

If you travel by commercial airlines, your luggage may be subjected to x-rays each time you board the aircraft. Also, all carry-on luggage is x-rayed.

To avoid x-ray, hand carry your film and ask that the film be visually checked rather than x-rayed. Also, a special lead bag is made to protect film from this type of damage.

Expiration Date. You should expose and process film before the expiration date printed on the package. Films kept beyond this date, without special treatment (see Long-Term Storage) may be unsatisfactory due to changes in the speed, contrast, and fog level.

Long-Term Storage. For storage over long periods of time, try to maintain the following storage temperatures:

Storage Period	2 Months	6 Months	12 Months
Temperature	75°F	60°F	50°F

In Focus/Film and Filters

1. In this exercise you will shoot films with two different sensitivities to light (ISO/ASA ratings). Buy two black and white films of the same brand, for which you can use the same developer. The only difference in the films should be their sensitivity to light. Try to use films with a rather large difference in ISO/ASA ratings, such as ISO/ASA 25 and ISO/ASA 400. After you have exposed and developed both rolls, print a few shots from each roll. The prints should measure 8" x 10" or 11" x 14". There should be a difference in the grain pattern when photographs from the two rolls are compared. The photographs from the higher ISO/ASA film will have a grainy appearance while the photographs from the lower ISO/ASA film should have a much finer grain pattern and a greater tonal range.

 As you may have noticed as you shot the pictures for this assignment, the higher ISO/ASA film allows you to take pictures with less available light than the lower ISO/ASA film. When both films are used in the same available light, the higher ISO/ASA

film allows you to shoot at a faster shutter speed at a smaller f/stop. At the same time, the higher ISO/ASA film will produce photographs which have more contrast and less resolution.

2. Shoot a roll of black and white film outdoors on a sunny day. Some pictures should be shot with a medium yellow (No. 8) filter, some with a medium red (No. 25) filter and some with no filter. Make the sky a prominent part of all the photographs.

You will notice a very clear difference in the appearance of the photographs made in each category, especially in the sky area. The yellow filter will produce a darker sky when compared to photographs taken without a filter. As explained in this chapter, this darker sky tone caused by the yellow filter is really closer to the sky tone as seen by the eye. The red filter will produce an even darker, more dramatic sky than the yellow filter. If clouds are present, they will remain very light against the dark sky. This is only one of many applications of the use of filters with black and white film. You may want to photograph a variety of subjects in the same three ways in order to study the effects that are produced. Remember that if you do not have a through-the-lens metering system, you must make a correction in your exposure in order to compensate for the light that is absorbed by the filter. See "Filter Factors" in this chapter.

Light

We are able to see because of the presence of light. The more light available, the brighter an object appears. Without light, we are blind. Light also makes photography possible. When light is recorded on film, an image forms. Whether that image is abstract or realistic depends on the photographers control of light. By controlling that light, he or she is free to determine expression and impressions in a scene. You, as a photographer, can use light to communicate atmosphere and mood. You can establish an interrelationship of patterns and forms within the boundaries of a photograph. You can begin to realize the full potential of the art of photography.

Natural Light

The way a subject appears to us, and to the film, is directly influenced by the quality of the light that is illuminating it. When a light condition changes a scene, the photographer, if aware of that change, may see a new range of photographic possibilities, even if it is a scene he or she has seen many times before. Light then, is never stable, it is always changing from second-to-second, minute-to-minute, hour by hour. The photographer who is aware and sensitive to these ever-changing conditions will not only be able to see a more exciting world, he or she will be able to photograph it.

All light has certain fundamental pictorial qualities. By natural light we are referring to light that may fall into several different qualities: (1) direct light, (2) directional-diffused light, (3) diffused light, and (4) silhouette or back-light.

Direct lighting generally occurs when light is hitting the subject from one angle. The light source is thus pinpointed toward the subject. It creates a hard-edged effect that may leave the shadow areas void of any details. In a portrait, this effect may be thought of as being dramatic, or bold. Often times, a clear, bright sunny day, either early in the morning or late in the afternoon, will produce a direct-light quality, leaving a high-lighted area surrounded by dark shadows. *Directional-diffused light* has some of the quality of direct light, in addition to light that has been scattered or diffused. While a directional-diffused quality of light appears to come from

direct light

139

direct-diffused light

diffused light

one direction, it also includes shadow areas that are softer, less hard-edge than direct light. Details in the shadow areas of direct-diffused images can be seen, so that they reproduce as a shade of gray, rather than as a black mass.

One source of a direct-diffused light can be a photograph taken next to a window. The direct light source is, of course, the light shining through the window. The light then will hit the subject and the walls near the subject. Thus, the shadow area receives some light. Another source of direct-diffused light can be found outdoors when it is a moderately overcast day.

Diffused light scatters itself over the entire subject from all directions. Diffused light is rather difficult to achieve indoors since most indoor illuminations come from a single point light source. Outdoors, however, diffused light can usually be achieved by photographing on a heavily overcast day. Also, the use of a relatively slow ASA film will lower the contrast and thus provide for an even more diffused quality.

A *silhouette* is created when the subject is underexposed due to great difference in brightness between the subject and background. The classic silhouette is essentially a back-lighted photograph that is metered for the background as opposed to the subject, or is achieved by averaging a light meter reading. A person standing in front of a window will produce a silhouette if the meter reading is based solely on the background.

Existing Light Photography

Light can be added to a scene with the use of artificial light sources such as photo flash, electronic flash, or floodlights. However, once light is added to a subject, the picture no longer possesses one of the inherent qualities of photography—the capturing of an unplanned moment. Existing light photography—picture-taking in available light—allows the photographer an endless array of photographic possibilities. They range from a photograph taken with a single candle as illumination to a brilliantly sunlit view of the Grand Canyon. The term "existing light," however, has come to mean pictures taken in low-light levels. Usually these are indoor scenes with a variety of light sources, such as candles, lightbulbs, window light, and stage lighting like that at rock concerts. Picture-taking in available light requires certain equipment. The camera lens should be reasonably fast, at least f/2.8 or faster. If a slower lens were used, the necessary shutter speed required for a correct exposure would be so long that the picture would be blurred. For the same reason, the film should also be fast, ASA 400 or better. Two other equipment items should be considered for existing light photography, especially for very dimly illuminated subjects such as night scenes. These are a tripod and a cable release. When you are taking pictures at shutter speeds slower than 1/30, any movement of the camera will cause blurry images. Since you cannot hold perfectly still this long, you use the tripod to support the camera as you shoot. Assuming that the tripod is on a solid, vibration-free surface, you can eliminate such vibrations. A cable release is a flexible cord that enables the photographer to trip the shutter button as the camera rests on the tripod. Some cable releases have locks that, with the camera on the "B" setting, will keep the shutter open as long as the photographer wishes.

a sturdy tripod will eliminate camera movement

camera on a tripod and cable release

141

Exposure Considerations

Illumination in existing light photography is unfortunately often very contrasty. For example, the light around the bulb of a street light is very bright, a few feet away that illumination stops and total darkness begins. Because of this, exposure literally becomes "a shot in the dark."

You will often want to use existing light for pictures of people. However, you may find yourself in light so low that your exposure meter doesn't seem to work. In that case, use a white card for your reading, rather than the person's face. The correct exposure will be about 2½ times the exposure indicated on the card. For example, at a shutter speed of 1/60 you might get a reading of $f/8$ off the white card. You would then open your lens 1½ f/stops to a setting halfway between $f/4$ and $f/2.8$. However, it is still preferable to take your reading directly off the subject's face.

Another situation in which you want to use existing light is in photographing concerts or plays. Although the stage lights are often very bright, they are directed at only a few people, while the rest of the stage is dark. It is important to avoid the dark areas on the stage when calculating exposure. You will tend to overexpose such pictures because the dark areas combined with the spotlight areas tell the meter that there is less light on the stage than actually exists. Be sure that you always expose only the area in the spotlight. It is best, if possible, to walk up to the stage and take a meter reading off your hand. Use that meter reading no matter where you are sitting when you actually shoot the picture. However, if this is impossible, point the meter toward the stage from where you are seated and then close the lens down by at least one f/stop. Remember, that meter reading takes into account the dark areas and so is based in part upon a lack of light, while actually there is a great deal of light on stage.

The best thing to do with existing light is bracketing the exposure. In other words, if the correct exposure is 1/30 at $f/5.6$, take another picture at 1/30 at $f/8$ and one more at 1/30 at $f/4$. This should allow for any error in your judgment of the exposure.

Because existing light photography requires a film with a high ASA number, grain may be a problem. To minimize this, try not to overexpose your negatives. Overexposure coupled with a high ASA film will result in large clumps of grain in the photo, making the image less sharp.

Shutter speeds for existing light photography are generally slow. When possible use a tripod and cable release. If your subjects move during a slow exposure time, the image will blur. Some subject movement can add interesting effects to a photograph. Camera movement, though, usually ruins the picture.

concert photograph illuminated by stage lights only

Existing light photography usually requires that the *f*/stop be wide open, and so depth of field is not very great. You must focus the shot very carefully. (It is best to focus on the eyes when photographing people.)

The following chart provides general exposure guidelines for the subjects listed. However, it is only a guide since lighting situations vary. Exposure bracketing is recommended. The chart is based on a film speed of ASA 400. If the film you are using is faster, shorten the exposure time. If the film you are using is slower than 400, then increase the exposure. For example, if the ASA of your film is 800, cut the exposure on the chart by half.

	Fairs, amusement parks	1/30 sec f/2.8
OUTDOORS AT NIGHT	Amusement park rides—light patterns	1 sec f/16
	Fireworks—displays on the ground	1/60 sec f/4
	Fireworks—aerial displays (Keep shutter open on Bulb or Time for several bursts.)	f/16
	Lightning (Keep shutter open on Bulb or Time for one or two streaks of lightning.)	f/11
	Burning buildings, campfires, bonfires	1/60 sec f/4
	Subjects by campfires, bonfires	1/30 sec f/2
	Night football, baseball, racetracks	1/125 sec f/2.8
	Moonlighted—Landscapes	8 sec f/2
	Snow scenes	4 sec f/2
INDOORS IN PUBLIC PLACES	Basketball, hockey, bowling	1/125 sec f/2
	Boxing, wrestling	1/250 sec f/2
	Stage shows—Average	1/60 sec f/2.8
	Bright	1/125 sec f/4
	Circuses—Floodlighted acts	1/60 sec f/2.8
	Spotlighted acts (carbon-arc)	1/250 sec f/2.8
	Ice shows—Floodlighted acts	1/125 sec f/2.8
	Spotlighted acts (carbon-arc)	1/250 sec f/2.8
	Interiors with bright fluorescent light	1/60 sec f/4
	School—stage and auditorium	1/30 sec f/2
AT HOME	Home interiors at night—Areas with average light	1/30 sec f/2
	Areas with bright light	1/30 sec f/2.8
	Candlelighted close-ups	1/15 sec f/2
	Indoor and outdoor holiday lighting at night, Christmas trees	1/15 sec f/2
OUTDOORS AT NIGHT	Brightly lighted downtown street scenes Wet streets add interesting reflections	1/60 sec f/2.8
	Brightly lighted nightclub or theatre districts	1/60 sec f/4
	Neon signs	1/125 sec f/4
	Store windows	1/60 sec f/4
	Subjects lighted by streetlights	1/15 sec f/2
	Floodlighted buildings, fountains, monuments	1/15 sec f/2
	Skyline—distant view of lighted buildings at night	1 sec f/2.8
	Skyline—10 minutes after sunset	1/60 sec f/5.6

(Overall section label: INDOORS)

Existing light photography offers many photographic possibilities. Pictures taken in natural light look honest and candid. However, there are many times when existing light photography is just not possible or acceptable. Sometimes there is not enough light for a picture; some subjects cannot be seen to their best advantage in existing light. Whatever the reasons, you also need to know how to use artificial light sources.

Artificial Light Sources

Artificial light sources for photography are of two kinds: instantaneous and continuous. Instantaneous light sources include all the varieties of flashbulbs, and electronic flash. Continuous light sources are photo floodlights, spotlights, or any other light that remains on after the exposure has been made. Flashbulbs, probably the most popular light source, are a fairly recent development. Before their invention, flash powder was used. It was a compound of chemicals that, when ignited, produced a bright flash and clouds of smoke. It often caused burned hands, singed hair and occasionally a good house fire. Flash powder is seldom used today, except by a few nostalgic photographers who long for the good old days.

A flashbulb is a glass bulb filled with shredded foil of hydroaluminum in an oxidizing atmosphere. Electricity passes through a filament encased in a primer that ignites the shredded foil and causes a flash of light. Flashbulbs differ in the amount of light they can give off, the amount of time they emit light, the color of the light, and its direction. Popular bulbs include these (starting with the least powerful): AG1 or AG1B (B means blue), M2 or M2B, M3 or M3B, 5 or 5B, 6 or 6B. Each of these bulbs needs a reflector to direct the light. The smaller the reflector, the more concentrated the light; the larger the reflector, the more area the light will cover. The type of reflector used with each of these bulbs is one of the elements that determines exposure.

Another type of flashbulb is the flash cube. There are two types of flash cubes, the regular cube (also known as Supercubes®) and X cubes (also known as Magicubes®). The regular cubes are powered by batteries in the camera, while the X cube is set off mechanically. Both types of cubes contain integral reflectors and will give four separate flashes per cube. Most Instamatic-type cameras are equipped with a socket to hold either a magic cube or a regular cube. Another type of flashbulb, called Flip-Flash® will yield eight or ten separate flashes.

The more popular instantaneous light source is the electronic flash. It may consist of a battery (sometimes rechargeable), a capacitor, and a flash tube. The battery sends electricity into the capacitor, where it is stored. When the energy is released, it produces a bright, split-second flash in the flash tube. The flash tube, unlike the flashbulb, is reusable for many thousands of flashes. Because of this, electronic flash has become increasingly popular. It can be adapted for most types of cameras. Some electronic flash units are more powerful than others. These produce more light and allow the photographer to take pictures at a greater distance or with a smaller lens opening. Other variables in electronic flash units are rechargeable batteries, AC power supplies, and the angle of the flash. (See automatic electronic flash features.)

flash cube

Flip-Flash

Flash Exposure

Flash exposure is simplified by using guide numbers. A guide number represents an *f*-number multiplied by the distance of the subject. The manufacturer of the light source assigns a guide number for any combination of film speed, type of flash (size), and reflector. These are found on any package of flashbulbs or in the instruction manual of an electronic flash. Suppose you were using an ASA 64 film and a shutter speed of 1/30 with a regular flash cube. The guide number for this combination is 80. To find the correct lens opening, divide the distance from flash source to subject into 80. For example, if your subject is 10 feet away, divide 80 by 10 (= 8). For this picture, *f*/8 at 1/30 would yield a correct exposure.

Another example of how guide numbers work: Suppose you were using a faster ASA film such as Plus-X® (ASA 125) with AG1B flashbulbs. In this case, a reflector must be used on the flash or the light will be scattered. A larger reflector will decrease the guide number, while a smaller reflector, which concentrates the light more, will increase it. The reflector for this example is small, so the guide number is 1/60. The flash-to-subject distance remains at 10 feet. By dividing 10 into 160 we get 16. The correct exposure is 1/30 at *f*/16 at a distance of 10 feet.

Guide numbers for flashbulbs are usually based on a shutter speed of 1/30. For electronic flash, the shutter speed is usually irrelevant to the guide number. It is important that the flash be synchronized with the shutter; that is, it should peak while the shutter is fully open. Otherwise, only part of the photograph will be illuminated by the light, while the remaining part is dark.

Different types of flash are synchronized for different shutter speeds on various cameras, for example, Class M, FP, and X.

Class M bulbs are medium-peak. In other words, they reach their full brilliance after the shutter button is released. Cameras equipped with M synchronization incorporate a delaying device that gives the flashbulb a headstart before the shutter opens. By the time the shutter is fully opened (about 20 milliseconds after the shutter button is released), the lamp and the shutter are in full synchronization.

Class FP lamps are used for cameras that have a focal plane shutter (such as most single-lens reflex cameras). FP lamps like 6 or 6B can peak for 40 milliseconds. The "peak" must be this long because the focal plane shutter has a slit in the curtain that passes across the film, exposing it to the light. Therefore, the bulb has to peak longer to compensate for the time it takes for the whole curtain to travel across the film.

Type X synchronization is used for electronic flash. Here the flash peaks very fast. When the shutter button is depressed, and before the shutter is fully opened, the flash must be reaching its peak. If the peak occurs after or before the shutter is fully opened, part of the picture will be dark. Shutter speed selection for X syn-

chronization will depend upon the type of shutter in your camera. If the camera is equipped with a focal plane shutter, the speed is usually synchronized at 1/60. The focal plane shutter travels horizontally (sideways) across the film. Some cameras have metal "Copal" shutters, which travel up and down instead of sideways. These shutters are synchronized at 1/125. If the camera has a between-the-lens shutter, then speed selection usually doesn't matter. Check your camera instruction manual to find what speed should be used for X synchronization.

Many flash units today, especially electronic ones, are equipped with dials that automatically calculate exposure without the need of guide numbers. In the illustration, notice that the ASA indicator is pointing at 100. The distance scale is marked off in feet. If the flash-to-subject distance is 10 feet, the number above 10 is 8. The f/stop, is, therefore, f/8. If the flash-to-subject distance is 15 feet, then, according to the dial, the f/stop would be f/4. Such dials of this type facilitate calculating exposures.

Many manufacturers of electronic flash units unfortunately assign a guide number that is too high. In this case, you will constantly have underexposed negatives. Should this happen, you may want to use a larger lens opening than the one recommended by the flash unit (probably one-half to one full stop). This adjustment will require some testing. However, once you know how much to open your lens, it becomes a matter of routine since the amount of light doesn't vary from flash to flash.

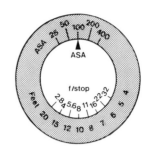

flash calculator

Automatic Electronic Flash

Exposure calculation is simplified with the use of an automatic flash. Invented by Honeywell Photographic products in 1965, the duration of the pulse of light produced by the flash is controlled by a light sensor. The sensor responds to the pulse of light reflected from the subject. When enough light for a correct exposure has been received by the sensor, the flash is electronically turned off. A thryistor automatic flash is an energy saving device that controls the capacitor to release only the energy needed to produce the light required. A thryistor unit will thus have a faster recycling time.

Many automatic flash units have the light sensor built into the flash head. This will put the sensor in line with the flash-to-subject axis. These units are intended to be mounted on top of the camera via a shoe provided on the camera. They are not intended to be used for bounce-flash in the automatic make. (See "Using Flash".) Some automatic flash units can be used on automatic for bounce-flash because the sensor is separate from the flash head.

With an automatic flash unit, the flash calculator on the back of the flash will tell the photographer what f/stop is to be used with a particular ASA. As long as the flash is used within the distance

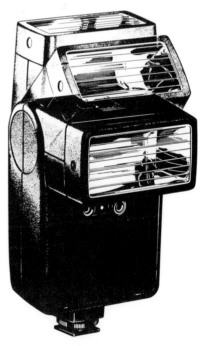

automatic electronic flash showing the various bounce positions

"seen" by the sensor, that f/stop will remain constant. Most exposure that is determined by the sensor is based on the assumption that an average subject reflects approximately 18% of the incident light. Thus, it is important to remember that unusually bright subjects may be underexposed, while dark subjects may be overexposed. Also, the sensor reads a narrow angle-of-view. If the subject is placed off to the side of the frame, the sensor may not read any of the light reflected back by the subject. Consult your instruction book to determine the angle-of-view of the sensor.

Dedicated Electronic Flash

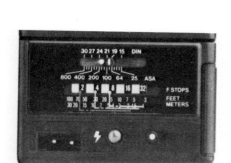

aperture scale selector on the back of a dedicated electronic flash

As the name might imply, a dedicated electronic flash is one designed for a specific camera or series of cameras, usually electronic and semi- or completely automatic. To work, they are attached to the camera via a specially designed hot shoe found on top of the camera. By attaching a dedicated flash unit to an f/stop priority camera, the user need not worry about flash synchronization since the circuitry built inside the camera and flash unit automatically selects the correct shutter speed. In a shutter priority camera, the camera selects both the correct shutter speed and f/stop.

A typical dedicated flash unit might have three automatic ranges plus manual. For example, notice that the flash illustrated has three automatic ranges at 15 feet, 30 feet, and 60 feet. If the film speed was 100, then the corresponding f/stops would be between f/8 and f/5.6 for the 15-foot range, between f/2.8 and f/4 for the 30-foot range, and between f/2 and f/1.4 for the 60-foot range. The user would decide what distance is needed for the flash to cover, plus the desired f/stop and program for the flash.

Because dedicated flash units are designed for specific cameras, you must use one that is made for the brand or model of your camera. All camera manufacturers produce dedicated flash units. In addition, most independent manufacturers also produce dedicated flash units, although they generally must be used with a module or adapter to insure dedication.

Electronic Flash Features

Some other features beside degree of automation are worth investigating. They include power, power source, recycling time, portability, energy requirements, and trends.

Power. In general, the greater the power, the more desirable the unit. The more powerful the unit, the greater the flash distance becomes. More power also allows for the use of smaller apertures. On the negative side, added power costs more and involves a physically larger unit.

Power Source. Most popular flash units today are powered by batteries, usually size AA. In most cases, these are alkaline batteries that drain quickly. Thus, some units have recharging capabilities

with nickel-cadmium batteries. A few rechargeables use standard AC current.

Recycling Time. The period of time for a flash unit to reach full power again after firing is called its recycling time. This time varies anywhere from less than 1 second to 10 seconds or more. As battery power drains, recycling time increases.

Portability. Larger units generally have more power and faster re-cycling times. This is because most larger units can use external power sources, called battery packs, which carry more powerful batteries (like 510 volts). However, those battery packs must be carried separately, usually over the shoulder.

Energy Requirements. The majority of flash units made today feature an energy saving circuitry, called a thyristor, which both prolongs the life of the battery and shortens the recycling time. A thyristor acts as a governor controlling the flow of power from the battery to the capacitor, where the power is stored.

A second energy-saving device found on more expensive units is a power reduction switch. This switch allows the flash to be used at fractions of the maximum power of the unit. For example, some units offer energy reductions of ½ power, ¼ power, and 1/16 power. Saving power is especially useful for close-up photography where overex-posure can become a problem.

Trends. With the advent of the microprocessor (microchip), flash units promise more sophistication. For example, calculator dials on the backs of most units will be replaced with liquid crystal displays (LCD). In addition, computerized circuitry allows for more auto ranges (such as, eight *f*/stops instead of the usual three or four). More expensive units will offer interchangeable flash heads, thus allowing for more creative uses of the flash. Finally, features such as the audible indicator will replace the ready light.

Special Purpose Flash Units

A *ringflash* is an electronic flash unit that surrounds the lens of a camera. It procures a soft, shadowless illumination that is useful for photographing recessed areas. Many dentists use ringflash to make photographic records of dental work since the flash light can be directed into the mouth. Thus, it is a useful aid for close-up photography.

A *stroboscopic flash* produces a series of rapid sequence flashes in a short period of time. Many stroboscopic units can be set to flash up to 50 times a second at a duration of at least 1/10,000 second each. It allows a photograph to show progressive stages of motion on a single exposure. Thus, they use it quite often for time and motion studies, or for special effects in advertising photography.

Generally, when a stroboscope is used, the camera is set on a tripod and set at B (bulb), or one second. The subject is in front of a dark background and moves while the shutter is open and the flash

ringlight

is being fired. The result is frozen motion, the study of each movement for each time the flash fired.

Using Flash

Flashbulbs or electronic flash can usually be used in the same ways as natural or artificial light. Flash units are most commonly attached to the camera, giving you the advantages of both speed and convenience. You need not hold or aim the flash separately. This is convenient when photographing action, such as sports events. Calculating exposure is usually more accurate because the camera and flash are the same distance from the subject. However, there are some disadvantages to having the flash attached to the camera. The major one is that the picture may have a washed-out background and probably a harsh shadow behind the subject. Another disadvantage is that the subject will have little or no modeling. For an object to look three-dimensional, there must be both shadows and highlights. A camera-mounted flash usually makes people's faces look flat. One way to avoid this is to keep the flash above and slightly to one side of the subject. Remove the flash unit from the camera and either attach it to an "L" bracket or hold it in your free hand. However, it is difficult to hold the camera steady when using only one hand.

Bouncing the light is another way to soften it. This is done by aiming the flash at a surface that will reflect the light back onto the subject, such as white walls and ceilings or mirrors. Bounce light, however, reduces the amount of light on your subject, and so you must increase the exposure. A quick rule of thumb is to open the lens two stops. A more accurate way is to measure the flash to the reflecting surface and from the surface to the subject. Divide the total into the guide number to determine exposure. Remember that bounce light only works in a small, light area and that dark colors absorb light while light colors reflect it.

Using Flash Outdoors

When photographing portraits outdoors, you will probably want to "fill in" the deep shadows under the eyes that bright sunlight creates. To do this, you will need a long PC cord (the cord which plugs into the camera from the flash). First calculate the exposure of the subject as if you were not using the flash at all. After the exposure is known, divide the flash guide number by the f/stop you have selected. This will give you the flash-to-subject distance. Remember that some cameras are synchronized for flash at a certain shutter speed only. Most SLRs are synchronized at 1/60 with electronic flash. So, you will have to calculate the exposure at 1/60 if you are planning to add electronic flash. For a "bright fill," place your flash at this distance. For example, suppose your exposure was 1/60 at f/8 with an ASA 25 film. The guide number of the flash was

*results of using flash
mounted on top of
camera*

*results of using flash
mounted on the side of
camera*

results of using bounce flash

no fill

normal fill

bright fill

40, so you divide 8 into 40 and place your flash 5 feet from your subject. Unless you want to take the picture from 5 feet, it may be necessary to use a support like a tripod to hold the flash. Be sure to direct the flash at the subject.

"Bright fill" will wash out all shadow detail in your subject's face. For a "normal fill," move the flash back again half the distance. In the example given above, you would move it 2½ feet more, for a total of 7½ feet. Normal fill allows some darkening under the eyes. For still more darkening or shadow area, "weak fill" can be used. This allows almost as much shadow under the eyes and mouth as there would have been without using the flash. For weak fill, double the bright fill distance. Using the same example, you would place the flash 10 feet away—double the distance for bright fill.

Continuous Light Sources

Continuous light sources are any light sources that provide a steady flow of artificial illumination. A flashlight, for instance, gives a steady flow of light, although it is not normally bright enough for photography. Certain types of lightbulbs have been designed for photographic purposes. Called photofloods, they provide an even, steady flow of light that is bright enough for photographing. The light from photoflood bulbs must be directed. This can be done with either reflectors or reflector floods. Reflectors direct the light so that it travels at a certain angle. Generally, the larger the reflector, the more area the light will cover. Usually the smaller the reflector,

the more concentrated the light will be. A large reflector with a 12-inch radius, for instance, would be used to light a large area such as a room. Reflector floodlights are photoflood bulbs with built-in reflectors. This type of light source provides a concentrated light beam. Reflector floods are useful when the light is to be directed on a small area, like the face. Both types of bulbs must be mounted in a light socket. A clamp and cord set provide a socket as well as a clamp to fasten the unit on a chair or other support. The bulb can also be fastened on an adjustable light stand, which can be lowered and raised like a camera tripod.

Reflectors and bulbs give you an effective way to control light. A typical lighting set-up in a professional studio may use as many as seven different lights at different angles. These give a more even light than found in daylight. However, many successful portraits can be done using one to three lights.

Try this exercise to practice different lighting techniques. Use a Number 2 photoflood lamp, which uses 500 watts of light (a Number 1 lamp uses 250 watts). Attach the bulb to a clamp or light stand with a 8″–12″ reflector. (You can also use a reflector flood alone.) Either ask a friend to model or place a mannequin head (with painted features) in front of a white wall or screen. Set the camera about 3 to 5 feet from the head. The image of the head should fill the viewfinder. This distance should not vary with each photograph. There should be no lights in the room except the photo lamp. *Shot #1*—place the light as near the camera as possible, aimed squarely at the subject. *Shot #2*—place the light on the left side of the subject at a 45° angle to the camera-subject line. *Shot #3*—same position as #2 but raise the light to shine down on the subject at a 20° angle. *Shot #4*—same position, but lower the light to beam

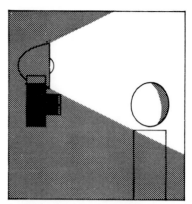

1. light source near camera

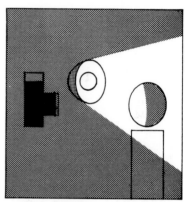

2. 45° to the left

3. same as 2 but 20° higher

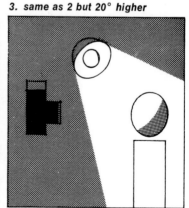

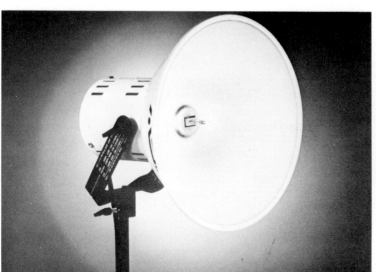

quartz bulb reflector-flood

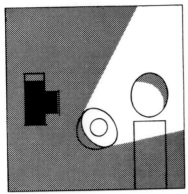

4. same as 2 but 20° lower

5. straight down

6. straight up

7. light on background

up at the subject. *Shot #5*—place the light so that it beams directly down on the subject's forehead. *Shot #6*—place the light directly below the subject's face, aiming up toward the chin. *Shot #7*—aim the light behind the subject onto the white background.

After the photos have been developed and printed, compare them. The first photo will show the subject well lighted without shadows. However, the features will appear flat. Shot #2 will be a contrasty rendering of the subject, with deep shadows beside the nose and mouth. Shot #3 will show the subject with deep shadows under both eyes and underneath the mouth. In Shot #4, the face will look somewhat strange because the shadows fall upward. Shot #5 will have extreme shadows under the eyes and mouth. Shot #6 will make the subject look scary and grotesque. Shot #7 produces a silhouette.

Multiple Lighting

After you have done the above exercises, you may want to experiment with more than one light, especially for portraits of people. When a second light is used, that light is called a *fill*. The first light source then becomes the *main*. The general purpose of the fill light is to add some light to the shadow area. It, in effect, will reduce the harsh contrasts between the dark (shadow) and light areas. Thus a more direct-diffused quality of light is achieved.

The simplest and most effective way to add a fill light is the employ of a reflector to bounce the main light back to the subject and to the area that it's needed most. One way to make a reflector is to use a piece of stiff cardboard about 16″ × 20″ with a white surface on one side. On the other side, attach some crumpled up aluminum foil that has been smoothed flat. Tape the corners of the foil to the other side of the board.

fill light

The white side will give a soft, even illumination, which works well for portraits. The aluminum foil side reflects a hard-edge light, which will be more direct.

Another possible solution to a fill light is to use a second light. The second light should have a lower wattage than the main light, and should be placed at a distance at least equal to the distance from the subject to the main light. For example, if the main light were a 500 watt bulb, the fill should be a 250 watt. If the main light were placed 15 feet from the subject, the fill should be placed at least 15 feet away as well. The fill should not eliminate the shadow completely.

Lighting, of course, can get more complicated than using just two lights. Some of the other variables are: (1) how many lights are used; (2) angles of light in relationship to the subject; (3) distance between lights and subject; (4) the size of the reflector used; and (5) the color of the background. There is one other variable that is the most important—the subject. Lighting should not make every-body look alike. The lighting should fit the personality of the subject rather than what is easier for the photographer to set up. The eighty-eight cent special color portrait that is consistently advertised in newspapers and magazines employs the same type of lighting for each person being photographed. This, of course, cuts down on costs, but approximately two million other babies have been photo-graphed exactly the same way. The resulting photograph is not a unique one.

background lighting *broad lighting*

The diagrams above illustrate combinations using four lights. Each lighting set-up highlights a different characteristic of the subject. Commercial photographers would probably arrange the lights in a similar manner to the illustrations. Remember though, the goal of the commercial photographer is to produce a realistic, but idealized representation of the subject. After all, most people don't want to pay money for a portrait that makes them look ugly.

Exposure Calculations

When reading the meter for a subject illuminated by artificial light, it is usually best to average several readings together. (See Chapter 4.) In other words, take an exposure reading from various areas of the subject, such as hair, face, clothes, and shadow areas, and then find the average exposure. If the subject is to be silhouetted on purpose, then read the background area only.

One physical law about the behavior of light is important to know when using artificial light: The intensity of light falls off rapidly as the distance between the light source and subject is increased. In mathematical terms, the illumination of a surface is inversely proportional to the square of the distance between the light source and the illuminated surface. If you double the distance between the subject and the light source, the light becomes only one-fourth as bright. For example, if the correct reading were 1/125 at *f*/11 with the light 10 feet from the subject, moving the light back to 20

feet (twice the distance) would mean the exposure should be increased to 1/125 at 5.6. The closer the light is to the subject, the more light the subject will reflect, thus requiring a shorter exposure time. The longer the distance between the subject and light source, the less intense the light will be. Less light will be reflected, and the exposure will have to be longer.

Whatever kind of light you choose for your photograph, artificial or natural, learn to control it to achieve what you want.

In Focus/Light

1. Try some existing light photographs under a variety of conditions such as those described in the chart in this chapter. Bracketing your exposures under these unusual conditions is usually best. Keep records of your exposure settings and compare with the final photographs, discovering what approach works best for you.
2. There are some disadvantages to having the flash attached on top of the camera. The major disadvantages are that the picture may have a washed-out background with a harsh shadow behind the subject, and the subject will have little or no modeling. For an object to look three-dimensional, there must be both shadows and highlights. Therefore, we recommend that you shoot several rolls of film to master the technique of bounce-lighting.
3. Shoot two groups of photographs with at least three photographs in each series. One series should use a person's face as its subject, the second series should use an object or collection of objects as the subject. The two groups should illustrate how the same subject can appear different, and communicate a different mood as the lighting is changed. All the light used in these photographs should be directly controlled by you through the use of artificial light sources.

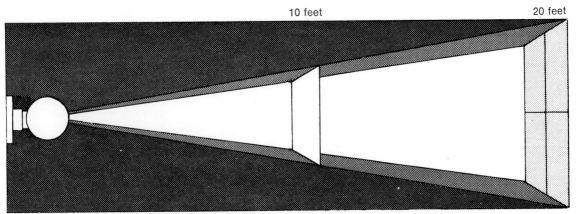

Light incidence is four times more intense at 10 feet than at 20 feet.

Lenses

10

The purpose of a lens is to gather light and to direct that light to the film. The pinhole camera, which had no lens, produced images that were not sharp and had little contrast between tones. A lens provides a definite plane of focus, giving a sharp, focused image and increasing the contrast between tones. A photographer need not know everything about lens design or construction in order to take a good photograph. However, the more you know about how lenses work, the better your chances are of taking that good photograph.

Lens design is based on the principle that light is bent, or refracted, as it passes from air to glass or glass to air, as it does in a prism. In the case of a double prism, a second ray of light begins at the same point. It enters the lower prism and is eventually bent back upward so that they both meet at a common point. Lenses are made in different shapes and sizes, but they can be classified as negative or positive based on how they disperse light rays. In a negative lens, the light rays diverge or spread out as they pass through the lens. In a positive lens, the light rays converge at a common point. More sophisticated lenses contain not one piece of glass but many. In these lenses, each piece of glass is called an element. The various shapes and combinations of elements (called groupings) determine the quality and use of a particular lens.

Terminology

Understanding lenses requires your knowing some of the technical terms used in describing them.

Focal point. All rays of light approach a lens from a point of infinity. These rays of light are parallel as they travel through air until they enter a lens. After they are bent by the lens, they converge at a common point, the *focal point*. More specifically, the focal point is the point where the light rays converge when the lens is focused at infinity. Basically a thin lens causes light rays to converge at a farther point than a thick lens. Consequently, the film in the camera is placed at the focal point of the lens. This area of the camera is called the focal plane.

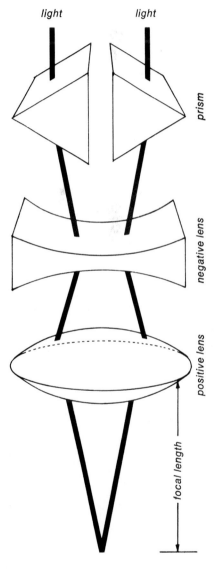

Circles of confusion. If you recall from Chapter 2, "The Pinhole Camera," the larger the hole size was, the fuzzier the image became. The smaller the hole, the sharper the image was. This is due to an optical effect called "circles of confusion."

Examine the following illustration. (See Fig. 10-1.) Figure A represents the subject that is being photographed. B represents the pinhole. C represents how the image will be recorded on the film. Notice that the image is upside down and reversed and is made up of tiny little circles. Only a few rays of light from each point on the subject can pass through the small opening. These "light rays" strike the film in very tight clusters so that blurring is reduced to a minimum.

The size of the opening was increased in this second illustration. (See Fig. 10-2.) The larger hole allows a greater number of rays from each point on the subject to enter the camera. These light rays spread before reaching the film and are recorded as large circles. Because of their size, these circles overlap each other, thus creating a blurry photograph. In other words, the larger the circles are, the more they will overlap and the blurrier the picture will be. These circles, which make up all photographic images, are called circles of confusion.

Fig. 10-1

subject

pinhole

small pinhole projects light clusters

projected image

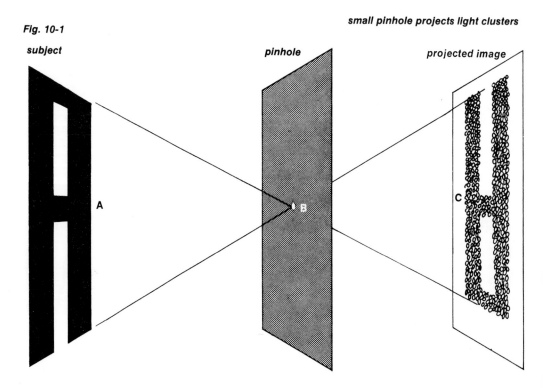

A

B

C

Focal length. The focal length of a lens is a factor that determines the size of the image on the film, the picture angle covering the area of the subject to be photographed, the brightness of the image, the depth of field, and the *f*/stop. Focal length is the optical distance from the lens, when focused at infinity (not necessarily the middle of the lens), to the focal point. In Chapter 2, you learned about pinhole-to-film distance in the pinhole camera. Had there been a lens on the pinhole, this distance could have been called the focal length.

The focal length of a lens never changes, even if the lens is removed from the camera, or if it is focused at a closer point than infinity. It is the result of the fundamental design of the lens.

f-number. Because of the variety of lenses available, a formula is used to describe the ability of a lens to gather light: f-N = FL/D. F-N represents the *f*-number, the maximum light-gathering ability of a lens. D represents the diameter of the lens. FL represents the focal length of the lens. (See Fig. 10-3.) The *f*-number, as you already know, is a fraction. It represents how many times the full effective diameter of the lens can be divided by the focal length. For example, if *f*/8 is the widest opening on a lens, then the widest diameter of that lens is ⅛ the focal length. Because an *f*-number is based on the relationship of focal length and diameter, *f*/8 on

larger pinhole projects larger overlapping clusters

Fig. 10-2

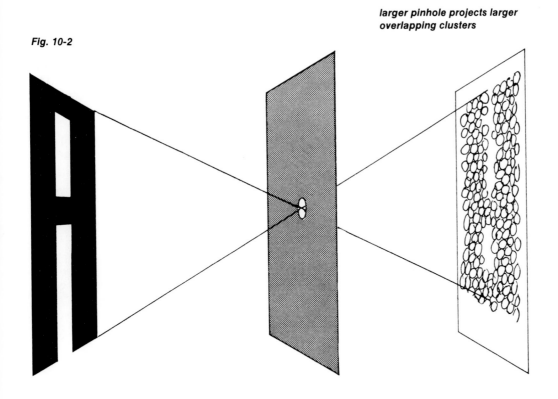

161

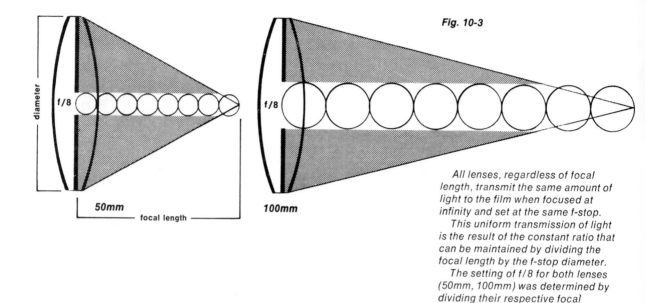

Fig. 10-3

All lenses, regardless of focal length, transmit the same amount of light to the film when focused at infinity and set at the same f-stop.

This uniform transmission of light is the result of the constant ratio that can be maintained by dividing the focal length by the f-stop diameter.

The setting of f/8 for both lenses (50mm, 100mm) was determined by dividing their respective focal lengths by the f-stop diameter.

a lens with a 12-inch focal length allows just as much light to reach the film as f/8 on a 6-inch focal length lens although the actual size of the opening will be different.

Depth of field. Depth of field (discussed in Chapter 3) is the range of distance, before and behind the subject, that is in acceptable focus. Among the factors that determine the depth of field are: (1) lens aperture, (2) focal length, and (3) focus distance.

The smaller the lens aperture, the greater the depth of field. The larger the lens opening, the shorter the depth of field. This is because a large opening produces larger circles of confusion while a small opening produces smaller circles of confusion.

Depth of field is influenced not only by aperture size but by the distance from camera to subject as well. The simple rule is, the closer you are to the subject you are focusing on, the fuzzier everything else will be, or the less your depth of field will be.

Another factor that affects depth of field is the focal length of the lens. A short focal length lens (wide-angle) has great depth of field at a given f/stop. The normal focal length lens has a longer focal length than the wide-angle, so depth of field is not as great. The telephoto lens, which has an even longer focal length, has very little depth of field. To summarize: the shorter the focal length, the greater the depth of field. The longer the focal length, the less depth of field.

Depth of field scales. The way in which depth of field is indicated

graphic approximation of area in focus

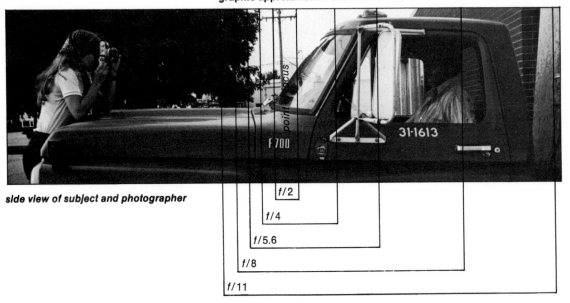

side view of subject and photographer

f/2

f/4

f/5.6

f/8

f/11

on a camera depends on how the camera is focused. If the camera cannot be focused, its depth of field is fixed. Usually such cameras have great depth of field, giving acceptable sharpness between 6 feet and infinity. Other cameras have depth of field scales. On most single-lens reflex cameras, the depth of field scale is on the lens. (See Fig. 10-4.) To use this scale, first focus the lens at, say, 10 feet. Below the footage indicator is the depth of field scale, a double series of numbers representing *f*-numbers. To find the depth of field at a given *f*/stop, *f*/16 for example, read the distance scale at the points opposite the engraved "16" on both sides of the dot. (That dot is the reference marking for the distance.) You will see that the depth of field is from 6 feet (left of the dot) to 15 feet (right of the dot). Now suppose that you are using *f*/4 instead of *f*/16, while keeping the distance at 10 feet. Locating "4" on the left side of the dot, you find that the depth starts at 9 feet. To the right of the dot, depth of field ends at 12 feet. So the depth of field is less because the aperture size was increased.

Depth of field scales vary from camera to camera. It is always wise to check the instruction manual of your camera.

These scales do not give you any way of seeing depth of field. However, some cameras provide a depth-of-field preview button. Pressing this button will stop down the lens to a predetermined *f*/stop. You can see in the viewfinder what will be in focus and what will not.

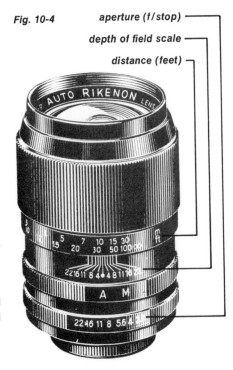

Fig. 10-4

aperture (f/stop)

depth of field scale

distance (feet)

Zone Focus

Zone focus is useful when photographing fast-moving subjects at sports events, etc. Because it is difficult to focus and refocus constantly, the camera is set for the distance where the subject is most likely to be. The depth of field scale or preview is then checked to see how far the subject can move without getting out of focus. As long as the subject remains within this range, pictures can be taken without refocusing.

Normal Focal Length Lenses

A normal lens and the human eye "see" objects the same size from the same distance. A "normal" lens for a 35mm camera is 50mm. An 80mm, focal length lens is considered normal for a 2¼" × 2¼" camera. For a particular camera, normal focal length lens is the diagonal measurement of the film. For instance, the diagonal measurement of 35mm film is almost 43mm. Thus, the normal focal length lens for 35mm is 50mm.

telephoto lens

One thing to keep in mind is that a "normal" focal length lens for one camera using a certain size of film will not be normal for a different camera using a larger or smaller film size. For instance, a 50mm focal length is normal for 35mm film, but a 50mm lens used on 2¼" × 2¼" size film would be a "wide-angle."

The normal lens, which can usually be focused down to 2 feet, is the most popular focal length in use today. Usually, the faster lens available with any camera is a normal lens. In other words, they can have an *f*/stop range up to *f*/1.2, making them very useful for existing light photography. However, there are times when you need a lens with a shorter or longer focal length—a wide-angle or telephoto. Of course, to use either a telephoto or wide-angle lens, you must have a camera on which you can substitute these lenses for the normal lens (called "lens interchangeability").

wide-angle lens

Telephoto Lenses

Sometimes your subject is too far away to be seen in a viewfinder. Sometimes you don't want the subject to know you are taking a picture. A telephoto lens, like a telescope, magnifies the subject so that it appears closer than it really is. Telephoto lenses are long focal length lenses. In other words, the focal length is longer than the diagonal measurement of the film. The longer the focal length, the larger the image on the film. As with normal lenses, a telephoto lens is relative to a particular film size.

Because there are so many telephoto lenses available, we will discuss only those used on 35mm cameras. One reason is that many more 35mm cameras are made with lens interchangeability.

Telephoto lenses for 35mm cameras are generally divided into three types—short, medium, or long. Short telephoto lenses are

between 85mm and 105mm. Though small, they increase the image size recorded on the film. Many photographers use a short telephoto lens both for shooting subjects at a distance and for portrait work. The telephoto has two advantages for portrait work: (1) The camera can be placed farther from the subject's face, allowing a more relaxed, natural pose; and (2) a telephoto distorts facial features less than a normal lens used at minimum focus.

Medium focal length telephoto lenses are in the 135mm–200mm range. These middle-range lenses are probably the most popular telephotos. The 135mm lens can be used for portraits, sports events, and landscapes. They are also quite widely used for candid photographs of people. While a 100mm lens will double the image size on the negative, a 200mm lens will magnify the image four times.

Any lens longer than 200mm is usually classified as a long telephoto. These are used when the distance between photographer and subject is great—at a football game or ski run, for instance. They are also quite useful for photographing animals in their natural habitats. A 400mm lens will magnify the subject by 8. That is, if the subject were 80 feet away, it would appear to be only 10 feet away in the film image. One problem, however, is that perspective may be distorted.

Perspective is the relationship between objects in terms of position and distance, as seen from a certain viewpoint. A long focal length lens, which is generally used at a great distance from the subject, and has a narrower field of view than a normal lens, appears to compress or shorten the distance between objects. Because of this, long focal length lenses are seldom used for portraiture. However, they are useful tools in many picture-taking situations.

When using any telephoto lens, remember that the longer the focal length, the less the depth of field. Telephoto lenses are usually heavier than other lenses and they generally are rather slow. Very few telephotos are faster than f/4. Because of the weight and the loss of depth of field, a fast shutter speed should be used. A tripod will provide good support for the camera with a long, heavy telephoto lens, especially if the focal length exceeds 200mm.

Wide-Angle Lenses

Wide-angle, or short focal length lenses are the opposite of the telephotos. They allow the photographer to record more of the total area of scene without moving the camera back. For example, if you had to be 20 feet away to photograph an object with a camera with a normal lens, using a wide-angle might allow you to shoot the same area from only 10 feet away.

The term "wide-angle" refers to the "angle of acceptance," the area "seen" by the lens. How wide this angle is depends on the focal length. Wide-angle lenses have short-focal lengths. They are shorter than the diagonal measurement of the film. The shorter

28mm wide-angle lens

50mm normal lens

100mm short telephoto lens

200mm telephoto lens

close-up with wide-angle lens

the focal length, the wider the angle of acceptance. For example a normal 50mm lens for a 35mm camera has an angle of acceptance of 46°. A 500mm telephoto for a 35mm camera has an angle of acceptance of only 5°. Clearly, the 500mm lens has a much narrower angle of acceptance, or angle of view. A 28mm wide-angle lens for a 35mm camera, however, has an angle of acceptance of 76°. A much wider area is covered. The chart illustrates these relationships (see Fig. 10-5.) The focal lengths 20mm, 28mm, and 35mm are wide-angle lenses for 35mm film. The 50mm and 55mm are normal focal length lenses. In the telephotos, 85mm and 105mm are short, while 135mm and 200mm are medium telephotos. Beyond 200mm are the long focal length lenses. Starting with the 20mm wide-angle lens, notice how the angle of acceptance gets narrower. The diagram illustrates the differences in area covered by a wide-angle, a telephoto, and a normal lens for a 35mm camera.

A wide-angle lens also appears to distort perspective, but differently from a telephoto lens. Rather than compress space or shorten the distance, it appears to extend space or make it longer. In reality, the apparent differences in perspective between various lenses are a result of the differences in area covered by each. Thus, because a wide-angle lens covers more area, objects close to the camera appear unusually large.

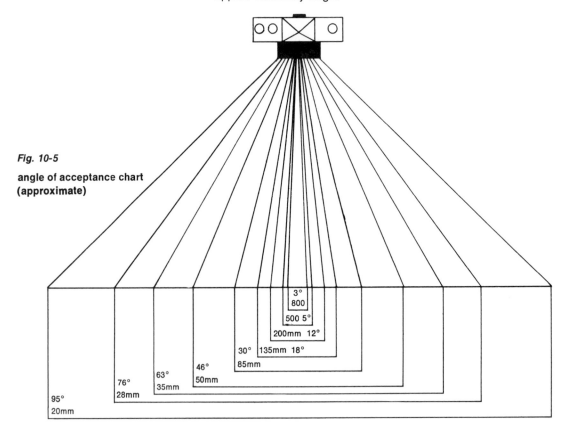

Fig. 10-5

angle of acceptance chart (approximate)

3°
800

500 5°

200mm 12°

30° 135mm 18°

46° 85mm
50mm

63°
35mm

76°
28mm

95°
20mm

28mm lens

**cut-away version of
28mm lens**

Zoom Lenses

The most popular lens today is the zoom lens. A zoom lens is a variable focal length lens. By internal shift of the elements, zooms can vary their focal length. The degree to which zoom lenses vary their focal length is expressed as their range. Ranges generally fall into these categories:

1. Wide-angle (21 to 35mm, 24 to 35mm)
2. Wide-angle to normal (24 to 45mm, 28 to 50mm, 28 to 55mm)
3. Wide-angle to telephoto (28 to 80mm, 28 to 135mm, 35 to 70mm, 35 to 135mm)
4. Normal to telephoto (55 to 220mm, 40 to 300mm, 50 to 135mm, 50 to 200mm)
5. Short telephoto to telephoto (70 to 150mm, 70 to 210mm, 75 to 300mm, 80 to 200mm)
6. Telephoto to telephoto (100 to 200mm, 100 to 300mm, 100 to 600mm, 200 to 500mm)

Because of their flexibility and convenience, zoom lenses dominate the marketplace. They allow the photographer to stand in one position and vary the angle of view of the subject without the need to change lenses. In addition, many zooms are capable of focusing at very close distances. This type of zoom is referred to as a macro lens (see Special Processes and Techniques). Two notes of caution concerning zoom lenses: their quality varies widely between brands (you get what you pay for); and while they will allow for greater creativity and flexibility, their use does not insure success.

Special Lenses

Many camera lens manufacturers produce an array of lenses for special purposes. These include fisheye, perspective control, and macro. The fisheye is an extreme wide-angle lens that usually

zoom lens

produces a circular image on the film. Some fisheye lenses are even capable of photographing objects slightly behind the lens because they have a 220° field of view. Generally they are used for scientific purposes, such as photographing cloud formations for weather records. However, fisheyes can also be used to achieve special effects.

Usually, when a camera is tilted upward, as in shooting a tall building, the sides appear to converge at the top. In other words, the building may look more like a pyramid than a rectangular structure. A perspective control lens (PC) can correct for this type of distortion because the lens, not the camera level, is raised. PC lenses are used in architectural work when a realistic interpretation is required.

Macro lenses are useful for most types of photography. They are normal lenses that can focus very close to a subject. This makes them especially useful for close-up shots, such as photos of insects, jewelry, or coins. They are also used to copy documents or material from books.

Supplementary Lenses

A supplementary lens is one that is attached either in front of or behind the existing lens. One type of supplementary device, the tele-extender, can increase the effective focal length of the lens attached to it by two or three times. The tele-extender is placed on the camera body, and then the lens is attached to it. A 2X extender (converter) will double the focal length of the lens. For instance, a normal 50mm lens attached to a 2X converter will make it a 100mm telephoto. A 3X converter will triple the power. A 50mm attached to a 3X converter will make it a 150mm lens. The tele-extender is useful because it gives the photographer a telephoto lens inexpensively. However, it absorbs considerable light. A 2X converter will require opening the lens two more stops. A 3X converter requires three more f/stop openings. A tele-converter also will reduce the sharpness of the lens being used with it.

Another type of supplementary lens is the Plus lens or close-up lens. These are actually more like filters, because they screw onto the front of the regular lens. Plus lenses come in various powers. The Plus 1, Plus 2, and Plus 3 lenses allow the photographer to get increasingly closer to a subject without being out of focus. They can also be used in combination. For instance, you can make a Plus 6 lens by using a Plus 1, Plus 2, and Plus 3 all together. One thing to keep in mind when using close-up lenses is depth of field. The closer you are to the subject, the less depth of field. Plus lenses are not as sharp as a macro lens used at the same distance. However, because of their cost, they are more popular.

Special processes and techniques will explain how to use supplementary lenses and other types of special lenses for close-up photography.

Fig. 10-6

Care of Lenses

Most good lenses are made of glass and are susceptible to scratching. A scratch on a lens may reduce its sharpness. Protective lens caps are made for both the front and back of a lens. If the lens is not in use, it should be protected with a rear lens cap as well as one on the front.

Lenses must also be free from dirt, dust, or fingerprints, since these will all cut down the sharpness. Cleaning a lens requires care because the glass is so easily scratched. A camel's hair brush is used to clean any dust or lint from the surface of the lens, while tissue is used to wipe away dirt. Use the lens tissue with a circular motion (see Fig. 10-6.); scrubbing with the tissue may scratch the lens. Be sure to use only tissue designed for camera lenses. Tissues for cleaning eyeglasses contain a cleaner that is harmful to the lens coating.

For fingerprints use a commercial lens cleaner. These are solvents that dissolve away the fingerprints without too much rubbing with the lens tissue.

Many photographers like to keep either a UV (ultraviolet) or 1a (skylight) filter on the camera lens at all times to protect the lens from scratches and dust.

use lens tissue for thorough cleaning

In Focus/Lenses

1. Depth of field is the range of distance, in front of and behind the subject, that is in acceptable focus. Among the factors that affect depth of field are (1) lens aperture, (2) focal length, and (3) focus distance. In this exercise, it will be necessary to shoot several rolls of film. First, photograph a subject using the various apertures on the camera lens from a stationary point. Next, photograph the same subject, under the same lighting conditions, at a closer distance, again using the various apertures. Repeat this procedure for a third set of photographs at a still closer distance. Develop the negatives and compare the results.

use a camel's hair brush to dust lens

2. If the camera you are using has interchangeable lenses, try to obtain a wide-angle, telephoto, or zoom lens to use on it. This can usually be accomplished by either borrowing the lenses from a friend who has the same camera mount system as you have, or by renting the lenses from a local camera store. When using these different lenses, keep in mind these factors: (a) depth-of-field, (b) distortion, (c) perspective, (d) angle-of-acceptance, (e) focusing range.

The Camera

The camera is the tool that enables a photographer to record a personal interpretation and viewpoint of reality. By creative use of the camera, the photographer has a way of seeing, understanding, and appreciating the visual world. By using the camera intelligently, the photographer can communicate these impressions to others.

As you learned from investigating the pinhole camera (Chapter 2), all cameras are basically similar. Each is a light-tight box with film at one end and a hole or lens to admit light at the opposite end. All cameras, regardless of cost, work in that manner. The differences are how well, how easily, and how flexibly they transmit light to the film to make an image.

There are hundreds of cameras available today. Choosing a camera can, and often does, become confusing. However, most cameras can be classified by their viewfinder systems. Rangefinder cameras provide a separate viewfinder for framing and focusing the shot. Most rangefinder cameras are held up to the eye and can be focused quickly. The rangefinder itself (see Chapter 3) consists of a pair of mirrors placed a few inches apart so that the eye sees a double or ghost image of the subject. The other mirror moves while the lens is being focused, so that when the subject is in focus, the two images are superimposed. Rangefinder cameras are made in several film sizes, the most popular being 35mm. Rangefinder cameras provide the brightest possible view of the subject, making them ideal for low-light situations. Also, they are quieter than an SLR.

Rangefinder cameras do, however, have certain disadvantages. Parallax (see Chapter 3) can occur because you are framing the photo through a separate viewing system, not through the lens. This problem is especially critical when working less than 2 feet from the subject. Another problem is the lack of versatility of most rangefinder cameras. Except in very expensive models, most rangefinder types cannot use interchangeable lenses. Finally, many rangefinder cameras have built-in automatic exposure systems. This is a plus feature if working fast is important. However, there are disadvantages of having an automatic camera that doesn't have an override.

The single-lens reflex (SLR) cameras provide the best way to see exactly what the camera lens sees. (See Chapter 3.) A system of prisms and mirrors lets you look right through the lens. Viewing

rangefinder camera

35mm single-lens reflex

2¼ single-lens reflex

your subject through the lens, you can see the depth of field and frame precisely what will be included in the photograph and what will not. Single-lens reflex cameras are made in different film formats, the most popular using 35mm or roll film such as 120 film.

The single-lens reflex camera has several advantages over the rangefinder. For instance, parallax is no longer a problem since the camera allows for viewing through the lens. Also, many SLRs offer interchangeable lenses. However, they too have their disadvantages, the main one being weight.

The SLR in most cases weighs more than the rangefinder and is usually less compact, although manufacturers are working to solve this problem. They are also more complex mechanically than the rangefinder, and so the potential for broken or out-of-order parts is greater. Because the mirror on an SLR must move out of the way to make the exposure on the film, they are also noisier than other types of cameras. This can be a problem in photographing animals or self-conscious people. Finally, because the light bounces off several points inside the camera before it reaches your eye, and because each of these points absorbs some light, it is often hard to focus in dim light and with slow lenses. This is one reason why rangefinders are popular with many photographers. Even with these disadvantages, the SLR has become the most popular focusing system in better quality cameras.

Many photographers prefer to compose their images on a large flat ground glass, rather than at eye level. A twin-lens reflex (TLR) allows the photographer to turn a three-dimensional scene into a two-dimensional image, which is the way all scenes are rendered in a photograph. Like the rangefinder camera, the twin-lens reflex has a viewing system separate from the lens. However, like the single-lens reflex, the TLR uses a mirror that reflects the image of the scene onto a viewing screen or ground glass (see Chapter 3). Most twin-lens reflex cameras use roll film, either 120 or 220. (220 film does not have a paper backing like 120. Because of that, more film is contained on the same size spool, so that more exposures can be made. Not all 120 cameras can use 220 film however, mainly because there must be an automatic exposure counter to show how many pictures have been taken, without numbers on the paper backing.)

The TLR camera, because the mirror is stationary, is quieter than the SLR. Its ground glass is much larger than in eye-level cameras, making it easier to focus and to compose the picture. Since the photographer looks down into the camera, it can be set on the ground for compositional effects or to photograph low subjects, such as pets or babies. Another advantage of the TLR is the film size used. A 2¼″ × 2¼″ is four times the area of a 35mm negative. Thus, a bigger enlargement can be made from it. If you desire the larger format, the TLR is probably the best choice since large-format SLRs are quite expensive.

The major problems with the twin-lens reflex are parallax, size, speed, viewing, and versatility. Parallax is a problem except in the

best of these cameras. Because most TLRs use a large film size, they are bigger and more cumbersome to carry around. Another problem is that while they provide a large, flat viewing screen for focusing and composing, the image on the screen is reversed, left to right. It takes practice to compensate for this. Another drawback is that most of these cameras do not offer lens interchangeability. However, for those people who like to photograph scenery, architecture, or still-lifes, or who simply want a larger negative for better enlarging quality, the TLR should be considered.

The view camera has the advantages of both a through-the-lens viewing system and a large negative size. If the photographer works precisely and methodically and wants a sharp, high quality negative, the view camera is considered ideal. View cameras work like an accordion, with a lens in front and a ground glass viewing screen opposite the lens. They are focused by moving the lens back and forward. The view camera is the ideal choice for product illustrations, super-sharp close-ups, portraits, and studio photography. It is also the choice for the photographer who wants to control distortion, because the film plane and lens can be tilted, raised, and lowered. No camera is better for architectural work.

All view cameras use film that is cut to a particular size, called cut film or sheet film. The most popular size is 4″ × 5″, although it comes as large as 11″ × 14″. Such a large negative produces an excellent print, assuming all the other variables are constant.

2¼ twin-lens reflex

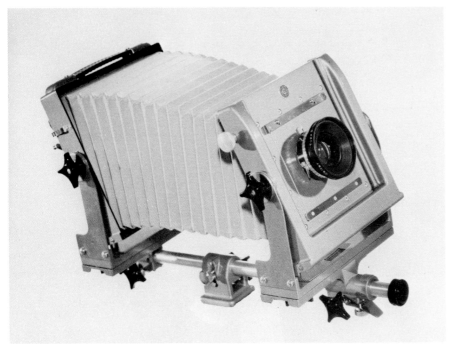

view camera

The view camera, however, is not the ideal choice for all types of photography, especially when speed is important. A tripod must be used because of the camera's size and weight. The image on the viewing screen is not bright. Photographers often drape a dark cloth over the camera to block out strong light so they can see to focus better. Also, the image on the viewfinder is reversed and upside down. Getting used to that is also a problem. Finally, there is the cut film itself, which must be loaded by the photographer into sheet film holders. Each holder, however, can hold only one piece of film on each side, giving only two exposures for each holder. The photographer who uses a view camera generally must carry a number of holders to take several exposures. If you want the highest quality negative and are willing to sacrifice speed and convenience, the view camera, when used properly, has no equal.

Other Camera Types

Certain kinds of cameras cannot be classified by type of view-finder. These usually use special kinds of film. These cameras are (1) subminiature, (2) cartridge-load, (3) instant, (4) three-dimensional, and (5) panoramic. The tiny subminiature camera was developed as a high-precision instrument for espionage work during World War II. After the war, they became popular with the general public. Some of them are as small as a pack of gum. Because of their size, they produce a very small negative, some of them four times smaller than a 35mm negative. Subminiatures are useful because you can carry them in a pocket or purse. However, they require special equipment for processing and, at best, do not yield a very good quality print much larger than 3½″ × 5″.

subminiature

When the concept of Instamatic® photography was introduced in 1963 by the Eastman Kodak Company, it virtually eliminated film-loading problems for even the most amateur photographer. After the original 126 film-size Instamatic was introduced, another smaller film size, the 110 or Pocket Instamatic®, was developed. Both Instamatic-type cameras use cartridge-loaded film that is dropped into the camera. The least expensive of these cameras are basically "box cameras." That is, their lenses are quite crude, they are pre-focused at about 8 feet, and they have only two shutter speeds, one for flash and the other for outdoor use. The more expensive cartridge-load cameras have better optics as well as devices for focusing. Some also have automatic exposure systems, which, when combined with a good lens and focusing, will yield a fairly good negative. However, even the best cartridge camera will not yield as good a negative and print as a good 35mm properly used.

disc camera

The disc-loading camera, first introduced in 1981, is basically an evolutionary step in the development of cameras made for mass merchandising. With this camera, negatives are held separate from each other (as opposed to a roll) by a plastic disc. Like its immediate predecessor, the disc camera is aimed primarily at a market which

instant camera

does not, in any way and under any circumstances, want to learn anything about photography. Because of this assumption, only color film is made.

When George Eastman named his first camera the "Kodak," the name caught on until it became a household word synonymous with photography. And when Dr. Edwin H. Land introduced his Polaroid Land® camera in the late 1940s, that name became synonymous with instant-picture photography. There are many different Polaroid® models, varying in cost and features. They use only Polaroid® film, which is available in both black and white and color. Some of these films yield a fully developed black-and-white negative and positive in a matter of minutes. Some of the more sophisticated Polaroid® cameras do not have built-in automatic exposure systems. In addition, both Kodak and Fuji manufacture instant cameras. Currently, the only film made for these cameras is for color prints.

The idea behind three-dimensional (3-D) photography is older than photography itself. A photograph is always a two-dimensional representation of three-dimensional reality (holography and copying aside). Three-dimensional (also called stereo) photography attempts to recreate the missing dimension, depth. Until recently, stereo photography consisted of a camera which took two pictures simultaneously from slightly different angles that were then viewed together with the aid of special glasses or a viewer. This time-honored system brought complaints of headaches from those who viewed the pictures and a reasonable degree of success in recreating the illusion of depth.

Modern technology offers the Nimslo camera, which again gives the illusion of depth perception. This specially designed camera takes four pictures at once onto a roll of color negative film. A distinctive

3-D camera

panoramic camera

(and secret) process is then employed that combines the four images onto a photo-sensitive lenticular screen. The image produced is not unlike 3–D postcards.

The panoramic camera allows the photographer to record wide field views of subjects or scenes without the usual distortion associated with wide-angle lenses. How wide is wide? For example, a 20mm lens mounted on a 35mm camera allows about a 95° angle of acceptance. However, most panoramic cameras will permit an angle of acceptance of 180°, while some are capable of a full 360° without distortion. Panoramic cameras are used for scenic views, group shots, architectural work, and topography (mapping).

Buying a Camera

The purchase of a camera will probably represent a large investment for you. Thus, purchasing a new camera requires some investigation. Some of the factors that should be considered are the negative format, versatility, size, weight, type of built-in meter, availability of service, and of course, price.

The price of the camera does not always determine the quality of the camera. Camera manufacturers are in a state of war with each other. The claims and counterclaims in these advertisements can leave one somewhat dazzled. Many of the advertisements promote a life-style one can expect if one buys that particular camera; some appeal to potential consumers on the basis of status, while a few others promote themselves to consumers on the basis of sex. All of this has nothing to do with the quality of the camera. For the most part, any brand name camera will perform well given proper care and usage.

176

a modern camera system

Generally, the more expensive the camera, the more versatility and features it offers. Some of these features may include motor drive capability for sequence shooting and interchangeable backs to accept different film formats. For example, some 35mm cameras can use Polaroid film with a different back attached to it, while some backs will imprint information in the negative. This information may be important for classifications of records. Some cameras offer interchangeable focusing screens that may be critical for architectural work or microphotography. Other features today may include a built-in power film advance, automatic focusing, LED and LCD exposure readouts in the viewfinder and an array of specialized lenses. Many cameras, especially 35mm SLRs have automatic exposure control; some are shutter speed preferred (you select the shutter speed, it selects the *f*/stop) or *f*/stop priority. Some will allow you to do both at your option, while a few will do both for you. In other words, some cameras have become electronic toys, so that it is first necessary to determine your needs and separate that from your wants.

The negative format of the camera will, to some extent, determine the type of photography you can do as well as the size and quality of the finished photograph. Many people consider the 35mm as the best compromise, but remember that a larger negative format will allow for bigger enlargements of superior quality when compared to a small negative.

The size and weight of a camera is, of course, partially determined by the negative format. Small negative cameras need not be big, while large format cameras are larger and heavier. However, as the negative becomes smaller, the image becomes grainier as it is enlarged.

In most cases the maker will have a *list* price on its equipment. However, these prices are almost always discounted, sometimes as

much as 50 percent. It is always a good idea to shop around at several stores. Some personnel at camera shops will spend more time explaining different models and operations of cameras than others, which may be worth any added expense to get the extra service.

One popular rip-off performed by the less ethical dealer is the selling of *gray-market* equipment. This equipment is imported into the country bypassing the official distributor. The result is that the equipment is not covered by the manufacturer's warranty. Be sure that you buy equipment with an official warranty card issued by the manufacturer.

Another trick used by a small minority of dealers is the removal of items that normally come packed with the equipment (such as, a lens cap, battery, and strap).

Some people, especially those in areas with few camera shops, prefer to purchase by mail-order since the prices are very competitive. However, the disadvantages of mail-order shopping include merchandise that is often out-of-stock, lack of service, misleading prices (always read the fine print), and the problems already discussed.

In summary, (1) it is a bad idea to base a camera's quality on the amount of advertising done to promote it, (2) it is equally as bad to purchase a camera because a friend of yours has one and gets good pictures from it (which just confirms that the person knows how to use it correctly), (3) set some sort of price limit before you buy, and buy it from a dealer who will spend the time to show you how to operate and service it for you, and (4) decide on the features that are important for you and not on the status of owning an electronic toy.

Used Equipment

Many photographers cannot afford a new camera, and so they turn to used equipment. By shopping carefully, they can probably find a fairly recent model in good condition at a reasonable price. Although some photographers think they must have all the latest features, this is not really true. Although you may, when buying a used camera, end up with someone else's troubles, most photo dealers are reliable and will let you return a used camera if it is not working right. Usually a camera is sold either because its owner didn't understand how to use it, or because it was old and didn't have all the latest features.

When buying a used camera, look it over for signs of misuse. Dents or rust in the body or around the lens rim indicate that the camera was dropped or banged. While it may still be usable, it probably is not worth the risk to buy it. Look at the rear and front sides of a lens to see if the lens is free from scratches. Make sure the aperture ring on the lens turns and stops at each f/stop setting. The focusing ring, like the aperture ring, should turn smoothly, not too tight or too close. If the lens is interchangeable, remove it from the body to check the wear and tear on the lens mount. Next, check the shutter speeds. With older cameras, the slower speeds tend to

stay open, or stick. Shutter overhauls are very expensive. If the camera has a built-in meter, check it against a hand-held meter using an 18 percent gray card. If possible, try the equipment first by shooting a roll of film. Use a 36-exposure roll of film to check for overlapping negative frames on the processed roll. Check the developed negatives for even sharpness edge to edge.

In any case, get a warranty in writing. Most camera shops will provide a short-term, written warranty (30 to 90 days being the norm). A private party may or may not be willing to do the same.

Camera Care

The camera you are using is a fine, precision instrument. It was made with great care and contains a great many moving parts, which must work in harmony. Continual attention to your camera is primarily common sense care. The following are some basic tips for keeping your camera in good condition.

Storage. When the camera is not in use, it should be protected from dust, preferably in a case. Avoid storing the camera in excessively hot, cold, or damp places. Normal room temperature is best. Always attach a body cap when the camera body is to be stored separately. Never leave the shutter or self-timer cocked if the camera is to be stored overnight or longer. Remove any batteries if the camera is not to be used for several weeks. Batteries can leak causing corrosion.

Camera Body. Brush the inside of the camera periodically using a soft brush. This is especially important after you have used the camera on a beach, or other conditions where dust or sand can infiltrate into the mechanism. If you have an SLR, keep the mirror free from fingerprints and dust.

Usage. Keep the camera away from water. Avoid excessive moisture. If the camera is to be used near water, guard it against splashes, especially from salt water. If some lever or turning part does not move with the usual pressure, do not force it. If this happens, it is usually caused by an oversight in the sequence of operation. The shutter will not trip, for example, unless it is cocked, or unless the film is advanced in an automatic cocking camera. No amount of pressure on the shutter release will activate the shutter. When all steps of operations have been checked, and the mechanism still does not operate with normal pressure it's time to see a camera repairperson.

Repairs. Camera repairs are expensive. If a repair is in order, obtain a written estimate of the cost from a reliable repair shop before approving any work. Be prepared for some shops to charge for estimates. Be sure that any work done is covered by a written warranty. New cameras are covered with a warranty that is issued by the maker, usually for a period of one year after purchase. If this is the case, return the camera to the store where you bought it.

Camera Manufacturers and Distributors

All camera manufacturers or their distributors supply information about their particular line of equipment. Simply write them a letter asking for information.

AGFA
Agfa-Gevaert, Inc.
275 North St.
Teterboro, N.J. 07608

ANSCO
Ansco Photo Products
155 Louis Ave.
Elk Grove Village, Ill. 60007

BRONICA
GMI-Photographic
1776 New Highway
Farmingdale, N.Y. 11735

CALUMET
Calumet Scientific
890 Supreme Dr.
Bensenville, Ill. 60106

CANON
Canon U.S.A.
Lake Success Plaza
Lake Success, N.Y. 11042

CHINON
Chinon U.S.A.
43 Faden Rd.
Springfield, N.J. 07081

COSINA
Cosina America
3669 W. 240 St.
Torrance, Calif. 90505

DEARDORFF
L. F. & Sons Deardorff
315 S. Peoria
Chicago, Ill. 60607

EASTMAN KODAK
Eastman Kodak
343 State St.
Rochester, N.Y. 14650

FUJICA
Fuji Film U.S.A.
350 5th Ave.
New York, N.Y. 10001

GLOBUSCOPE
Globuscope, Inc.
1 Union Square W.
New York, N.Y. 10003

HANIMEX PRACTICA
Hanimex (U.S.A.) Inc.
3125 Commercial Ave.
Northbrook, Ill. 60062

HASSELBLAD
Victor Hasselblad Inc.
10 Madison Rd.
Fairfield, N.J. 07006

KONICA
Berkey Marketing Co.
25-20 Brooklyn-Queens
 Expwy. West
Woodside, N.Y. 11377

LEICA
E Leitz, Inc.
24 Link Drive
Rockleigh, N.J. 07647

MINOLTA
Minolta Corp.
101 Williams Drive
Ramsey, N.J. 07466

MINOX
Same address as Leica

NIKON
Nikon, Inc.
623 Stewart Ave.
Garden City, N.Y. 11530

NIMSLO
Nimslo Corp.
3500 McCall Pl.
Atlanta, Ga. 30340

OLYMPUS
Olympus Camera Corp.
Crossways Park
Woodbury, N.Y. 11797

PENTAX
Pentax Corp.
35 Inverness Dr.
Englewood, Colo. 80112

PLAUBEL MAKINA
Copal USA Inc.
16-00 Rt. 208
Fairlawn, N.J. 07410

POLAROID
Polaroid Corp.
549 Technology Sq.
Cambridge, Mass. 02139

RICOH
Ricoh of America
20 Gloria Ln.
Fairfield, N.J. 07006

ROLLEI
Rollei of America
5501 S. Broadway
Littleton, Colo. 80121

VIVITAR
Vivitar Corp.
1630 Steward Ave.
Santa Monica, Calif. 90406

YASHICA
Yashica Inc.
411 Sette Dr.
Paramus, N.J. 07652

In Focus/The Camera

1. The two most popular camera types used by photographers are the rangefinder and the single-lens reflex. Contrast these two camera types in terms of the following: (a) focusing methods, (b) path of light from subject to the photographer's eye, (c) brightness of image in the viewfinder, (d) type of shutter, (e) weight and bulk, (f) availability and use of accessory lenses.
2. If you are using a 35mm camera try to obtain a larger film format camera such as 2¼″ × 2¼″. This can usually be accomplished by renting the camera from a local photo store. Photograph the same subject, under the same lighting conditions, from the same distance with each camera so that you have identical sets of negatives. After developing and printing the negatives from each roll, compare the results from each camera. Keep in mind these factors: (a) image quality, (b) image sharpness, (c) contrast, (d) grain, (e) tonal range.

Special Processes and Techniques

12

One facet of photography is that the more you learn about it, the more you need to know. Every day a new process, product, or technique is introduced which may make obsolete an existing process. Thus, some techniques, which may have taken hours of painstaking patience to create a few years ago, may now be accomplished within a few minutes.

Some special techniques are accomplished by using special equipment, while others require some manipulation in the making of the print. For example, close-up photography is done using special equipment on the camera. This equipment will allow the camera to focus a few inches from the subject. Thus, detail that cannot normally be seen is expanded and enlarged, sometimes much larger than the subject itself.

The printing technique of *solarization* will create images that are part negative and part positive. This effect is not possible with ordinary photographic techniques. This chapter will explain some of the possible alternative ways of taking pictures and making pictures.

Close-Up Photography

In close-up photography, a photographer is attempting to isolate a subject or detail from its context by the use of magnification. An object that may normally be viewed and photographed as totally recognizable at a distance of four feet may appear menacing, threatening, and totally foreign to our visual memory if seen and photographed at a distance of two inches. Therefore, some close-up photographs expand and heighten our visual sense. Many close-up photographs reveal detail and texture that cannot normally be seen, while others form a visual scientific record of objects too small to be seen by the unaided eye.

Definition of Terms

The relationship between the size of the image on the film and the size of the subject being photographed is usually expressed as a ratio, such as 1:1 or 1:10. The first number refers to the image size, while the second number is the subject size. This is the *image ratio* or *reproduction ratio.* When it is expressed as a multiplier, such as 1/10X or 1X, it is often called *magnification.* For example, a one-tenth life-size image is expressed as 1/10X, or 1:10. A life-size reproduction on the negative of a subject is expressed as 1X or 1:1, whereas a twice life-size image on the negative is 2X or 2:1. In many of the data sheets packed with lenses, bellows, or tubes, magnification is given in decimal units, such as 0.10 (1/10X) or 1/0 = (1X).

Unfortunately, the advertising world has succeeded in creating a word game out of close-up photography. The following terms are used interchangeably, and all indicate close-up photography: *Microphotography, photomicrography* and *close-focus.* However, in reality, there is a distinction between these terms.

For our part, we will attempt to define these terms in their classical definitions. However, what we may be defining as macrophotography, may be defined as microphotography by another source. Thus, the authors plead for some standardization of terminology.

Macrophotography will be defined here as the term used to describe the recording of a life-size (1:1) reproduction on the negative of a subject with enlargements, reaching its effective limit at magnifications at 10. life-size. *Microphotography* is defined as an image larger than 10. magnification, but not taken through a microscope. *Photomicrography* is any magnified image taken with the use of a microscope. Finally, any image of at least 10. life-size, but not larger than life-size on the negative, is defined as *close-focus.* These terms all apply to the negative image, not enlarged, in ratio to the size of the subject. We are not involving ourselves with the sixty-foot photo-mural of a face on a billboard that is obviously larger than life.

For most types of close-up work, it is preferable to use a single-lens reflex camera with through-the-lens metering and interchangeable lenses. Because you are looking directly through the lens, focusing is considerably easier. The through-the-lens metering simplifies exposure calculations, and many of the close-up attachments require that the lens be removed from the body of the camera.

Supplementary Lenses

The easiest method for taking close-up photographs is with supplementary lenses. These lenses are also called close-up or plus lenses. Essentially, supplementary lenses are positive magnifying glasses of various powers that are attached to the front of the normal taking lens. Supplementary lenses enlarge an image in two ways.

They allow the lens to focus closer to the object than it normally could, and they add their own power to that of the taking lens.

The power of a supplementary lens is expressed in diopters, a term usually reserved for optometrists. The *diopter* describes both the focal length and the magnifying power of the lens. Thus, a +1 diopter lens will focus on an object one meter (3.25 ft.) away. A +2 diopter focuses at half that distance (approximately 19.5 inches). Thus, in effect, it is twice as much. A +3 diopter will magnify three times as much, and so on.

Supplementary lenses of varying diopters can be combined to provide a greater magnification, as long as the strongest lens is attached to the taking lens first. Thus a +2 diopter lens can be added to a +4 to create a +6. However, the image quality tends to suffer when lenses are combined because of some extra lens flare that is created from the two extra glass surfaces.

Once a supplementary lens is attached to the front of the taking lens and set at infinity, the new maximum focusing distance will be that of the focal length of the supplementary lens. This is true regardless of what focal length camera lens is being used. For example, a 50mm lens set at infinity focus, with a +2 diopter, will always focus at an object 19.5 inches away. If a 135mm lens was used instead, and again the focus was set at infinity, with a +2 diopter, it, too, could focus on an object 19.5 inches away. However, the ultimate image size will depend on the focal length of the lens being used. This is because the degree of magnification is determined not only by the diopter of the supplementary lens, but also from the magnifying power of the lens that the diopter is attached to. Thus, a +2 diopter on a 135mm lens will give a greater magnification than a +2 attached to a 50mm lens, if both lenses are set at the focus distance.

Another variable in the magnifying power of supplementary lenses is dependent on the distance set on the focusing scale of the lens. When a lens is focused closer than infinity, it will allow that lens to focus closer, increasing the degree of magnification.

Supplementary lenses are quite popular because they do not require any type of exposure compensation, are inexpensive, and can be used with many types of cameras (although the SLR is recommended). The major disadvantage of supplementary lenses is a loss of resolution and sharpness. Also, since most people seem to use supplementary lenses on normal focal length lenses, which normally do not focus closer than three feet, true macrophotography is not possible unless the negative is enlarged.

The following data is included in the following chart: diopter of the supplementary lens, lens-to-subject distance (in inches), approximate field size of the subject as it will appear on a 35mm negative without enlargement, and finally, magnification ratio based on the use of a 50mm lens focused at infinity. Magnification ratios will increase at closer lens-to-subject distance and/or by using a longer focal length lens.

Close-Up Data for 35 mm Cameras

Close-up Lens and Focus Setting (in feet)		Lens-to-Subject Distance (in inches)	Approximate Field Size (in inches)	
			50 mm Lens on a 35 mm Camera	Magnification Range
+1	Inf	39	18 × 26 3/4	1:20
	15	32 1/4	14 3/4 × 22	1:20
	6	25 1/2	11 3/4 × 17 1/4	1:20
	3 1/2	20 3/8	9 3/8 × 13 3/4	1:20
+2	Inf	19 1/2	9 × 13 1/2	1:10
	15	17 3/4	8 1/8 × 12	1:10
	6	15 1/2	7 1/8 × 10 1/2	1:10
	3 1/2	13 3/8	6 1/8 × 9 1/8	1:10
+3	Inf	13 1/8	6 × 8 7/8	1:6.6
	15	12 1/4	5 5/8 × 8 3/8	1:6.6
	6	11 1/8	5 1/8 × 7 1/2	1:6.6
	3 1/2	10	4 5/8 × 6 3/4	1:6.6
+3 plus +1	Inf	9 7/8	4 1/2 × 6 5/8	1:5
	15	9 3/8	4 1/4 × 6 3/8	1:5
	6	8 5/8	4 × 5 7/8	1:5
	3 1/2	8	3 5/8 × 5 3/8	1:5
+3 plus +2	Inf	7 7/8	3 5/8 × 5 3/8	1:4
	15	7 1/2	3 1/2 × 5 1/8	1:4
	6	7 1/8	3 1/4 × 4 7/8	1:4
	3 1/2	6 5/8	3 × 4 1/2	1:4
+3 plus +3	Inf	6 5/8	3 × 4 1/2	1:2.9
	15	6 3/8	2 7/8 × 4 1/4	1:2.9
	6	6	2 3/4 × 4 1/8	1:2.9
	3 1/2	5 5/8	2 5/8 × 3 7/8	1:2.9

camera attached to bellows

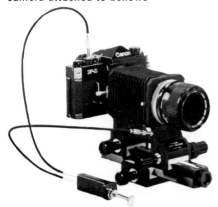

Bellows and Extension Tubes

Another method that can be employed to achieve close-up photography involves the use of extension tubes and bellows. Either accessory is mounted between the body of the camera and the lens. They are, in effect, extending the lens closer to the subject while moving the lens further from the film plane. This will magnify the subject, since the lens is focused on a smaller portion of the subject, but will project the image of that portion onto the same area of the film. Therefore, the closer the lens is focused to the subject, the larger the image size on the film.

Versatility is the major difference between bellows and extension tubes. Extension tubes are rigid metal tubes, which are generally sold in sets of three. Each succeeding tube is larger than the one preceding it. Some common lengths of tubes are 12mm for the shortest,

20mm for the middle length, and 36mm for the longest. Thus, seven different combinations of extension lengths can be achieved, 12mm, 20mm, 32mm, 36mm, 48mm, 56mm, and 68mm. A 12mm extension used with a 50mm lens focused at infinity will allow the subject-to-lens distance measure 10.1 inches, resulting in a ratio of image size to subject size of 0.24. If a 50mm lens is used with the 68mm extension instead, the subject-to-lens distance would only be 3.4 inches, resulting in a greater magnification ratio of 1:36.

Bellows, on the other hand, are made of a flexible material (usually leather), and provide a continuous focus over their extendible range. Bellows are mounted on a rail. In some cases, twin rails are used for support. Thus, while tubes are set at predetermined steps, depending on the length of each tube and how many are used in combination, bellows are flexible over an entire range and, depending on the length of the bellows, offer greater magnification. The rail on the bellows unit almost always has a magnification and a millimeter scale engraved on it. This allows for easier computation of the exposure factor increase. Other variables for bellows units may include a copy attachment for duplicating slides or making negatives from color slides, and lens reversal rings, which allow the lens to be used in the reversed position for greater magnification.

extension tube

Macro Lenses

Macro lenses are specially designed to deliver optimum resolution (sharpness) and contrast for subjects that are focused at close distances. Most standard lenses are designed to deliver their optimum performance at infinity focus; therefore, their quality, in terms of resolution and contrast, falls off at closer distances. A general rule of thumb is when the lens-to-subject distance is equal to the lens-to-film distance, the magnification is life size (1:1). As this distance to the subject is reduced, the magnification increases beyond life-size.

Macro lenses are made in various focal lengths to meet different requirements. Some of these focal lengths may include 20mm, 38mm, 50mm, 80mm, and 100mm. Generally, the 20mm, 38mm, and 80mm lenses are used in conjunction with a bellows unit. A 20mm lens mounted on a bellows will normally provide optimum resolution at 5X–12X magnification. A 38mm lens used in conjunction with bellows will allow a magnification range of 2X–6X, while the 80mm is designed to offer optimum resolution at a 1:1 magnification. The 20mm, 38mm, and 80mm are generally designed to be used with photographing flat field copies (similar to copy slides made from books).

The two most common macro focal lengths, however, are the 50mm and 100mm. A 50mm macro can be used in place of a normal 50mm, since both have the same angle of view (47°). The major difference is that most 50mm macro lenses can focus down to approximately 9 inches, which provides a magnification of 1/2 life-size. In addition, if an extension tube is placed between the lens and camera body, a 1:1 image can be obtained. Also, the 50mm

macro lenses

macro lens can be used in reverse position with an adapter, which in combination with extension tubes, would allow for a magnification of up to 4X.

Many photographers prefer the use of a 100mm macro lens. The 100mm is an ideal focal length for general portraiture. In addition, this lens allows twice the working distance of the 50mm macro. This extra distance helps prevent perspective exaggeration with close-ups of three-dimensional objects, and provides a greater distance between the subject and the lens. This allows for more working space between the lens and the subject so that lighting is made more flexible. The 100mm macro lens is used on bellows or tubes in the same manner as the 50mm.

bellows unit

Exposure Considerations

It seems that nothing comes easy in photography. For every rule, there are at least ten exceptions, and so it is true with close-up photography; exposure must be compensated.

The *f*/stop on the lens is a precise indication of the diameter-focal length relationship when focused at infinity. As the lens is focused to closer distances and the lens-to-film distance increases, the light diverges over a wider field. The effect is that less light is received on the film at any given point. However, this effect is not important up to image ratios of 1:8. When the image ratio is closer than this point, an exposure-factor increase is necessary. An exposure-factor is like a filter factor—a certain amount of light has to be increased.

In general, if you are using an SLR camera with through-the-lens metering, your meter will take into account the loss of light due to the lens-to-film distance. This would be true for automatic bellows, or automatic extension tubes. An automatic bellows unit, or automatic extension tubes, usually provide a link-up with the light meter in the camera, and allow for automatic diaphragm control.

With almost all bellows units, a magnification scale is engraved on the rail supporting the bellows. Extension tubes usually come with a chart that supplies the magnification ratio based upon the lens being used with the various combinations of tubes. The chart below lists the combinations of tubes using lengths of 12mm, 20mm, and 36mm with a 50mm lens.

			Close-Up Data for 50mm Lenses*					Exposure Data		
				Subject-to-Lens Distance		Subject-to-Film Distance		Ratio of Image Size to	Exposure Increase	Open lens this many
			Total Tube Extension	mm	inches	mm	inches	Subject Size	Factor**	f-stops***
			0	—	—	—	—	—	1.0	0
	12		12mm	258	10.1	320	12.6	0.24	1.5	½
		20	20mm	175	6.9	245	9.6	0.40	1.9	1
	12	20	32mm	175	5.03	210	8.3	0.64	2.7	1½
		36	36mm	119	4.7	205	8.1	0.72	3.0	1½
12		36	48mm	102	4.01	200	8	0.96	3.8	2
	20	36	56mm	95	3.7	201	7.9	1.12	4.5	2
12	20	36	68mm	87	3.4	205	8.1	1.36	5.6	2½

*The above chart is designed as a guide only. Exact data will vary slightly, depending on the lens/camera combination being used. For best results keep your lens focused at infinity.

**This column shows the factor by which the camera shutter speed must be multiplied if you wish to leave the lens f-stop set as indicated by your meter or exposure chart.

***This column shows the number of f-stops to open your lens if you wish to leave the camera shutter speed set as indicated by your meter or exposure chart.

If you are using a bellows unit with an engraved image ratio, the following chart will provide the necessary exposure factor increase.

EXPOSURE FACTOR TABLE FOR IMAGE MAGNIFICATION

Image Ratio[1]	Exposure Factor[2]	f/Stop Adjustment	Image Ratio	Exposure Factor	f/Stop Adjustment
0.1	1.21	¼	4.8	33.64	5
0.2	1.44	½	5.0	36.00	5 ¼
0.3	1.69	¾	5.2	38.44	5 ¼
0.4	1.96	1	5.4	40.96	5 ¼
0.5	2.25	1 ¼	5.5	42.25	5 ½
0.6	2.56	1 ¼	5.6	43.56	5 ½
0.7	2.89	1 ½	5.8	46.24	5 ½
0.8	3.24	1 ¾	6.0	49.00	5 ½
0.9	3.61	1 ¾	6.2	51.84	5 ¾
1.0	4.00	2	6.4	54.76	5 ¾
1.2	4.84	2 ¼	6.5	56.25	5 ¾
1.4	5.76	2 ½	6.6	57.76	5 ¾
1.5	6.25	2 ¾	6.8	60.84	6
1.6	6.76	2 ¾	7.0	64.00	6
1.8	7.84	3	7.2	67.24	6
2.0	9.00	3 ¼	7.4	70.56	6 ¼
2.2	10.24	3 ¼	7.5	72.25	6 ¼
2.4	11.56	3 ½	7.6	73.96	6 ¼
2.5	12.25	3 ½	7.8	77.44	6 ¼
2.6	12.96	3 ¾	8.0	81.00	6 ¼
2.8	14.44	3 ¾	8.2	84.64	6 ½
3.0	16.00	4	8.4	88.36	6 ½
3.2	17.64	4 ¼	8.5	90.25	6 ½
3.4	19.36	4 ¼	8.6	92.16	6 ½
3.5	20.25	4 ¼	8.8	96.04	6 ½
3.6	21.16	4 ½	9.0	100.00	6 ¾
3.8	23.04	4 ½	9.2	104.04	6 ¾
4.0	25.00	4 ¾	9.4	108.16	6 ¾
4.2	27.04	4 ¾	9.5	110.25	6 ¾
4.4	29.16	4 ¾	9.6	112.36	6 ¾
4.5	30.25	5	9.8	116.64	6 ¾
4.6	31.36	5	10.0	121.00	7

Notes: 1. Image ratios are variously expressed as 0.9x, 9/10, and 9:10, all being equivalent. 1/10x is expressed as 0.1. It may also be expressed as 1:10. Similarly 0.5 equals 1/2x equals 1:2; 1x equals 1:1; 2.6x equals 2.6:1; etc.
2. Shutter speed compensations may be made by multiplying the nominal shutter speed by the shutter factor.

It is possible to estimate image ratios by comparing the size of the subject with the size of the image on either the long or short side of the picture frame (negative size). For example, the format of a 35mm negative is 24mm x 36mm (1 × 1½), so the short side is one inch. If a one-inch portion of your subject fills approximately one-third of the size, the ratio is 1:3. If a one-inch subject fills half the short side of the frame, the ratio is 1:2. In other words, if a half-inch high portion of the subject fills this side (high side) the ratio is 2:1 or 2X. The exposure factor can then roughly be calculated as below:

Image Ratio	Exposure Factor
1:8 to 1:4	1.5X (½ f/stop)
1:3 to 1:2	2X (1 f/stop)
2:3 to 3:4	3X (1½ f/stops)
1:1	4X (2 f/stops)

As mentioned in earlier chapters, depth of field generally advances 1/3 while it recedes 2/3 from the plane of focus. This, however, does not apply for photographs taken at high magnifications. In extreme magnifications, depth of field extends equally in front of, and behind, the plane of focus. The other problem with depth of field is its virtually non-existence at high magnification. For example, at a 1:1 image ratio with an aperture of f/11 the depth of field is about 4/100 inch (1 mm). Thus, as long as the image size remains the same, depth of field will be the same, regardless of the type of lens being used. Using a small f/stop to compensate for shallow depth of field will produce only very small changes.

Another problem often encountered is lighting the subject. All lighting arrangements for extreme close-up photography must be designed to produce an intensity of light in an extremely small area. This is so the exposure times are kept as short as possible, and that the image projected on the focusing screen of the camera is as bright as possible. Thus, focusing is made easier. Because the subjects are small, lights can be brought in quite close to the subject. However, because the lens-to-subject distance is also close, the lens protrusion may interfere with the placement of the light. This is why many photographers prefer the use of a short telephoto (like a 100mm), since the subject-to-lens distance is increased while maintaining the same magnification ratio.

Two problems may occur if the lights are throwing off too much heat; the photographer will be uncomfortable, and there may be possible harm to the subject under the lights. For example, if you are photographing a small insect, using two 500 watt photo-reflector bulbs, you may find your subject a burnt mass of dead animal life. One way to avoid this is with the use of an electronic flash or with

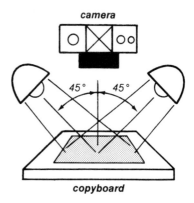

camera

copyboard

reversible tripod

a ring-light. Another possibility is to use one or two small light sources, like a high-intensity desk lamp. Lighting for two-dimensional subjects, like books or postage stamps, will be discussed further on page 193.

Finally, since focusing is so critical in close-up photography, the camera must remain rock-steady. Any vibrations, even if they are caused by passing motor vehicles, will cause the image to be out of focus. The camera must be supported on a tripod with a cable release. An alternative support called a copy stand will be discussed next.

Copying

Copying is the photographic recording of a subject that exists in either two dimensions, (paintings, drawings, or other photographs) or three dimensions (any object that has depth to it). For our purposes, however, we will limit copying to subjects that are essentially two-dimensional.

It is possible that some flat subjects contain some texture, which technically makes them three-dimensional. However, the depth is so shallow (like the brush stroke of a painting), that no part of the subject is out of focus due to depth of field.

The Equipment

Copying is a form of close-up photography. Therefore, much of the equipment discussed in the preceding pages will be used. Again, it is recommended that you use a single-lens reflex camera to eliminate parallax error. Other necessary equipment includes a cable release, a light meter, an 18% gray card and two, or four, photoflood lamps and reflectors for illuminating the copy. You will also need a tripod with a reversible column or a copy stand.

A copy stand is very much like an enlarger except without the head. It consists of a vertical pole, an adjustable arm that can move up or down the pole, and a camera-holding plate or head. When mounted on a copy stand, the camera can be used with any of the close-up devices discussed earlier, since the stand will provide the necessary support. The two-dimensional subject that is to be copied is placed on the baseboard of the copy stand. Sometimes, one or two reflector photoflood lights can be mounted on the baseboard or on the pole of the copy stand, to supply the necessary lighting.

Some tripods have center columns that can be reversed. This will allow for near ground level mounting of the camera. If access to a copy stand is not available, and the tripod's center column cannot be used in a reverse position, the copy (if two-dimensional) can be fixed to a wall or some sort of horizontal surface. This should be done by some means other than sticking pins into the corners, since they will cast undesirable shadows onto the surface of the copy. Remember though, the camera will still have to be on a tripod, and should be positioned center and parallel in relation to the subject.

copy stand

Lighting

The best lighting arrangement for copying is to use two photo-flood lamps, placed symmetrically at a 45° angle on either side of the subject. If the subject being copied is larger than 11 × 14 inches, a second light can be added to both sides. The distance between the light source and the subject should be far enough apart to flood the surface with a strong intensity of light. It should be even across the entire subject, so that the edges are not brighter than the center of the subject. One way to check this is with the use of an exposure meter. If it registers different from one edge to another, you know your lights are uneven. Another technique is to hold a pencil perpendicular to the copy at its center, in line with the optical axis of the lens, and then comparing the shadows cast by the pencil stem. If the shadows are of equal intensity and the length is the same on both sides of the stem, the lighting is balanced.

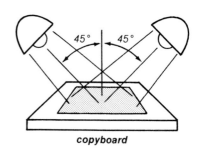
copyboard

With a large subject, like a painting, this standard setup can be altered by arranging the lights at a more oblique angle, and directing them so that they illuminate the subject from edge to edge. This will help bring out the brush stroke and texture of the painting.

The size of the reflector used will also alter the illumination. A bullet reflector, which is generally about 4″ in diameter, will not distribute the light at as wide of an angle as would a 12″ reflector. Thus, for very small subjects, use a small reflector; for large subjects, use a reflector with a large diameter.

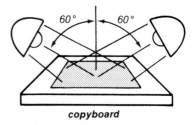
copyboard

Subjects that are covered over with glass will sometimes cause a glare. Changing the angle of the lamps might eliminate this. Should this method fail, you may need to use a polarizing filter on both the lens and the reflectors. Polarizing filters are sold in large sheets for this purpose.

Exposure Considerations

By far and away, the easiest method for exposure determination for copying is with the use of an 18% gray card (Kodak Neutral Test Card). This card can be used for determining the exposure for both black and white, and color films. To use, place the card in the same plane as the subject that is to be copied, and take a normal reflected light reading. If you are using a hand-held meter, be careful not to cast a shadow over the card by getting your arm in the way of the lamps. Remember, if the subject is closer than eight times the focal length of the lens being used (8X), an increase in the exposure is necessary. See page 190 for exposure factors in close-up photography. It is always a good idea to bracket your exposures.

Films for Copying

Several factors must be considered in choosing a black and white film: (1) the tonal scale of the subject, (2) the color of the original, and (3) the use of the copy. If color films are used, add Kelvin temperature to the list.

There are many films specifically designed for copy work. Many of these are designed for large format cameras for professional use. Some copy films are made only in 100 foot rolls so that it is necessary to load the film yourself into a film cassette with a bulk film loader. However, there are a couple of films that are often used for copy work of a general nature.

If the subject is black and white (like a photograph from a book or another photograph) and you want to make a negative of it, you need to use a continuous tone film such as Kodak's Panatomic-X, or Plus-X. If what you are copying is essentially black and white (like a pencil drawing), you need a film that will render the image in high contrast, like Kodak Tri-X Ortho.

For extremely high contrast, one which will render the subject either a stark black or a stark white, use Kodak Kodalith Ortho 6556, Type 3. (More about Kodalith later in this chapter.)

To make continuous tone black and white slides, use Kodak Panatomic-X. Normally, this film has an ASA of 32. However, for copy work expose it at a speed of 64 (80 for outdoor use). Panatomic-X exposed as a positive black and white film requires special processing. Kodak makes a kit for this purpose: Direct Positive Film Developing Outfit.

To make color slides, you must balance the film to the light source. If you are using 3400K° photofloods, use Kodachrome 40 (KPA). Bulbs of 3200K° require either Ektachrome 50 (EPY), or Ektachrome 160 (ET). Daylight film is not recommended for copy work.

High-Contrast Images

High-contrast effects can be achieved with the camera using either a slow-speed film (such as Ilford Pan F, Agfa 25, or Kodak Panatomic-X), or as you just learned, by special purpose copy film. It is also possible to use some high-contrast copy film outdoors.

When a scene is photographed on high-contrast film, the mid-range tones in both the highlight and shadow regions of the image are lost. This is dependent on the film used, the exposure, the processing technique used, and the lighting of the original scene. The high-contrast effect can further be exaggerated by printing on a high-contrast paper (like #5).

Copy films appear almost grainless, even at great enlargement. Thus, by altering them through exposure and development, some photographers use them for general photography and achieve a full-tonal range.

With the standard pictorial films, high-contrast can be accomplished by selecting a high-contrast scene and by basing the exposure on a selective (spot) reading of the highlight area. This will, in effect, put the darker portions of the scene beyond the exposure latitude of the film. Thus, no image will be recorded in the shadow

areas. With overdevelopment, the highlights will block up in the negative but will have little, if any, effect on the shadows; thus the increase of contrast.

Another way to increase contrast with standard panchromatic films is to underexpose the scene by one stop, and increase the development time 50%.

At this point, we know that we can achieve a high-contrast effect by either copying the original image onto a high-contrast film like Kodalith or high-contrast copy. We also know that high-contrast copy films can be used to take the photograph in the first place. We also know that we can achieve a high-contrast effect using a slow pictorial film and altering the exposure and development. However, many photographers use another method, which involves the use of an enlarger.

Darkroom Effects

It is possible to take a standard negative and enlarge it onto a high-contrast sheet film. One such film is Kodalith Ortho film, Type 3 by Kodak. (Other graphic arts materials are available from Agfa and Ilford.) These materials are often called "lithographic" or "lith" film because they are often used in the printing industry. Most of them are blue-sensitive and thus can be handled under a red safelight.

To make a high-contrast positive, first select a suitable negative. Generally, it should consist of bold simple outlines and contain some patterned detail. The high-contrast sheet film is made in sizes that include 4 × 5 or 8 × 10. You will probably want to use 8 × 10, as it can be contact printed with the photo paper.

High-contrast sheet film is handled as though it were enlarging paper. Insert the negative into the enlarger and expose onto the emulsion side of the film.

Since Kodalith Ortho film Type 3 is readily available, we will assume you are using that. Enlarge in the normal manner onto the film.

Step 2 is developing the ortho film. For ultimate contrast, use a high-contrast developer like Kodalith Super for approximately 2¾

Kodalith negative print

minutes at 68° with continuous agitation. After developing, use a stop bath for 10 seconds. Next, fix the image in a fast working fixer like Kodak Rapid Fix for 1½ minutes. Now wash the film for 10 minutes. Use a wetting agent and hang it up to dry from a line using clothespins or film clips.

Positive or Negative

The result is an enlarged positive transparency. Sometimes this enlarged transparency contains small pinholes, or clear specks in the dark areas. These are caused by dust on the film, or from under-exposure. They can be blocked out by using a material known as *opaque*. The opaque is brushed directly onto the transparency. If this enlarged positive transparency was contact printed onto standard photo paper at this point, you would have a high-contrast negative print. If you want to make a high-contrast positive print, you first need to make a high-contrast negative. This is easily done by laying your high-contrast positive on top of another sheet of Kodalith film and exposing it like you would a contact print. This will result in a high-contrast negative which then could be contact printed onto a sheet of photo paper, resulting in a high-contrast positive print.

Kodalith positive print

negative and positive Kodalith print

Kodalith positive line copy

part negative, part positive Kodalith line copy

A Line Print

A line print is similar in effect to a pen and ink drawing. However, it is photographically done. You already have all the necessary ingredients for a line print from the last exercise. All you need to do is place the enlarged high-contrast negative on top of the enlarged high-contrast positive. Align them so that they overlap exactly. The result will look opaque, or solid black. However, from an angle, light can pass through the outlines of the paired images. Tape the edges of the two images together. Next, place the paired images into a contact print over a sheet of unexposed Kodalith. Place the frame on a lazy Susan tray or a record turntable. Expose the image using a 100 watt frosted light bulb placed at a 45° angle approximately 3 feet from the rotating device. Now rotate the turntable, or tray, for a 15 second exposure under the light. Develop the Kodalith film in the usual manner. The result is a line picture on film. The line picture can be copied directly onto another sheet of film to reverse the image and then contact printed onto a sheet of photo paper. In other words, you can have a clear-line-on-black background, or by reversal, have a black-line-on-white background.

There are many variations using high-contrast films. For example, take any 35mm negative and make an 8 × 10 Kodalith negative and positive. Next, without disturbing the negative in the enlarger, or the easel that was used to hold the 8 × 10 Kodalith, place a sheet of

Normal negative enlarged over a Kodalith negative.

normal photo paper under the Kodalith. Next, lay either the Kodalith negative or positive on the easel over the photo paper. Now with the negative already in the enlarger, expose the paper in the normal manner. The result will be part high-contrast and part normal-tone photograph.

Color in High-Contrast

It is also possible to color tone either the high-contrast film or print in the same manner as described in Chapter 6. Thus, you can sandwich a Kodalith negative of one color on top of a Kodalith positive of another color, then lay it on a small light table and copy it into a color transparency film. Or, you can make several negatives or positives of the same subject but of varying exposure. Each negative, or positive, is then toned using one of the chemical toners like Edwal Color toner or Edwal Fototints. Sandwiched together, the effect can be quite striking. Again, the image can be rephotographed on a copy stand as long as the light illuminating from underneath and the bulbs are color balanced for the film.

Another way to produce a colored posterization is to use diazo materials used by display artists. These are sold under the trade names, Transparex, Color-Guide, and Color-Key. Most of these materials are sold at art supply stores, or graphic arts dealers. Instructions for their use is packed with the material.

Multiple Printing

An entirely different effect is accomplished by multiple printing. Two or more images can be printed together (known as a sandwich), or sequentially on the same sheet of paper for a multiple-exposure effect. When the negatives are sandwiched together, you will produce an effect that is similar to a multiple exposure in the camera. Each image appears stronger, or more visible in the thin shadow regions of the other negative. When the negatives are exposed sequentially, (printing one image first) and then the next image on top of that, the second image appears most visible in the highlight regions of the first image printed. This effect cannot be accomplished by using the camera for multiple exposure.

When a negative sandwich is made, the negatives should generally be placed together emulsion to emulsion. If they are placed with the plastic side facing each other, there will be a double layer of film between the images, which will probably cause one of the images to be slightly out of focus. You may like the effect of the second image slightly out of focus, in which case it can be enhanced by inserting one or more layers of clear film or acetate between the negatives.

In the sandwich technique, the density is, of course, increased. Thus, it will be necessary to increase the exposure. There is no formula for success except experimentation.

negative sandwich

When sequential exposures are made, each exposure should be some fraction of the total required for a normal print. The exception being if the second image is to appear entirely within a highlight area of the first image printed due to that area receiving little or no light in the first exposure. Look at the photographs of Jerry Uelsmann to see how well this technique can be carried out.

Texture Screens

A negative of a texture screen can also be printed as a sandwich or sequentially. Texture screens are available commercially in many camera shops, or you make your own. Simply photograph any pattern, regular or irregular, such as burlap, moire patterns, tree bark, sand, cement, fishnets, etc. For some of these you may need to use a close-up attachment. In any case, slightly underexpose the texture negative so it will work better. You can even sandwich lens tissue in contact with a negative.

negative sandwich

A texture screen can also be placed in contact with the photographic paper. Simply lay the screen on top of the photo paper and expose the negative for the normal amount of time. Cheesecloth, gauze, or burlap can all be used in contact with the photo paper. You may also try using a piece of textured glass or plastic in contact with the photo paper.

It is, of course, possible to combine a negative sandwich with a Kodalith positive and expose both through a texture screen. As a matter of fact, there are probably thousands of different variations that are possible to explore with multiple printing, either by sandwiching the negatives (or positives), or by sequential exposure. Add to that the use of texture screens and you have an unlimited opportunity for your imagination to run wild.

Kodalith autoscreen film

Kodak Autoscreen Ortho Film

There is one high-contrast film that already contains a dot pattern. Manufactured by Eastman Kodak, Autoscreen Ortho 2563 will automatically produce a dot pattern, not unlike a magnification of a photograph reproduced in a newspaper. This film, unlike Kodalith Ortho, will allow the image to reproduce an effect similar to a continuous tone, or one with varying degrees of tone. This is because as areas of greater density are increased, the amount of dots increases.

Autoscreen and Kodalith, besides having unlimited use for special effects, are often the base image for photo silk screen film, or emulsion, which serves as a mask during printing. It is one step removed from the photographic process. The silk screen image is printed onto paper (not photographic) by squeezing ink through the screen while it is in contact with the paper. Any number of screens can be used to create an image of various colors. Thus, what begins as a photograph or photographs ends, and the graphic art process begins.

window screening used as a texture screen

Thus, the photographer who has motive and drive, and who may feel bound by some of the limitations of regular photographic processes, may want to experiment with photo-silk screening. However, like photography, photo-silk screening also has a technical side. A single chapter would not provide you with enough information. Thus, we refer you to the following books: *Inko Silk Screen-Printing; Screen Printing Photographic Techniques,* Fossett; *Photographic Screen Printing,* Kosloff; *Silk-Screen Techniques,* Bielgeleisen and Cohn.

Almost any art supply store will carry the necessary material needed. If one is not located nearby, try the following companies: Screen Process Supplies Manufacturing Co., 1199 East 12th St., Oakland, Calif. 94600; Ulano Products & Co. Inc., 210 East 86th St., New York, New York; Rockland Colloid Corp., 302 Piermont Ave., Piermont, New York 10968.

Solarization and the Sabattier Effect

Another unusual effect that produces a negative and positive on the same film or paper is the Sabattier effect. Many people confuse solarization with the Sabattier effect because both techniques produce similar looking results. However, true solarization is coupled by extreme overexposure, approximately 1,000 times the amount needed to produce a normal contrast negative with normal development.

Solarization, like the Sabattier effect, will produce a reversal of the image, both negative and positive on the film. This used to occur quite frequently in long exposures taken at night. The streetlights in a scene would be so overexposed that they would reverse and produce a positive image in the negative. With today's films, however, solarization is next to impossible to obtain due to the improvements in the film itself.

The Sabattier effect will produce both a negative and positive image on the same film or photo paper. The effect is achieved, however, by re-exposing the film during the development stage rather than to overexposure. In effect, when re-exposure occurs, the already developed image acts as a negative through which the rest of the light-sensitive silver in the film or paper is exposed. This results in some reversal of the image. If your re-exposure is long enough, the resulting positive will develop to a greater density than the original negative image.

The Sabattier effect produces a narrow line of low density called a Mackie Line, between the highlight and shadow areas. The Mackie Line occurs because the shadow areas, which have already been exposed, are not that affected by the re-exposure to light. The bright areas, however, still contain many sensitive silver crystals and thus respond to the re-exposure. The bright areas therefore turn gray, but usually remain somewhat lighter than the shadow areas. The silver

Sabattier effect

bromide along the highlight and shadow boundaries retards the development forming a more or less, white or clear line—the Mackie Line.

Since the Sabattier effect can be produced on both film or photographic paper, all one needs is the use of any white-light source for the re-exposure step. The light from the enlarger can be used if the negative is removed first. The hardest part of the Sabattier effect is determining the length of time for the re-exposure. There is an advantage to working with film since you can make as many prints as you want from the negative. It's next to impossible to duplicate a print made using the Sabattier effect.

These are some of the variables that will affect the results: (1) The length of time of the re-exposure, (2) the extent of development after re-exposure, (3) the time during development when the re-exposure takes place, (4) type of film or paper being used, (5) dilution of the developer, and (6) the intensity of the light source.

Kodalith positive print

Kodalith negative print

In general, if the reversal effects are too strong, reduce the re-exposure time, or develop the film or paper longer before giving it the re-exposure. To obtain more reversal, increase the re-exposure time, or make the re-exposure earlier in the development stage. Normally, re-expose the paper or film at about one-third of the development time. Stop agitating the film or paper approximately 10 seconds prior to the re-exposure. This will allow the film or paper to settle to the bottom of the developing tray. After re-exposing, continue the developing with continuous agitation until the normal development time is complete. The following steps can be used as a guideline for producing the Sabattier effect with most fiber base papers.

1. Make a test print in the usual manner and process it in your normal developer. A normal-to-high contrast paper generally works best.
2. Use the time determined by your test print and expose normally.
3. Set your timer for approximately 90 seconds and begin development.
4. Develop the paper with continuous agitation, for 20 seconds. Next, flip the paper so that the emulsion side is up. Without agitating, let it settle to the bottom of the tray for 10 seconds.
5. Re-expose the paper to white light while it's in the developer.
6. After re-exposure, begin agitating until the 90 seconds is up.
7. Continue the normal chemical steps.

Sometimes it is possible to lighten the highlights with the use of a chemical reducer such as Kodak's Farmers Reducer. For more contrast, copy your Sabattier photograph onto Kodalith Ortho Film 6556.

High-contrast films usually produce very dramatic results with the Sabattier effect. The Mackie Line is extremely visible with high-contrast films. Also, because it is on film, you can either make a positive image or a negative image by contact printing one film to another. The following is a guide for producing the Sabattier effect with Kodak Kodalith Ortho Film 6556, Type 3.

1. Make a test print in the usual manner and develop it in a high-contrast developer. (Kodalith Super Developer)
2. Expose the film using the exposure time determined from the test.
3. Set timer for 2¾ minutes. This is the total development time.
4. Immerse the film in the developer, emulsion side up, with continuous agitation for 50 seconds. Then allow the film to settle to the bottom of the tray for 10 seconds. Do not agitate.
5. Re-expose the film to white light.
6. Continue to develop for the remaining time, or pull the film out of the developer when the effect you desire is achieved. Do not agitate.
7. Continue with the remaining chemical steps for the recommended time.

In Focus/Special Processes and Techniques

1. Through the use of some close-up device, use your camera to explore small portions of common objects such as vegetables, furniture, and automobiles. You will find that ordinary objects will take on new characteristics when viewed a small part at a time through a close-up lens or bellows extension.
2. We have discussed three ways to create high-contrast photographs: (a) underexposure and overdevelopment, (b) use of high-contrast copy film, and (c) enlarging a standard negative onto Kodalith Ortho film.

 When a photograph with a normal range of tones is rendered in high-contrast, the composition becomes flat due to the absence of a gradation of tones. The resulting graphic composition must be evaluated as an abstract pattern of black and white shapes. Keeping this in mind, print a series of photographs in both normal and high methods in order to study the changes that take place.
3. The use of multiple images through both the sandwiching of negatives and sequential printing, makes available a great range of image manipulation. There is possibility for numerous combinations.

 After some experimentation with available negatives, try to pre-visualize a finished photograph that makes use of multiple images. Shoot photographs specifically for this purpose. As you do more multiple printing, you will develop an ability to shoot what you know can be used with existing shots, creating your finished product.

A History of Photography

13

Photography is not a natural phenomenon; it has its basis in science, and thus, it had to be invented. Because of the value of photography today, it seems surprising that it took so long to be developed. The invention wasn't simply a matter of someone making a camera and putting some film into it for the first time. It evolved over hundreds of years and was much like a jigsaw puzzle. One man would make a small discovery and another man, years later, would build upon that discovery, until the pieces of information finally fit together.

The Camera

There is no way of knowing who constructed the first camera, or, as it is called in Latin, the *camera obscura*. (The principle was known to the Arabian scholar Ibn Al Haitham before 1038.) In its basic form, the camera obscura was a dark chamber or room. Light passed through a small hole at one end of the room and formed an image on the opposite wall. This image was not sharp, as no lenses were attached to the opening in the wall. However, the smaller the hole, the sharper the image, as in pinhole photography. In 1558, Giovanni Pattista della Porta described the camera obscura at length. He was also the first to suggest that the camera obscura be used as a guide for drawing, and it is for this that he is remembered. The application of lenses to camera obscuras (by 1550) increased both the sharpness and brightness of the image and led to further investigations into design and construction.

As more people became interested in them, the size of camera obscuras shrunk, until they became extremely portable (by comparison) and could be used by more people as a help in rendering perspective correctly. In 1676, the first "reflex" camera appeared—for example, one in which the image is reflected onto a top-mounted viewing screen by an inclined mirror behind the lens. All the artist had to do was put a piece of tracing paper on top of the viewing screen and trace the outline. Thus, the camera became part of the artist's tools.

camera obscura

207

Photographic Chemistry

Photographic chemistry came rather late in the long history of the development of the camera. Photographic chemistry refers to the invention of a light sensitive material, an emulsion. The first important discovery was made by Johann Heinrich Schulze, a professor of anatomy at the University of Altorf near Nuremberg.

In 1725, Schulze saturated chalk with nitric acid that contained some silver. Exposing this mixture to the sun, Schulze was amazed to discover that the mixture facing the sun turned dark violet, while the portion turned away from the sun remained white. At first, he believed that the darkening was due to the mixture of chalk and nitric acid, but he failed to repeat this experiment. Some time later, he remembered that the mixture had contained silver, as well as chalk and nitric acid. Finally realizing that it was the silver and nitric acid that caused the darkening by light, Schulze prepared more concentrated solutions, until he was able to form words on the bottles containing the solutions by stenciling out letters and exposing the bottles to direct sunlight. Although Schulze mentioned that it was possible to spread the silver solution on skin, bone, and wood to produce images, he did not do it. At this time, there was no way to make these stencils permanent, and they soon faded away.

Permanent Image

The next important discovery was made by the Swedish chemist Carl Wilhelm Scheele. Scheele confirmed one of Schulze's discoveries; that the blackening effect of the silver salts was due to light and not to heat. To prove this, he spread the white compound on paper and exposed it to the sun for two weeks, during which the paper turned completely black. He then poured ammonia on the powder and then discovered that the blackened silver was metallic silver and had become insoluble in ammonia; that is, the ammonia did not dissolve the exposed silver. The ammonia, in other words, acted as a fixer. Scheele did not realize the importance of his discovery—the ability to make a photographic image permanent. Nor did Scheele conceive the idea of photography, an honor reserved for the Englishman, Thomas Wedgewood.

Thomas Wedgewood, the youngest son of Josiah, the famous potter, was brought up in a scientific atmosphere. The exact dates of his experiments in photography are not known, although they are presumed to be around 1800. Wedgewood did not succeed in making the images he exposed through a camera obscura permanent; so none of them survive today. Although Wedgewood was familiar with Scheele's work, neither Wedgewood nor Scheele realized the importance of the ammonia fixer. Wedgewood was the first, however, to conceive the idea of photography with the use of a portable camera obscura.

The earliest known permanent camera image done from nature was made by a Frenchman, Joseph Nicephore Niepce, at his family's estate near Chalon in 1826. The culmination of an experiment begun ten years earlier, it began the long history of contributions to the development of photography by artists, as Niepce was by trade a lithographer, which in 1813 was a new art. (Lithography is a process whereby a drawing, made with a grease pencil on limestone, can be printed on paper many times over. It began as a method of reproduction and soon became an art form in its own right. After the drawing is made on the limestone, the stone must be treated with a series of chemicals before it is ready to be printed.)

Niepce's son, Isidore, made the drawings on the stone while his father attended to the chemical process. They soon switched to using pewter instead of stone (the material on which the first photograph was made) because limestone was difficult to get locally. The next year, Isidore joined the army, which caused a problem since Joseph Niepce was not able to draw very well. It was at this point that Niepce began to look for a way to make the action of light etch the pictures into the pewter plate.

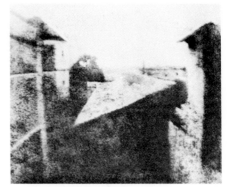

Joseph Nicephore Niepce, *Heliograph, 1826*

Heliography

It is important to note that Niepce did not set out to make a photograph; he set out to make a photo-lithograph, trying to reproduce copies of drawings and paintings, which he succeeded in doing in 1822. He called his process heliography (sunwriting). In 1826, Niepce succeeded in making the first permanent photograph from nature using a camera obscura. The *heliograph* was made on a pewter plate, and it took eight hours for the image to be recorded!

In that same year, Niepce received a letter from a Parisian painter, Louis Jacques Mande Daguerre, who worked primarily with oils. Daguerre mentioned that he, too, had been working with light images and asked Niepce about his progress. Niepce was at first very cautious in replying to Daguerre, but after Daguerre visited him and the two men corresponded further, they formed a partnership in 1829. Their partnership, however, did not produce any noticeable improvement in making photography practicable. In 1833 Niepce— the inventor of photography—died.

Daguerre made photography practical. He improved the process so much that he felt justified in naming the product the "Daguerreotype." In August 1839, the French government honored Daguerre with a life pension and gave to the world, as public property, the Daguerrotype process—everywhere, that is, except England, where Daguerre had secretly patented the process.

J. Sidney Miller, *photographer, circa 1854,*
1/6 plate Daguerreotype

The Daguerreotype

The process of Daguerre was as follows. A sheet of copper was plated with silver—the silver surface being well cleaned and highly polished. The silver surface was exposed, in a small box, to iodine vapor until the surface was a golden yellow. The sensitized surface was then placed in a camera obscura, where it remained for five or six minutes. It was then taken from the camera and developed in a vapor derived from mercury. Then the plate was washed and dried, after which it was placed in a case with a sheet of glass over the Daguerreotype to protect its surface, as it is very easy to rub the image off the plate.

A well-exposed Daguerreotype is possibly the most beautiful form of photography. It possesses brilliance because of the silver surface and shows detail far better than any modern paper print. Of course, there are some outstanding defects in a Daguerreotype. The image can be seen only when it is held in a certain position; otherwise it simply reflects light over its surface because of its mirrorlike quality. Another defect of the Daguerreotype was that only one copy of the image could be made from each exposure.

Even with these defects, the Daguerreotype was the most important photographic process for more than fifteen years, and especially

in America, where many improvements were made. The most important improvement was the shorter exposure time it took to make the image. At first, the exposure time needed to make a Daguerreotype was five to twenty minutes—too long to make portraits feasible. By the end of 1840, however, several Americans had made significant improvements, so that the exposure time was cut to a few seconds. This, of course, made portraits possible, and by 1841 the first "chain" of portrait galleries was opened—by John Plumbe. There were also men who taught the art of the Daguerreotype, the most notable of whom was Samuel F. B. Morse, the inventor of the telegraph, who had met Daguerre in Paris while demonstrating his invention.

The list of those who studied under Morse reads like a Who's Who of photography: Edward Anthony, who started the photographic supply house E. Anthony and Company (which later became Ansco and now is known as GAF); Albert S. Southworth, who started the firm of Southworth and Hawes and was the best of the Daguerrian artists; and Mathew Brady, who opened his own chain of Daguerrian galleries (and, of course, documented the Civil War). Because of his teaching record, Samuel Morse earned the title Father of American Photography.

The Calotype

Men from all corners of the world praised Daguerre and his wonderful invention, never mentioning Niepce as the true inventor. Yet, there was one man who heard the news with dismay. An English country gentleman, William Henry Fox Talbot, saw Daguerre's method as a threat to his own process, the calotype—or, as it was known later, the Talbotype. Talbot began his experiments in 1834 after returning from a trip to Italy, where he drew landscapes. His first successful images, made in 1835, were of leaves and lace laid down on sensitized paper and fixed in salt water, which was also Daguerre's first method. (These are negative images on paper, today referred to as *photograms*.) Talbot made very little progress in the next three years because his attention was diverted to other matters. It was not until he received news of the impending announcement of Daguerre's method that he sought his place of honor. His actions from then on appear not to be those of an English gentleman.

Less than two weeks after the French government released the news of the Daguerreotype, Talbot visited John Frederick William Herschel, a prominent mathematician, astronomer, and chemist who was interested in photography from a chemist's viewpoint. Herschel was a generous man, and when Talbot visited him he described in detail a chemical he had invented that he called hyposulphite of soda. (This chemical is still in use today, known as "fixer." It makes photographic negatives and prints permanent.) Talbot, on the other hand, revealed nothing of his process. He immediately put Herschel's "hypo" to use, and when Talbot wrote to the French government of his method, Daguerre immediately applied it to his own process.

Hill and Adamson, *photographers, circa 1845, calotype*

211

Herschel not only discovered fixer, he coined the word *photography,* which comes from the Greek words meaning "light writing." Herschel used the term to differentiate between Talbot's negative paper prints and Daguerre's positive image method that used copper plates.

The calotype process could not compete with the Daguerreotype for several reasons. Perhaps the worst stumbling block in its evolution was Talbot himself, who patented the process and its improvements, and sold them upon receipt of a large amount of money. However, Talbot must receive the credit for inventing the photographic process we use today—that is, the negative-positive relationship.

In 1847, eight years after Daguerre and Talbot made public their discoveries and fourteen years after Joseph Niepce died, a cousin of the latter, Abel Niepce de Saint-Victor, invented a process for

Postmortem. *¼ plate-tintype by unknown American photographer, c. 1880.*

photographer unknown, *circa 1858, 1/6 plate ambrotype*

c.d.v. photograph, Rudd and Penny Photographers, *circa 1880, San Jose de Costa Rica*

sensitizing a glass plate with an emulsion of silver iodide and fresh, whipped eggwhite (albumin). The mixture was not very sensitive to light, but it was capable of rendering fine detail and good tone, which the calotype negative was unable to do. Talbot patented a slight modification of this albumin-on-glass process in 1849, even though this method used a glass negative instead of—as with Talbot's calotype—a negative made of paper.

The Wet-Collodin Process

Another, and more important, invention was made by an English sculptor, Frederick Scott Archer. Archer learned the calotype process in 1847 and decided to improve it. In March of 1851, he gave the world the "wet collodin" negative; but the advantage of the wet colloding process was difficult to obtain. A glass plate had to be cleaned, after which iodized collodin was poured on the plate, which was then immersed in a silver-nitrate bath and put into the camera while still wet. Development had to be performed before the plate dried, and because of this, it became known as the "wet plate" process. Again, Talbot claimed that the wet-plate process was an infringement upon his patented calotype, and he prosecuted anyone who didn't buy a license from him to use it. Finally, in December 1854, the courts found Talbot's claim illegal and released the process.

By 1858, the Daguerreotype was being replaced by the wet-collodin process. One variation of this process was known as the ambrotype, which was less difficult to make than the Daguerreotype. (An ambrotype is an underexposed wet-collodin negative on glass. When the ambrotype is mounted against a black backing, it appears like a positive.) Ambrotypes did not match the tonal range of a Daguerreotype. However, because they were quicker to make, they became very popular. Like the Daguerreotype, ambrotypes could not be duplicated, so copies could not be made.

The tintype was a variant of the ambrotype. Originally called a Ferrotype or Melainotype, it produced a positive image, usually on a thin sheet of iron (though some were made on leather and other materials). Tintypes were cheaper and easier to make than ambrotypes, and they were unbreakable. However, they lacked the tonal range of an ambrotype. Tintypes were made by the millions up to modern times.

Another type that was popular in the 1850s, along with the ambrotype, was the *cartes-de-visite,* a photographic visiting card. The fad began in France but soon was found almost everywhere: small photographs, the size of a business card, with a portrait or scene mounted to a cardboard backing. They were made by using a wet-plate negative, and thus, any number of prints could be made. Because of this, they were cheap and their popularity was enormous. (By 1860—with ambrotypes, tintypes, and *cartes-de-visite* being made at the same time—the Daguerreotype became a dead art.)

Roll Film

By 1880, the *wet* plate became dry, and thus a picture could be exposed and then developed weeks later. An amateur photographer of this period, George Eastman, became interested in the manufacture of dry plates. In December 1880, the Anthony Company (GAF today) began the sale of the Eastman dry plates. Some people, however, began to dream of a flexible film. On September 4, 1888, Eastman patented a camera that was loaded with a roll of flexible film capable of 100 exposures. The camera sold for $25, and its slogan was "You press the button; we do the rest." It was named the Kodak.

When the 100 pictures were taken, the camera was mailed to the company, where (for $10) the film was removed and processed, prints were made, fresh film was reloaded, and the camera was returned to the sender with the finished prints.

The idea caught on, and in no time "Kodak" was a household name. Photography was now in the reach of everyone.

Photographers, Directions and Movements

Portraits. "Give the people what they want," is an old saying. Without question, people wanted portraits; portraits of themselves, portraits of family members and friends, even portaits of people they did not know. Although early portraiture required the sitter to remain still for

photographer unknown, *circa 1889, for a No. 1 Kodak*

several seconds, people still flocked to the galleries, which were springing up in towns everywhere.

Portraits that were done in America before 1855 are generally Daguerreotypes. The Daguerreotypist or "artist" as many referred to themselves, generally fell into three large categories: The itinerant photographer, the competent small operator, and large studio operations.

The itinerant photographer was like a traveling salesperson, going from town to town to peddle his wares, which, in this case, was a photographic portrait. The aim was not necessarily to deliver the best possible portraits, but to make as much money as possible in the shortest period of time. The portraits these photographers took are generally primitive in appearance, even when compared with other Daguerreotypes of the same period. While some of the Daguerreotypes are technically weak, some are quite remarkable as a result of a direct rather than "arty" approach. These itinerant photographers also fulfilled a social need. Due to limited mobility, not everyone who desired a portrait could get to a gallery or studio. In addition, there simply were not that many practicing professional photographers, and there were no amateurs.

There were, however, some areas and towns that could support a "permanent" photographer. It is from many of these small operations that some of the most interesting examples of Daguerrian art have survived. Because these photographers had personal, social, or business ties with the people they photographed, their work showed pride and higher quality than that of itinerant photographers.

photographer unknown, *circa 1880s, cabinet card* **photographer unknown,** *circa 1880s, cabinet card*

In large population centers, there were many photographers from which to choose. Competition and rivalries existed, which created intense advertising designed to entice customers into a particular gallery. These galleries were frequently show pieces of contemporary trends of the time. Ranging sometimes to the bizarre, the New York photographer, Sarony, suspended a large, stuffed alligator from his ceiling.

The large gallery owners seldom took the photographs themselves. Usually one operator was employed to take the picture, another to develop it, a third to case the image, and a fourth to color it, if necessary, and so forth. This was the case in the large New York galleries like Brady's or Gurney's and in the Philadelphia firm of Marcus Root. One important exception to this method of operation was the firm of Southworth and Hawes, whose Daguerrian portraits are still some of the finest ever done.

Each technical improvement or new process further increased the demand for portraiture because of lowered costs passed on to the customer. By the middle 1860s, the photographic album containing pictures of friends, relatives, or famous people was as common in the home as the family Bible. The only major difference between the family album of then and the family album of today, besides the process employed, was the photographer. Then, the photograph was almost certainly taken by a "professional" photographer. Today, we each take our own photographs of our friends and relatives.

Photographs of War

The photographs of the British campaign in the Crimean War of the 1850s was the first war to be extensively photographed. The official photographer, Roger Fenton, outfitted a "photographic van" to serve as a portable darkroom. The process of this time, the wet-plate collodin, required that each negative be developed once it had been exposed. Fenton brought back over three hundred negatives showing battlefields, fortifications, and soldiers. Most of these photographs were taken either before or after a battle, since this process did not lend itself to "instantaneous" scenes.

The American Civil War was a more tempting opportunity for the birth of photojournalism. Mathew Brady, whose role in history began when he photographed the famous people of 1850 with the idea of publishing a book, *The Gallery of Illustrious Americans,* felt impelled to document the Civil War. Brady received President Lincoln's consent but no financial backing for that undertaking. However, Brady was a moderately wealthy man and had little reservation about spending his own money, thinking that after the war many people would buy prints of the battles. He assembled a staff of several men and outfitted them with the materials and equipment they needed to make wet-plate photographs. (Two of these men, Timothy O'Sullivan and Alexander Gardner, later became well known in their own right.)

credited to Mathew Brady

Brady, himself, very rarely left Washington, D.C., so that most of the picture taking was done by his assistants.

This enterprise left Mathew Brady practically destitute; people did not want to be reminded of the all-too-recent and horrible war. The negatives were stored in a warehouse and eventually auctioned off. In 1896, Brady died, penniless. Today, however, his negatives are priceless.

The South, too, had its photographers, such as George F. Cook of Charleston, South Carolina, who at one time was in charge of the Brady Gallery, and A. D. Lytle of Baton Rouge. (Lytle must have led the most dangerous life of all the photographers, for he would photograph Union forces and fortifications and forward his photos to Confederate headquarters.) For the most part, Southern photographers worked under greater hardships than Brady's men because their supplies had to be smuggled in from the North and Europe.

T.H. O'Sullivan, *photographer, 1868, Photographer's Van, Nevada*

Travel Photography

In the mid-1800s, distant lands were being explored, and foreign cultures studied. These explorations stirred people's imaginations and created a demand for visual depictions. There were, of course, drawings and engravings, but no other art form could give the reality of photography. Of special interest was the Middle East; it was exotic and distant, and its historical ties with Biblical places made it even more appealing.

Shortly after Daguerre's process became public, a team under the direction of Frenchman J. P. Girault DePrangey photographed in Egypt. However, widespread distribution of the pictures was not possible until the wet-collodin process was invented. Photographs by Maxine DuCamp, Francis Firth, Charles Negre, Felice A. Beato, and others were soon in demand.

One of the most beautiful regions of all remained largely unphotographed until the late 1860s. After the Civil War, several government expeditions were sent to the western United States to map and explore the region. A photographer accompanied them to record the details of the areas being explored. Thus, the photographer replaced the artist; the camera replaced the drawing pen; and, the photograph replaced the sketch. Civil War photographers T. H. O'Sullivan and Alexander Gardner both went West with these government expeditions as did William Henry Jackson. Other photographers who explored the regions were Carleton Watkins, Eadweard Muybridge and Andrew J. Russell.

G.N. Barnard, *photographer, stereo card, Great Chicago Fire of October 9, 1871*

Jackson, perhaps the best known of these men, began to photograph the West with the Hayden survey in 1870, which chiefly followed the Oregon Trail through Wyoming. In 1871, Jackson was probably the first person to photograph the region that became known as Yellowstone National Park. The value of Jackson's photographs is verified by a bill that was introduced in Congress to set Yellowstone aside as a national park. His photos were put on exhibition at the same time the bill was introduced, and for most of the men in Congress, this was the first time they had ever "seen" the region. The bill was passed.

Time, Motion and Perception in Early Photographs

Because we now use high speed films with high speed lenses, it seems inconceivable that any exposure should be longer than one second. However, the earlier processes employed a much slower emulsion which required exposures that were generally longer than one second. Therefore, people or objects that moved during the exposure time would be blurred, or, if the exposure were long enough, might disappear altogether from the photograph. Daguerreotypes of street scenes often showed no people, since they had not remained still long enough to be recorded in the plate.

Stereographic photographs were the most popular and earliest form of photograph to show action as it was taking place. From the

Daguerreotype period to the present, there has always been interest in stereographic images. Essentially, a stereographic photograph is two, nearly identical views of the same scene taken from two different vantage points, approximately two inches apart. These views are made either by moving the camera laterally or with a double-lens camera. When viewed through a stereoscope viewer, the two images blend together to produce a 3-D effect. By the late 1870s, almost no parlor was complete without a stereoscope and a stock of stereo cards.

Sometimes, by using a fast shutter speed, a photograph of a moving object will enable us to see things that are not normally visible to the unaided eye. A camera can, therefore, extend our vision. This was demonstrated by Eadweard Muybridge with a series of photographs depicting a galloping horse. The photographs proved that the legs of a galloping horse were off the ground only when they were bunched under the horse's belly. The results of these and other experiments forced painters to re-evaluate their concept of motion. It is not by coincidence that many impressionist painters were directly influenced by the photographs of Muybridge and Morey, and the "instantaneous" quality of stereo cards.

Eadweard Muybridge, *photographer, 1887,
from "Animal Locomotion," plate 187*

With the turn of the century approaching, people not only enjoyed looking at photographs of far-away places taken by other people, they were able to take the pictures themselves. George Eastman freed a great many people with his invention. While the turn-of-the-century amateur was busy photographing friends, family, and vacations, some photographers were beginning to explore the esthetic and social potential of photography.

Twentieth Century Photography

Photography as Art. One figure who vigorously advanced the cause of photography was Alfred Stieglitz, who was born in Hoboken, New Jersey, in 1864. He spent his student years in Europe and was introduced to photography in 1883. He immediately became obsessed with photography, and constantly experimented with it while studying photo-chemistry at the Berlin Polytechnic. During the nine years he spent in Europe, he traveled, taking pictures wherever he went. By 1889 he was an internationally famous photographer.

Stieglitz returned to New York in 1890 and began publishing *Camera Notes,* a quarterly for the Camera Club of New York. A small group of photographers soon surrounded him, which included Clarence White, Gertrude Kasebier, Alvin Langdon Coburn, Edward Steichen, and others—all of whom became great and famous photographers in their own right. In 1902, the group broke away from the Camera Club and formed its own group, which Stieglitz named the Photo Secession. One year later, Stieglitz published the first issue of *Camera Work,* a beautifully printed magazine that was devoted to promoting photography as an art form.

The new group met at 291 Fifth Avenue, in a room next to Edward Steichen's, where their photographs were displayed. The room, number 291, became the most famous locale of photography in the country.

The Photo Secessionists agreed on two fundamental principles; exploring new subject matter, and concentrating on rendering the subtleties of light. Stieglitz believed a photograph should be straight-forward, without manipulation on the paper surface, while others (like Steichen) believed the printing process should be controlled and manipulated. This same argument continues today.

In any event, *Camera Work* not only published the works of certain photographers, it was the means by which many European artists and writers were introduced to this country. The works of people such as Rodin, Matisse, John Marin, Gertrude Stein, Picasso, Brancusi, and Braque were published toward the end of *Camera Work.* In 1917, after alienating most of his fellow members by drastically reducing the number of photographs he published in *Camera Work,* Stieglitz was forced to close both the magazine and Gallery 291. However, Stieglitz succeeded in the promotion of photography as art. There is probably not a major museum in the world that does not exhibit photography.

Alfred Stieglitz, *photographer, 1907, "The Steerage"*

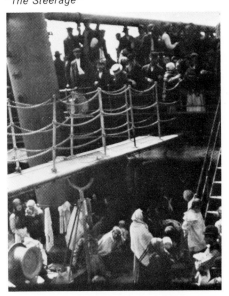

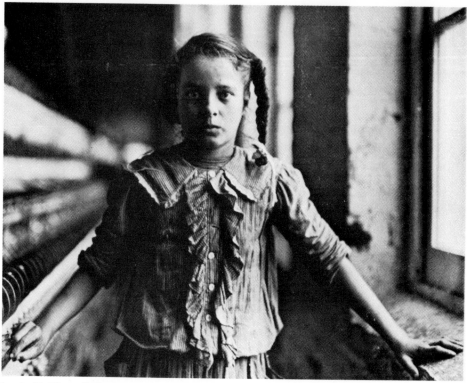

Lewis W. Hine, *1908*

The Photograph as a Document

The photograph has the unparalleled ability to document scenes of despair, cruelty, poverty, and their victims. While viewers may not believe or shrug off paintings and written accounts as artistic inventions, they cannot deny the evidence of photographic images. There is faith in the viewers' minds that cameras cannot lie. That photography represents truth is as true today as it was in 1839. Because of this responsibility to truth, the photographic historian, Beaumont Newhall, has commented, "that before a photograph can be accepted as a document the photograph itself must first be documented."

Photographs can be documents on various levels at the same time. For instance, most snapshots are visual records of particular places or people made to call back the memory at a later date. Newspaper photographs depict the reality of something that happened. Yet, we know on another level, photographs can record only a frame or slice of reality. They communicate not only the reality of detail in the image, but also the photographer's point of view about that reality. Therefore, no photograph is immune from the personality of the photographer; all subject matter is subjective. When a photographer purposely sets out to effect social change or a change in the social structure, the style is generally called *documentary.*

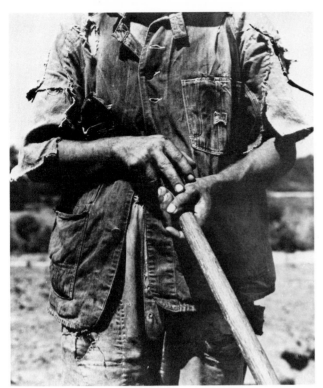

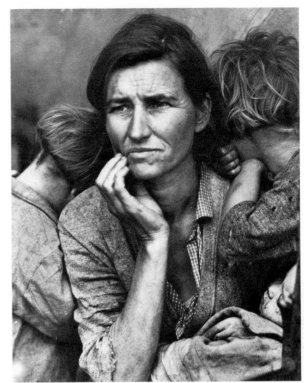

Dorothea Lange, *1936* Dorothea Lange, *1936*

In the late 1880s, Jacob Riis, a Danish immigrant in New York, became the first person to show how photographs could become social documents. Riis had been writing about the conditions of life in the New York slums and began to take pictures to illustrate his articles. Unfortunately, photographic reproduction was still young, and Riis' pictures appeared in the newspaper as facsimile drawings. However, in 1890, Riis published *How The Other Half Lives,* which contained seventeen photographic reproductions. The book had great impact on people and ultimately caused many housing reforms.

Similar motivations inspired Lewis W. Hine to photographically record the abuses of child labor. In 1900, there were approximately two million children under the age of sixteen employed, some under terrible conditions. Hine's photographs helped to pass the child labor laws.

Social conscience on a governmental level caused the Assistant Secretary of Agriculture, Rexford G. Tugwell, to appoint Roy Stryker to supervise the photographic recording of farm families during the depression of the 1930s. During the seven year lifespan of the Farm Security Administration (FSA), thousands of negatives were produced, most of them straightforward, strong, and shocking. Stryler recruited a remarkable band of talent for this project, including Walker Evans, Dorothea Lange, Arthur Rothstein, Ben Shahn, and Russell Lee.

New Visions

The beginning of the 20th century was a time of great strides in the fields of industry, science, politics, and the arts. Art movements, including Surrealism, Fauvism, Dada, and Cubism were forever altering the meaning of "art."

In areas of visual design and architecture, no school was more important than the Bauhaus in Berlin. The Hungarian artist Laszlo Moholy-Nagy came to the Bauhaus in 1922. Moholy-Nagy attempted to expand and explore photography, not within the pictorial structure of the 19th century but with a "new vision" compatible with contemporary life. Moholy-Nagy experimented with photomontage, solarization, optical distortions, multiple exposures, and photograms. His hope was to create and expand the visual language of photography.

Another artist working within Dadaist philosophy was Man Ray. The Dada movement stressed that life was full of absurdities, and it was the goal of the artist to create even greater absurdities. Man Ray had little respect for conventional form and technique in photography. He wrote, "A certain amount of contempt for the material employed to express an idea is indispensable...." Man Ray, like Moholy-Nagy, sought to alter not only the visual image of the photograph, but also the viewers' perception of that image. His photographs were a challenge to the eye and mind.

Man Ray

The Recent Past

The growth of photography since 1950 has been staggering. Because of this growth and appeal, there has been an increase in the public awareness of photography as a legitimate art form. Courses in photography have been added to the art departments in many schools. People enroll in these photography classes for various reasons: some want to learn how to take better snapshots; some need to learn photography for their jobs; and many learn how to use photography as a means of personal expression, and consequentially, as an artistic medium.

Photography as an art form has grown in many different directions since 1950. Areas that are still being explored are composite imagery and heavy manipulation of the photographic image. The work of Jerry Uelsmann and Robert Heinecken serve to illustrate this particular branch.

Another important area that continues to attract photographers is related to documentary photography. However, unlike the work of Hine or Riis, more recent documentary photographs are not meant to produce social change, but rather to display a slice of reality as seen through the photographers' eyes. Known as "social landscape," its major proponents have been Robert Frank, Diane Arbus, Lee Friedlander, and Garry Winograd. Arbus' photographs, for instance, show people who are unusual in one way or another; twins, giants, midgets, and ordinary people who happen to appear strange in the context of the moment. These photographs leave the viewer with the feeling that there exists a subculture of which he or she knows very little. At the same time, because her subjects appear calm and relaxed in the photographs, it is the viewer who feels the discomfort.

In a general way, the snapshot was rediscovered in the 1970s. Many photographers rejected the idea of formal or traditional structure that had long been accepted practice. Many photographers talked of the demise of technique during the sixties and seventies, while some complained that technique had hindered the growth of photography as a personal medium.

Photographic purpose and content were also challenged. In one camp, there were those who believed that the photographs had to be judged on the basis of what they said about the subjects. The other camp insisted it was more important that the content indicate something about the photographer.

There were, of course, many other ideas and thoughts about photography in the recent past. One need only to look at the amount of literature published recently. Photography has had many purposes in the past, and this will continue in the future. Each person who has taken a picture has added a new image to the history of photography.

cabinet cards by Sarony, *circa 1870s*

In Focus/A History of Photography

1. Since its invention, photography has passed through numerous stages or shifts of emphasis. After you review the history, try to duplicate in your own photographs the following historical trends: (a) the formal portrait, (b) scientific investigation or documentation, (c) travel, (d) social reform, (e) abstract composition, (f) documentation of contemporary social phenomena, (g) the informal snapshot and the candid photograph.

 Your attempts to produce photographs that illustrate these major trends in the history of photography will force you to make a rather close study of existing work in each category. In the process of trying to duplicate the mood and appearance of each stage, you will come to know them much better than if you simply look at other photographers' examples. Perhaps this somewhat lengthy and difficult exercise will suggest a direction for your future work in the field of photography.

2. In the bibliography section in the back of this book, you'll find a listing of books by and about photographers. Go to your local library and examine several of these books. Examine their photographs carefully. All of those photographers listed, and many more not listed, have added their own personal vision to the history of photography.

Appendix

Eureka School Outfit.

A. Carrying Case.

B. Ruby Lamp.

C. Double Plate Holder.

D. Dry Plates.

EE. Developing Trays.

F. Glass Graduate.

G. Developing and Toning
Solution.

H. Hyposulphite Soda.

I. Printing Frame.

J. Sensitized Paper.

K. Card Mounts.

Focusing Cloth.

Glossary

Aberrations Optical defects in a lens that limit the sharpness of the focused image.

Abrasions Marks or scratches on the emulsion surface of photographic materials (usually film).

Acetate base A support for photographic film usually composed of cellulose acetate.

Accelerator The chemical ingredient in a developer solution that increases the activity of the reducing agent.

Acetic acid A weak solution of acetic acid is used in stop baths to inhibit the action of the developer. It is also used in some fixing baths.

Agitation The process used to bring fresh chemical solution in contact with photographic emulsion.

Air bubbles Tiny bubbles of air that cling to the surface of an emulsion. They appear as black spots on a print. Sufficient agitation is usually recommended to prevent this from happening.

Antihalation backing A coating on the backing of film that prevents reflections within the film.

Angle of view The area of coverage that is viewed by the lens on a camera. The angle of view is determined by the focal length of a lens.

Aperture The opening in a lens system through which light passes. It is usually expressed as a fraction of the focal length, that is, *f*/stop.

A.S.A. (American Standards Association) A standardized system for rating the light sensitivity of films.

Automatic camera A camera with a built-in exposure meter that automatically adjusts the lens opening, shutter speed, or both.

Available light The term usually implies an indoor or night time light condition of low intensity. It is also called "existing light."

Back The portion of a camera that contains the film.

Back light Illumination from a source behind the subject as seen from the position of the camera.

Base See Acetate base.

Baseboard The large board to which the enlarger column is attached. The enlarging easel is usually placed on the baseboard.

Bellows The folding portions in some cameras and enlargers. It is accordion folded, usually made of leather or rubber.

Between-the-lens shutter A shutter designed to operate between two elements in a lens.

Bleach Usually a solution that makes the silver salts in the print or film soluble in fixer. It can be used to remove all or part of the image.

Bleed In a mounted photograph it refers to an image that extends to the boundaries of the board.

Blocked or *blocked up* Refers to an area of a negative that is overexposed.

Blotterbook A number of sheets of blotting paper, interleaved with nonabsorbent tissue used to dry photographic papers.

Blue sensitive The degree of color sensitivity of an ordinary silver emulsion to blue and ultra-violet wavelengths.

Bounce light. Light that is directed away from the subject toward a reflective surface.

Bracket To make a number of different exposures of the same subject in the same lighting conditions.

Bulb A marked setting (B) on some cameras that permits the shutter to stay open for an indefinite period by continued pressure on the shutter release.

Burning in The process of giving additional exposure to part of the image by an enlarger.

Cable release A flexible cord made out of cloth or metal that normally screws into a threaded socket on the shutter or camera body. When released, it will trip the shutter without camera movement.

Cadmium sulfide cell A photo-conductive light sensitive device used in some exposure meters.

Calotype A photographic process employing a negative image to produce a positive image. Invented by William Henry Fox Talbot around 1840.

Camera Latin meaning "room." The instrument with which photographs are taken.

Camera obscura Latin for "dark room." The camera obscura is the ancestor of the photographic camera. It was used by early painters as an aid for sketching.

Camera angles Various positions of the camera in relation to the subject, giving different effects or viewpoints.

Carrier The negative holder in an enlarger.

Cartridge A metal or plastic container in which film is held. Usually, it refers to the container for Instamatic-type film.

Cassette A metal or plastic container in which film is held. The cassette usually refers to the container for 35mm film.

CdS meter An exposure meter that uses a cadmium sulfide cell and is battery-operated.

Changing bag A light-tight bag with openings for the hands in which film can be loaded and unloaded in daylight.

Circle of confusion An optical term used to describe the size of an out-of-focus image point formed by a lens. The more out of focus an image is, the larger the circle of confusion.

Clearing agent A chemical that neutralizes hypo (fixer) in film or paper thus reducing washing time.

Close-up lens A supplementary lens that, when placed over a camera lens, shortens its focal length and allows a closer focusing distance.

Coating A thin film of magnesium fluoride, or other materials, that reduces the intensity of flare light within the lens, thus increasing the brightness and contrast of the image.

Cold tones Bluish or greenish tones in a black and white print.

Collodin Substance used to attach and suspend silver grains on a glass plate, used in the preparation of "wet plate" emulsion. Described by Frederick Scott Archer in 1851.

Color balance The ability of a film to realistically reproduce the colors of a scene. Color films are balanced in manufacture for light of certain color quality.

Color temperature A system established to determine the color of light. Color temperature is expressed in degrees Kelvin (K).

Composition The visual arrangement of all elements in a photograph.

Condenser lens An optical system of lenses used to help focus light in many enlargers.

Contact paper A photographic printing paper used in contact printing.

Contact print A print made by exposing contact paper while it is held tightly against the negative.

Contrast The comparison of tonal values in a negative or print. A contrasty negative or print has few middle tones.

Contrast paper A number given to a particular printing paper. The range is normally 1–6 with 2 considered normal. The higher the number, the higher the contrast. Printing filters are numbered similarly.

Contrasty The condition in which the range of tones in a negative or print is limited.

Cropping Selective use of a portion of an image recorded on a negative.

Cut film Film that is cut to various sizes (for example, 4 x 5, 8 x 10, etc.) Also known as sheet film.

Darkroom A light-tight area used for processing and handling light-sensitive materials.

Definition The impression of clarity of detail in the photograph.

Dense Darkness in a negative usually caused by overexposure or overdevelopment.

Densitometer An instrument for measuring the density of an area in a photographic image.

Density The blackness of an area in a negative or print that is determined by the amount of light that can pass through a negative or reflect from a print.

Depth of field The distance range between the nearest and farthest planes that appear in acceptably sharp focus in a photograph.

Depth of field scales A calibrated ring, chart, or scale often engraved on a camera lens mount on which the depth of field can be determined for any given distance and aperture.

Depth of focus The distance range over which the film can be shifted at the film plane inside the camera and still have the subject appear in sharp focus. This term is often confused with depth of field.

Developer A chemical solution used to make the latent image (invisible) become a visible image on exposed paper or film.

Developing tank A light-tight container used for processing film.

Developing out The photographic process by which a latent image is made visible by development.

Diaphragm A perforated plate or adjustable opening mounted behind or between the element of a lens that controls the amount of light that reaches the film or paper. These openings are usually calibrated in f-numbers.

Diffraction The spreading of a light ray after it passes near the edge of an object.

Diffusion Scattered, indirect lighting that softens detail in a print. Usually achieved with a diffusion disc or glass in an enlarger.

DIN The German system of determining film speed.

Distortion Defects in the shape of an image caused by certain types of lenses, such as the curvature of lines with wide-angle lenses.

Dodging The practice of using an opaque material to lighten an area in a print.

Double exposure The recording of two separate images on a single negative or the printing of two separate images on a single sheet of photographic paper.

Drum dryer A machine used for drying paper prints.

Dry mounting A method of mounting prints on cardboard or similar materials by means of heat pressure, and tissue impregnated with shellac.

Dry mounting press The machine used to dry mount photographs.

Dry mounting tissue A thin tissue paper, usually impregnated with shellac, which, when heated sufficiently will adhere a print to various materials.

Easel Holds photographic paper flat for exposure under the enlarger.

Electronic flash A repeatable flash produced by a high voltage electrical discharge in a glass tube filled with gas.

Element A single unit in the structure of a lens.

Emulsion A thin coating of light-sensitive material, usually silver halide in gelatin, in which the image is formed on film and photographic paper.

Enlargement A print that is larger than the negative. Also called blow-up.

Enlarger A device consisting of a light source, a negative carrier, and a lens, and a means of adjusting these to project an image from a negative to a sheet of photographic paper.

Exposure The quantity of light allowed to act on a light-sensitive material; a product of the intensity (controlled by the aperture size) and the duration (controlled by the shutter speed or enlarging time) of light striking the film or paper. Also used to describe the actual act of taking the picture.

Exposure latitude The range of camera exposures, from underexposure to overexposure which will produce an acceptable negative.

Exposure meter An instrument used to measure light and to equate that information into the appropriate shutter speed and aperture setting.

Exposure setting The lens opening and shutter speed selected to expose the film.

Fading The deterioration of the print image over a period of time.

Farmer's reducer A compound containing potassium ferricyanide and sodium thiosulfate, used to reduce negative densities.

Fast A term used to describe films of high sensitivity or lenses of large apertures.

Ferrotype Originally a name for the tintype process popular from the 1860s to 1880s.

Ferrotype plates (tins) Sheets of highly polished stainless steel, tin, or chromium plated metal used to dry prints to a high gloss finish.

Film The light-sensitive material used for exposure, generally in a camera.

Film clips Spring clips that hold the film securely at one end.

Film speed The relative sensitivity of the film to light. Rated usually in ASA numbers. (See A.S.A.)

Filter A colored piece of glass or other transparent material used over the lens to emphasize, eliminate, or change the density or color of the subject or a portion of the subject.

Filter factor The number by which the correct exposure without the filter must be multiplied to obtain the same relative exposure with the filter.

Fisheye lens A type of wide-angle lens, or lens attachment, capable of covering a field of 180° or more.

Fixed-focus lens A lens that has been focused in a fixed position by the manufacturer.

Fixing bath A solution that makes film or paper insensitive to further exposure to light. Usually contains hypo.

Flash A brief, intense burst of light produced by a flashbulb or an electronic flash unit.

Flashing A method of darkening an area of a print by exposing it to white light prior to the fixing bath.

Flat A term used to describe a low contrast negative or print.

Flatlighting Lighting the subject in such a way as to produce a minimum of shadows and contrast in the subject.

Flood A photographic light source designed to illuminate a wide area.

F-number A number used to designate the size and light-passing ability of the lens opening on most adjustable cameras. The larger the f-number, the smaller the lens opening. F-numbers are fractions of the focal length.

Focal length The distance from the lens to a point behind the lens (focal point) where the light rays are in focus when the distance is set at infinity.

Focal plane The plane where the image is brought into critical focus. In a camera, the film is placed at the focal plane.

Focal plane shutter An opaque curtain shutter containing a slit that moves directly in front of the film in a camera.

Focus To adjust the distance scale on a camera so that the image is sharp on the focal plane.

Fog Darkening or discoloring of a negative or print caused by extraneous light or chemical action. Can also be caused by using outdated film or storing the film in a hot, humid condition.

Foreground The area between the camera and the main subject.

Front lighting Light falling on the subject from in front of the camera.

Gelatin The material most often used in photographic emulsions to suspend the silver salts.

Glossy Used to describe paper with a smooth surface which can be used for ferrotyping. The print has a mirror-like finish.

Graduate A container which is calibrated in fluid ounces or millimeters used in measuring liquid photographic chemicals.

Grain The individual silver particles or groups of particles in the emulsion layer, which when enlarged, become visible.

Gray card A card of known reflectance, usually 18%, used to determine the exposure.

Ground glass A name for a type of focusing screen in a camera.

Halation A blur, or halo effect, that sometimes occurs around a bright subject.

Halides Metallic compound that contains the light-sensitive materials upon which most photographic processes are based.

Hard A term used to describe an image that is high in contrast.

Hardener A chemical that is added to the fixing bath to harden the gelatin after development.

Highlights The brightest areas on a print and the darkest areas in a negative.

Hyperfocal distance The distance from the camera to the near plane of the depth of field when the lens is focused at infinity.

Hypo Chemical used in fixing baths to make soluble the undeveloped silver salts in an emulsion and to stop the action of the developer.

Hypo eliminator A bath for film and papers. It is intended to shorten washing times. In reality hypo eliminator does not eliminate hypo but aids in its removal.

Image The visual result of the exposure and development on a photographic emulsion.

Incident light The light reaching the subject from all sources.

Incident meter A meter designed to read incident light.

Infinity In photography, the distance from the camera beyond which no further focusing adjustment is required to maintain a sharp image.

Infrared Light rays which are invisible with ordinary films past the red end of the visible spectrum.

Intensifier A chemical solution used to increase the density (contrast) of a photographic image.

Interchangeable lens A lens which can be removed from a camera body.

Iris diaphragm See Diaphragm.

Latent image The invisible image left by the action of light on photographic materials.

Leaf shutter A type of shutter consisting of a number of thin blades or leaves installed between the lens components (elements) or behind the lens.

Lens One or more pieces of optical glass, plastic, or other material, designed to collect and focus light rays to form a sharp image on the film or paper.

Lens barrel The tube in which the lens is mounted.

Lens board A wooden or metal panel on which a lens is mounted to an enlarger or view camera.

Lens hood An accessory used to shield the lens from extraneous light. Also called lens shade.

Lens mount A portion on a camera which holds the lens to the body.

Lens tissue A soft, lintless tissue used for cleaning lenses.

Light meter See Exposure meter.

Long lens A lens whose focal length is longer than the diagonal measurement of the film. Generally used to describe telephoto lenses.

Macro lens A special type of lens used for photographing subjects at very close ranges.

Matte Used to describe a finish on paper—nonglossy or dull.

Maximum aperture The largest opening on a lens.

M, F, X Marking found on many shutters to indicate the flash synchronization, M is for medium peak flash bulbs, F denotes fast peak flash bulbs, X used for electronic flash.

Micro prism A type of focusing aid found in many ground glass viewing screens. It usually consists of a pattern of dots.

Negative Any photographic image in which the subject tones have been reversed. Usually, it refers to film.

Negative carrier The frame which holds the negative in an enlarger.

Normal lens Any lens whose focal length is approximately equal to the diagonal measurement of the film being exposed through it.

Opaque Incapable of transmitting light. Also a commercial product which is painted on a negative to black out an area.

Orthochromatic A type of emulsion which is sensitive to visible blue and green but not to red.

Overexposure A condition in which too much light was allowed to reach the film. It produces a dense negative.

Panchromatic An emulsion which is sensitive to blue, green, and most of the red regions of the spectrum.

Paper The light-sensitive paper used in making prints.

Paper negative A negative image on a paper base.

Parallax In photography, the difference between the field of view seen through the viewfinder and that recorded on the film.

Photoflood A photographic light source.

Photogram An image made by placing objects on a sheet of photographic paper and exposing it to light.

Photomicrography Photography through a microscope.

Pinhole camera A camera that has a pinhole aperture in place of a lens.

Pinholes Tiny transparent spots in the negative caused by the developer not reaching the film.

Polarized light Waves of light which vibrate uniformly in, or parallel to, a particular plane.

Polarizer A filter or screen which transmits polarized light.

Positive An image in which the tones are similar to those of the subject. A print made from a negative.

Primary colors of light Any one of the three colors of light that make white light—red, blue or green.

Primary pigment colors A mixture of the primary pigment colors—magenta, yellow, and cyan—produces black.

Print An image, usually positive, on photographic paper.

Printing out A method of photographic printing, where the visible image is formed by the action of light, rather than being developed-out.

Projection print Refers to any print made by projection usually with an enlarger.

Rangefinder An optical-mechanical device consisting of a system of lenses and prisms. When installed in a viewfinder of a camera, it will visually show the out-of-focus image.

Rangefinder camera A camera with a built-in rangefinder.

Reciprocity law A law which states that exposure varies uniformly with changes in either time or intensity (exposure).

Reducer agent A chemical solution used to decrease the overall density of a negative.

Reflected meter An exposure meter which measures the light reflected by the subject.

Reflector Any surface used to reflect light.

Reflex camera A kind of camera in which the viewfinder image is formed by the lens and reflected by an inclined mirror onto a ground glass.

Refraction The bending of light rays as they pass obliquely from one medium to another medium of different density.

Reticulation The cracking or distorting of the emulsion during processing usually caused by wide temperature or chemical-activity difference between the solutions.

Roll film Film supplied in rolls rather than sheets. Usually used to describe those films protected from light by paper leaders.

Safelight Illumination in a darkroom that will not normally expose photo sensitive material.

Self-timer A device that is either attached or built in a camera to allow a time delay before the shutter is released.

Sensitivity The susceptibility of an emulsion to the energy of light.

Sepia toning A chemical process which converts the blackened silver image to a brownish image.

Shadows The darkest areas on a print and the lightest areas on a negative.

Sheet film See Cut film.

Short lens Any lens whose focal length is shorter than the diagonal measurement of the film. Also called wide-angle lens.

Shutter The device which opens and closes to admit light to the film.

Shutter release The lever which allows the shutter to operate. Also called the trigger.

Shutter speed The duration of the exposure. Also, the marked settings on a shutter dial.

Single-lens reflex A type of camera that allows viewing through the picture-taking lens. This is accomplished with the use of a mirror. Abbrev. as SLR.

Slow A term that denotes a long shutter speed. Can also be applied to a relatively insensitive film.

Soft Used to describe a print or negative which is low in contrast. Also used to describe an image which is not sharp.

Spectrum The colored bands of light formed by the dispersion of white light as it passes through a prism.

Spotting The process of bleaching or painting out spots or defects from a negative or print.

Spotting colors The colors used in spotting.

Stop bath A chemical solution which neutralizes the developer.

Stock solution Photographic chemicals in concentrated form. Intended to be diluted with water for use.

Stop down To reduce the size of the lens opening.

Supplementary lens A lens or lens system intended to be used over a camera lens to alter the effective focal length. Such a lens can allow closer than normal focusing distance.

Tacking iron A tool used to attach dry mounting tissue to the print or board.

Taking lens The lens which forms the image on the film in a twin-lens reflex camera. The other lens if for viewing and framing the subject.

Tank A light-tight container made of plastic or metal in which the film is placed for processing.

Telephoto lens See Long lens.

Test print A piece of photographic paper which is exposed to a sequence of regular and cumulative exposures to determine the correct exposure for a particular negative on that type of paper.

Thin Denotes a negative of low density.

Time A marking on many shutters (T). When the shutter is set on T and released, it will remain open until it is released again.

Time exposure Refers to an exposure longer than 1 second.

Tonal scale The range of grays (densities) in a photographic image.

Toning A chemical method for changing the color or tone of a photographic image.

Translucent A diffusing material such as frosted glass, which will transmit light, but not focus light.

Transparency A photographic image which is viewed by translucent light. Usually, a color positive (slide).

Tray A shallow container, usually rectangular in which prints and films are processed.

Tripod A three-legged stand or support on which a camera can be attached. They are usually adjustable in height and provide a means of tilting the camera.

TTL Through-the-lens, refers to light meters built behind the camera lens.

Tungsten light Artificial illumination as opposed to daylight.

Ultraviolet Rays which comprise the invisible portion of the spectrum just beyond the visible violet.

Variable contrast paper A type of photographic paper that by the use of variable contrast filters, will change contrast of the paper.

Viewing lens The lens in which the subject is seen in a twin-lens reflex camera.

Warm tones The shades of red and orange (brown) in a black and white image.

Washed out Denotes a pale, overall gray print lacking highlights.

Weight Refers to the thickness of photographic paper.

Wide-angle See Short lens.

Working solution Chemical solution mixed from the stock solution.

Zoom lens A type of lens with a range of various focal lengths.

Bibliography
Books by and about Photographers

Abbott, Berenice
Photographs. New York: Horizon Press, 1970.

Adams, Ansel
The Portfolios of Ansel Adams. Boston: New York
Graphic Society, 1977.
Singular Images. Hastings-on-Hudson, N.Y.: Morgan &
Morgan, 1974.
Ansel Adams. Hastings-on-Hudson, N.Y.: Morgan &
Morgan, 1972.

Arbus, Diane
Diane Arbus: An Aperture Monograph. Millerton, N.Y.:
Aperture, 1972.

Arnold, Eve
In China. New York: Alfred A. Knopf, 1980.

Atget, Eugene
The Work of Atget: Old France. Boston: New York
Graphic Society, 1981.
The World of Atget, by Berenice Abbot. New York:
Horizon Press, 1964.

Beaton, Cecil
Beaton. New York: Viking Press, 1980.

Brady, Mathew.
Mathew Brady: Historian with a Camera, by James D.
Horan, New York: Bonanza, 1960.

Brandt, Bill
Shadow of Light. New York: DaCapo, 1977.
Perspective of Nudes. Garden City, N.Y.: Amphoto,
1961.

Brassai
The Secret Paris of the Thirties. New York: Pantheon
Books, 1976.
Brassai. New York: Museum of Modern Art, 1968.

Bullock, Wynn
Photography: A Way of Light. Hastings-on-Hudson,
New York: Morgan & Morgan, 1973.

Callahan, Harry
Callahan. Millerton, N.Y.: Aperture, 1976.

Cameron, Julia Margaret
Julia Margaret Cameron. Millerton, N.Y.: Aperture, 1974.

Caponigro, Paul
Paul Caponigro (An Aperture Monograph). Millerton, N.Y.: Aperture, 1967.

Carroll, Lewis
Lewis Carroll, Photographer, by Helmut Gernsheim. New York: Dover Publications, 1969.

Cartier-Bresson, Henri
Henri Cartier-Bresson: Photographer. Boston: New York Graphic Society, 1979.
The World of Henri Cartier-Bresson. New York: Viking, 1968.
Photographs by Henri Cartier-Bresson. New York: Grossman, 1963.
The Decisive Moment. New York: Simon & Schuster, 1952.

Crane, Barbara
Barbara Crane: Photographs 1948-1980. Tucson, Ariz.: Center for Creative Photography, 1981.

Cunningham, Imogen
Imogen! Photographs 1910-1973. Seattle: University of Washington Press, 1974.

Davidson, Bruce
East 100th Street. Cambridge, Mass.: Harvard University Press, 1970.

Evans, Walker
Walker Evans: First and Last. New York: Harper and Row, 1978.
Let Us Now Praise Famous Men, James Agee. New York: Ballantine Books, 1972.
Message from the Interior. New York: The Eakins Press, 1966.

Frank, Robert
The Americans. Millerton, N.Y.: Aperture, 1978.

Heinecken, Robert
Heinecken. Carmel, Calif.: The Friends of Photography, 1981.

Hine, Lewis W.
Lewis W. Hine, edited by Judith Gutman. New York: Grossman, 1974.

Jackson, William H.
William H. Jackson, by Beaumont Newhall and Diana
E. Edkins. Hastings-on-Hudson, N.Y.: Morgan & Mor-
gan, 1974.

Karsh, Yousuf
Karsh Portfolio. Toronto, Canada: University of Toronto
Press, 1967.
In Search of Greatness. New York: Knopf, 1962.

Kertesz, Andre
Andre Kertesz: 60 Years of Photography 1912-1972.
New York: Grossman, 1972.
Andre Kertesz, Photographer. New York: Museum of
Modern Art, 1964.

Lange, Dorothea
Dorothea Lange. New York: Museum of Modern Art,
1966.

Lartigue, J. H.
Les femmes. New York: E. P. Dutton, 1974.
Boyhood Photos of J. H. Lartigue. Lausanne: Ami
Guichard, 1966.

Laughlin, Clarence John
The Personal Eye. Millerton, N.Y.: Aperture, 1973.

Lyon, Danny
Pictures from the New World. Millerton, N.Y.: Aperture,
1981.
Conversations with the Dead. New York: Holt, Rinehart
& Winston, 1971.

Man Ray
Man Ray. Boston: New York Graphic Society, 1975.

Metzker, Ray
Sand Creatures. Millerton, N.Y.: Aperture, 1979.

Moholy-Nagy, Laszlo
Painting, Photography, Film. Cambridge, Mass.: M.I.T.
Press, 1973.

Muybridge, Eadweard
Human and Animal Locomotion. New York: Dover,
1979.

O'Sullivan, Timothy.
American Frontiers. Millerton, N.Y.: Aperture, 1981.

Penn, Irving
Worlds in a Small Room. New York: Viking, 1980.

Porter, Eliot

In Wildness Is the Preservation of the World. A Sierra Club Book. New York: Ballantine Books, 1967.

Siskind, Aaron

Aaron Siskind: Photographer. Rochester, N.Y.: George Eastman House, 1965.

Smith, Eugene W.

W. Eugene Smith (An Aperture Monograph). Millerton, N.Y.: Aperture, 1969.

Steichen, Edward

A Life in Photography. Garden City, N.Y.: Doubleday, 1963.

Stieglitz, Alfred

An American Seed, by Dorothy Norman. Millerton, N.Y.: Aperture, 1973.

Strand, Paul

Paul Strand (An Aperture Book), Vols. I & II, Millerton, N.Y.: Aperture, 1972.

Uelsmann, Jerry N.

Jerry N. Uelsmann (An Aperture Monograph). Millerton, N.Y.: Aperture, 1970.

Vishniac, Roman

A Vanished World. New York: Farrar, Straus & Giroux, 1983.

Vroman, Adam Clark

Dwellers at the Source, by William Webb and Robert A. Weinstein. New York: Grossman, 1973.

Weston, Edward

The Daybooks of Edward Weston, Vols. I and II. Millerton, N.Y.: Aperture, 1973.
My Camera on Point Lobos. New York: DaCapo, 1968.
Edward Weston: Photographer (An Aperture Monograph). Millerton, N.Y.: Aperture, 1965.

Selected Books
on Photography

History

Buckland, Gail. *Fox Talbot and the Invention of Photography.* Boston: David R. Godine, 1980.

Coe Brian. *Cameras From Daguerreotypes to Instant Pictures.* New York: Crown, 1978.

Friedman Joseph S. *History of Color Photography.* London: Focal Press Limited, 1968.

Gernsheim, Helmut. *A Concise History of Photography.* New York: Grosset and Dunlap, 1965.

_____ *The History of Photography.* New York: Oxford University Press, 1955.

_____ *Creative Photography: Aesthetic Trends 1839-1960.* Farber & Ferber, 1962

_____ *L. J. M. Daguerre, The History of the Daguerreotype.* New York: Dover Publications, 1968.

Goldberg, Vicki, ed. *Photography in Print: Writings from 1816 to the Present.* New York: Touchstone, 1981.

Mess, C. E. Kenneth. *From Dry Plates to Ektachrome Film: A Story of Photographic Research.* New York: Ziff-Davis, 1961.

Newhall, Beaumont. *The History of Photography from 1839 to the Present Day.* New York: Museum of Modern Art, 1964.

_____ *Latent Image: The Discovery of Photography.* Garden City, N.Y.: Doubleday, 1967.

_____ *The Daguerreotype in America.* Greenwich, Conn.: New York Graphic Society, Ltd., 1968.

_____ *The History of Photography from 1939 to the Present Day.* Boston: New York Graphics Society, 1982.

_____ *The Daguerreotype in America.* New York: Dover, 1976.

Pollack, Peter. *The Picture History of Photography from the Earliest Beginnings to the Present Day.* New York: Harry Abrams, 1969.

_____ *The Picture History of Photography.* New York: Abrams, 1977.

Rinehart, Floyd and Marion. *American Dageurrian Art.* New York: Crown Publishers, Inc., 1967.

Rudisill, Richard. *Mirror Image, The Influence of the Daguerreotype on American Society.* Albuquerque: University of New Mexico Press, 1971.

Scharf, Aaron. *Art and Photography.* Baltimore: Penguin Books, 1974.

Taft, Robert. *Photography and the American Scene, A Social History, 1839-1889.* New York: Dover Publications. 1964.

Wall, E. J. *The History of Three-Color Photography.* London: Focal Press Limited, 1970.

Technical Books

Adventures in Existing Light. AC-44. New York: Eastman Kodak Co.

Applied Infrared Photography, M-28. New York: Eastman Kodak Co.

Artificial-Light Photography, by Ansel Adams. Hastings-on-Hudson, N.Y.: Morgan & Morgan, 1971.

Basic Color-Photography, by Andreas Feininger. Garden City, N.Y.: Amphoto, 1972.

The Camera, by the Editors of Time-Life Books. Hastings-on-Hudson, N.Y.: Morgan & Morgan, 1970.

Camera & Lens—The Creative Approach, by Ansel Adams. Hastings-on-Hudson, N.Y.: Morgan & Morgan, 1970.

Close-Up Photography, Vol. 1, N-12A. New York: Eastman Kodak Co.

Close-Up Photography, Vol. II, N-12B. New York: Eastman Kodak Co.

Copying, M-1. New York: Eastman Kodak Co.

The Creative Photographer, by Andreas Feininger. Englewood Cliffs, N.J.: Prentice-Hall, 1975.

Darkroom Techniques, by Andreas Feininger. New York: Amphoto 1974.

Dictionary of Contemporary Photography, by Hollis N. Todd and Leslie Stroebel. Hastings-on-Hudson, N.Y.: Morgan & Morgan, 1974.

Discover Yourself through Photography by Ralph Hattersley. Hastings-on-Hudson, N.Y.: Morgan & Morgan, 1971.

Filters, A-B-1. New York: Eastman Kodak Co.

The Hole Thing—A Manual of Pinhole Fotography, by Jim Shull. Hastings-on-Hudson, N.Y.: Morgan & Morgan, 1974.

Kodak Black-and-White Photographic Papers, G-1. New York: Eastman Kodak Co.

Kodak Color Films, E-77. New York: Eastman Kodak Co.

Kodak Darkroom Data Guide, R-20. New York: Eastman Kodak Co.

Kodak Master Photoguide, AR-21. New York: Eastman Kodak Co.

Kodak Professional Black-and-White Films, F-5. New York: Eastman Kodak Co.

Kodak Professional Photoguide, R-28. New York: Eastman Kodak Co.

Leica Manual, edited by Douglas O. Morgan, David Vestal, William Broecker. Hastings-on-Hudson, N.Y.: Morgan & Morgan, 1973.

Natural-light Photography, by Ansel Adams. Hastings-on-Hudson, N.Y.: Morgan & Morgan, 1971.

The Negative, by Ansel Adams. Hastings-on-Hudson, N.Y.: Morgan & Morgan, 1972.

Photo-lab Index, edited by Ernest M. Pittaro. Hastings-on-Hudson, N.Y.: Morgan & Morgan, 1975.

Photography with Large-Format Cameras 0-18. New York: Eastman Kodak Co.

Photography through the Microscope P-2. New York: Eastman Kodak Co.

Photographic Filters, by Leslie Stroebel. Hastings-on-Hudson, N.Y.: Morgan & Morgan, 1974.

Photographic Lenses, by C. B. Nesbett. Hastings-on-Hudson, N.Y.: Morgan & Morgan, 1973.

Photographic Sensitometry: The Study of Tone Reproduction, by Hollis N. Todd and Richard D. Zakia. Hastings-on-Hudson, N.Y.: Morgan & Morgan, 1969.

Photographic Literature, 1960-1970, Vol. 2, by Albert Boni. Hastings-on-Hudson, N.Y.: Morgan & Morgan, 1970.

Practical Sensitometry, by George L. Wafefield, Hastings-on-Hudson, N.Y.: Morgan & Morgan 1970

The Print, by Ansel Adams. Hastings-on-Hudson, N.Y.: Morgan & Morgan, 1971.

Processing Chemicals and Formulas J-1. New York: Eastman Kodak Co.

Professional Portrait Techniques O-4. New York: Eastman Kodak Co.

Special Problems, by the editors of Time-Life Books. Hastings-on-Hudson, N.Y.: Morgan & Morgan, 1971.

Zone System Manual, by Minor White. Hastings-on-Hudson, N.Y.: Morgan & Morgan, 1972.

Index